UCA

university for the **creative arts**

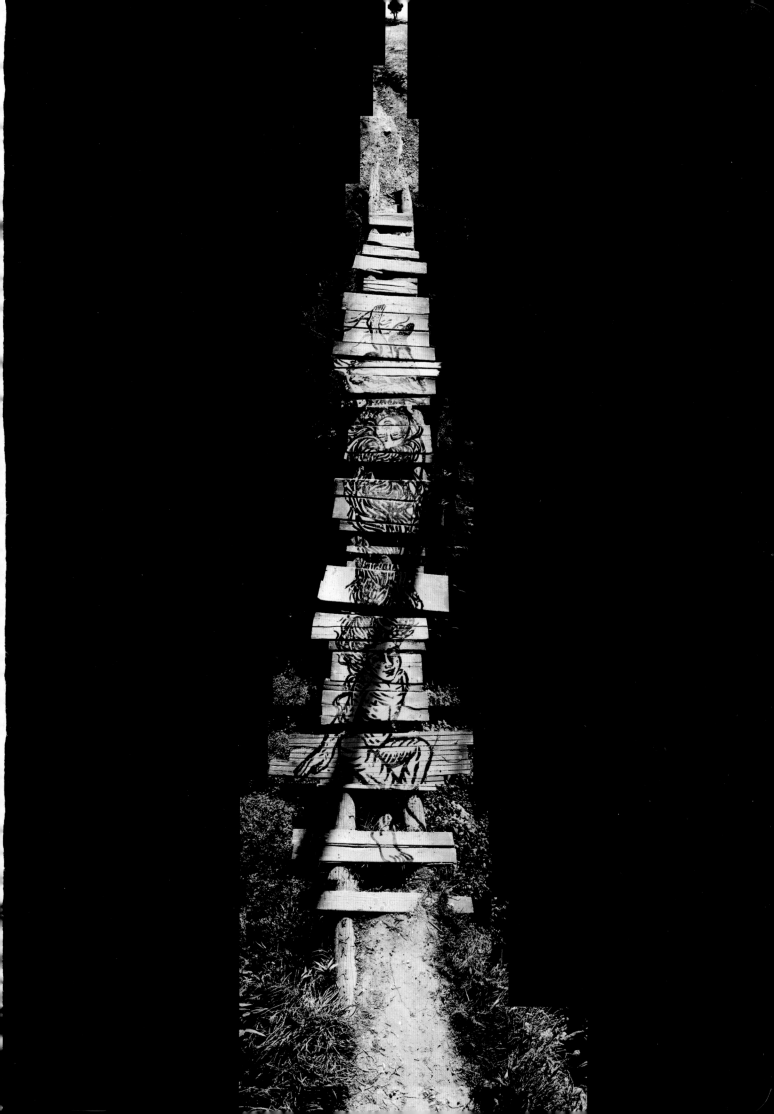

Street Sketchbook Journeys

TRISTAN MANCO

With over 800 illustrations

 Thames & Hudson

For my wife Olivia

Cover design by Ripo

First published in the United Kingdom in 2010 by
Thames & Hudson Ltd, 181A High Holborn, London
WC1V 7QX

Copyright © 2010 Tristan Manco

British Library Cataloguing-in-Publication Data
A catalogue record for this book is available from
the British Library

ISBN 978-0-500-51515-0

Printed and bound in China by Toppan Leefung

To find out about all our publications, please visit
www.thamesandhudson.com.
There you can subscribe to our e-newsletter, browse or
download our current catalogue, and buy any titles that
are in print.

amo te golfinho

Contents

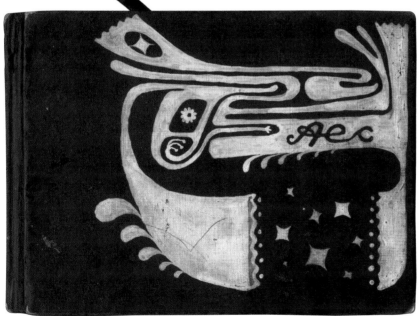

Introduction

Art is a journey. Each artist forges a personal path of discovery, gradually developing a unique style and creative outlook. This book traces the journeys of thirty extraordinary artists from around the world through the life stories and key moments that have shaped their artistic eye. Some have been inspired by their travels. For others, 'the journey' is the link between the people and things that spark their interest and motivate them to create art. This book goes on a visual voyage through these artists' work to discover beauty, mystery, tragedy, satire, magic and more.

How do artists come up with their ideas? What drives them to make art? How do they engage with the world? These are some of the fundamental questions we will attempt to answer by following the imaginative journeys made by this group of young artists. Through interviews and observing them in action, I have been granted a rare insight into their backstories, their inspirations and artistic viewpoints, and the methods they use to create their art.

The featured artists are among the most exciting talents emerging from today's independent art, design and street art movements. They are creative free spirits whose artistic paths have led them to express themselves in many different ways. From the kaleidoscopic visions of Brazilian artist Ramon Martins, who mixes comic-book art, pop culture and organic decoration in his sketches and graffiti, to the satirically poignant paintings and installations of Dran from Toulouse, the diversity of their approaches is striking. The majority of these artists create work on the street with graffiti art and murals, but they also produce art in countless other ways, from canvases to printmaking, filmmaking and animation to comic books and even performance art. The aim of this book is to share in these artists' passions and uncover their processes and obsessions. Through previously unseen sketchbooks filled with ideas, and behind-the-scenes photographs, we are given unique access into their creative lives.

Street art is not a new phenomenon, although it is still in its infancy as a genre. In this book we highlight artists who are bringing new art and ideas to the street. Some of them are just starting out in their careers, while others are more established. But they are all producing breathtaking work, such as the surreal fairy-tale worlds of Ukrainian duo Interesni Kazki and the captivating silhouette paintings of Spanish artist Sam3.

The appeal of street art is in the way it reflects the society around us. A canvas does not change, nor does a piece of paper, but the world around us does; as the streets adapt to the changing socio-economic environment, so street art becomes a continuous commentary that evolves with the times. For this reason it will continue to stay relevant as a movement because there will always be new material to bring to the streets.

The artists featured in this book create a lot of their work on the street and this work is by its nature ephemeral. However, introducing them as 'street artists' poses certain problems and I prefer to describe them simply as artists. Many do not want to be identified with street art alone, though they may remain committed to making art outdoors, on public display. The 'street artist' label puts all artists in the same box, but in reality they work on many levels, with different motivations. In the words of the Italian artist Run: 'I don't feel I belong to one particular "art scene".'

However they choose to define their activities or view their art, artists who put their heart and soul into street works tend to share similar attributes and values. They are intensely driven and passionate and their obsession for art is often necessarily combined with ingenuity and a do-it-yourself attitude. They don't wait for creative opportunities; they create them for themselves, in all manner of ways. They have a compulsion to create,

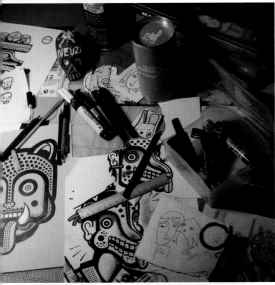

to paint just one more wall, and to doodle on every surface. Something else they share is a desire to involve the viewer in their art. At the same time, they possess a willingness to experiment and to be original and free in all their endeavours.

The creative journey is at the heart of being an artist. An artist needs to be open to change and to follow his own path of learning and inspiration. As we grow up, taking in the world around us, we absorb everything like a sponge and often imitate those things that we like. As artists, our tastes develop, we learn to assess our own drawing skills, to find ways to make images that please us

aesthetically and convey what we want them to. All that we have experienced is filtered into something original, which we then want to communicate to others. True originality is hard to achieve in the art world since some elements will always remind the viewer of something else. But perhaps the most important quality is an artist's personality, the thing that makes one artist's vision different from another's. In selecting artists for this book, I have been drawn to those who have strong artistic personalities and the admirable qualities of openness and integrity.

If an artist's journey has a beginning, a middle and an end, then the end of the journey is the art itself. Whether it's painted on the street or hung in a gallery, these artists – perhaps more than most – are naturally conscious of sharing the results of their work with an audience. Sometimes receiving feedback literally while they are painting a wall,

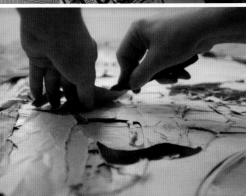

they tend to be uncompromisingly free and uncensored in what they express and how they express it. Art can of course convey many complex thoughts, feelings and ideas through the myriad decisions that each artist makes. It can also be ambiguous, as people interpret it in their own way, and often the best art has a certain enigmatic quality that allows for ambiguity. Even in the internet age, art can still play a vital communicative role, conveying a visual message that might take hours to express in another form. Conversely it also serves to slow things down, allowing the viewer a chance for contemplation rather than the constant consumption of new words and images.

The book travels the world, from Kiev to Bogotá and on to Valparaíso and beyond, showing how local culture influences an artist's outlook and means of expression. All artists are products of their upbringing and environment, although this manifests itself in different ways from person to person. Some may become fascinated by flora and fauna, while others are attracted to folklore, traditions or pop culture. As we get to know this selection of artists it becomes apparent how friends, family, opportunities or lack thereof have spurred each artist on, and how first-hand experiences can have a profound effect on a finished work. This is demonstrated by artists such as Vhils from Lisbon, whose childhood neighbourhood was being gradually redeveloped and modernized as he grew up; today his artwork reflects on the ghosts and lost histories within the city's walls.

As culture becomes more homogenized across the world, local cultures and traditions become increasingly important. By championing these issues, artists can play a key role in strengthening local identity and can also bring subjects to global attention. Many of the artists featured in this book are concerned with social issues and often play an active role in highlighting them. For instance, Bastardilla, an artist based in Bogotá, has produced graffiti art that exposes the plight of the homeless and displaced indigenous peoples. This tradition of protest art is particularly strong in Colombia. Bastardilla's social conscience has enabled her to produce some beautiful and compelling works, which are applauded by the community but also serve as a reminder of social and political challenges that must be confronted. Her defining images also have a second life beyond the street as they can be republished on the internet and spread to a worldwide audience.

Artists may also look to history and folklore as a means of exploring their own personal identity. This is particularly true of a number of Mexican artists who have been inspired by indigenous culture, pre-Hispanic art and the work

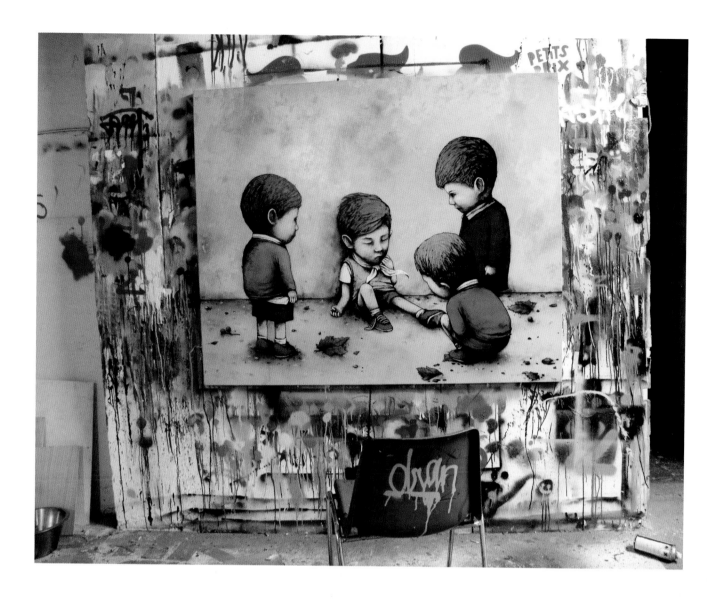

of local artisans. Saner, Neuzz and Losdelaefe are among those who have dug deep into Mexico's vast wealth of traditions, attracted by the country's folk tales, imagery and iconography. These artists may look to similar sources but it is interesting how different their responses are, due to their individual personalities and interpretations.

More than a third of this book's artists come from Mexico, where a new crop of artists are currently producing superlative work on the streets. In studios and makeshift galleries, young artists' collectives such as Arte Cocodrilo are working in printmaking, fine art and murals. Not all of these artists draw from their ancestral roots, but Mexico's rich visual heritage and landscape are an inescapable part of their make-up. Some are more concerned with observing daily life, such as Smithe from Mexico City who creates work with typography and comic characters. Sego, Dhear and News, also

from Mexico City, take their inspirations from nature despite living in one of the world's biggest urban areas. Although artists do not necessarily have to be defined by their homelands, there is clearly a creative energy in Mexico right now that is worth watching.

But looking towards a local culture isn't necessarily nationalistic. As Neuzz explains, 'I'm not interested in being identified as "Mexican" just for using officially recognized iconography.' These images could easily become clichéd, especially when trying to represent an alleged 'Mexican identity', but he points out that cultural icons 'belong to no one and to everyone, and every person has the right to explore their power as a source of inspiration'. Although a certain amount of respect and understanding of context is appropriate, we are all free to be inspired by any aspect of culture, ancient or modern, from any country we choose.

The world has become more open to cultural exchange, and many artists featured here have travelled abroad to work, study or simply to experience life elsewhere. When they recall their travels, it is the differences in sights, sounds and tastes that often have the greatest impact. Brazilian artist Thais Beltrame went to China and found that her work was profoundly affected by the silence and sense of contemplation she experienced there, as well as the attention to detail visible in Chinese art and design. Also from Brazil, the artist T*Freak spent many months in Japan after marrying his Japanese wife. As a third-generation Japanese Brazilian himself, this was the first time he had directly experienced the culture of his grandparents. What left a lasting impression on him was meeting people as he painted pieces in the neighbourhood and observing them going about their daily lives.

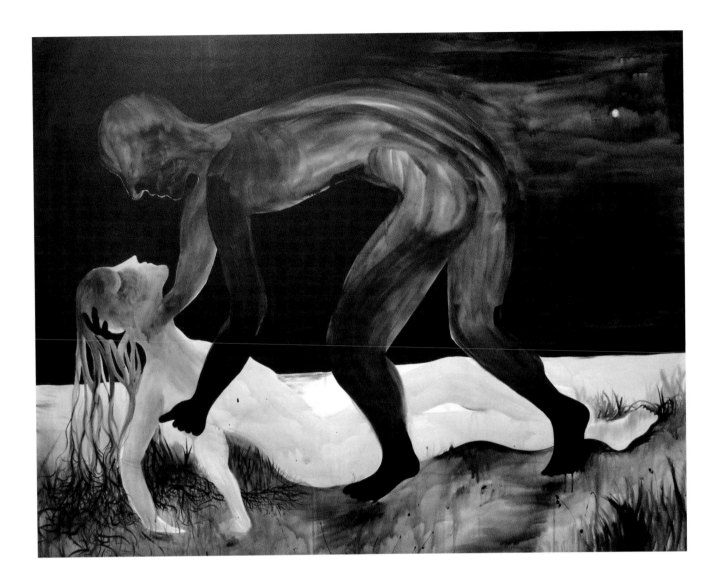

For a number of artists, travel has been an essential part of their mission. It is now common for street and graffiti artists to be drawn to new places to paint and collaborate with other artists they admire. Some focus on this activity more than others, taking to the road for long stretches in order to see and learn new things. For example, CharquiPunk from Chile has spent many years travelling throughout Latin America, painting with other artists and promoting graffiti as an art form. With his great regard for indigenous cultures, his journeys have allowed him to meet local communities and observe traditional festivals first-hand. He reflects on local social issues in his pieces, imbuing them with the life and colour of a particular place. American artist Ripo similarly spent many months in Latin America painting with local artists and also being inspired by the hand-painted signage he found there. By imitating vernacular typography, he produced work in situ

that blended into local styles but was at the same time subversive. A cultural exchange can also be two-way; the visiting artist experiences different cultural realities that can unlock ideas, while local artists can learn from seeing how others work and interpret their surroundings.

Focusing on artists who have travelled or who are scattered and clustered around the globe may seem wilfully exotic but it reflects our globalized world. Talent is rising from small creative hubs in sometimes overlooked places, producing fresh outlooks and approaches. While art institutions and museums are becoming more global in their outlook, graffiti and street art websites and blogs have long taken a more expansive view. Artists should be viewed on the strength of their work, and if an artist's talent is exciting, it is worth overcoming barriers of language and distance to make contact and give this art an international stage.

Finally I must mention the generosity of all the artists involved in this book, both in the time they have given up to take part in the project and in their abundant good nature. Their humanity is evident in their art, which is full of life, conviction and sensitivity. Being an artist is not always an easy road to travel, and the qualities of good humour and kindness can be just as vital as talent. I have known some of these artists for a number of years and have witnessed first-hand how important their art is to them. While some artists join a popular movement simply to make a name for themselves, these artists are the real deal: they want to make art their focus, and if they manage to make their name, it is a consequence but not a goal. It has been a pleasure to be in their company and share in their creative energy, and I hope some of that excitement will rub off as you become better acquainted with them and their work.

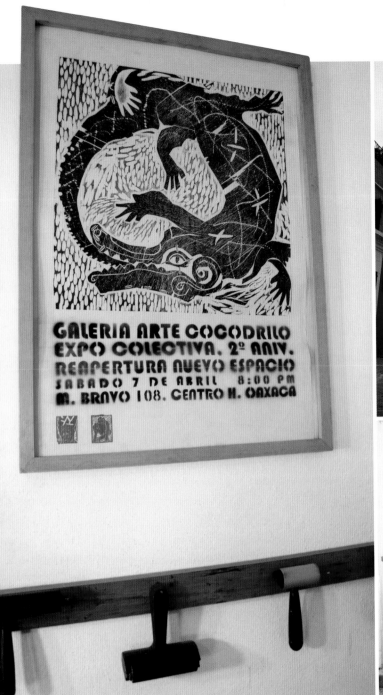

From Oaxaca to Monterrey
Arte Cocodrilo

Arte Cocodrilo is an independent artist collective, which has become a support network for over twenty artists primarily from the cities of Oaxaca and Monterrey but also from other states around Mexico. Formed in 2005, they opened their first Arte Cocodrilo space in Oaxaca, at a time when independent spaces in the country were still a rarity.

During the civil unrest that began in Oaxaca in 2006 and lasted nearly two years, the space remained open

with a schedule of exhibitions that changed every two months. These conflicts also drew a lot of attention to the city and spawned a strong local movement of protest art and graffiti. The collective of artists grew and, when the gallery space finally closed, the group stayed afloat by creating a strong website presence to promote projects and discussion. Over the past couple of years Arte Cocodrilo has continued to exhibit

in temporary spaces in Oaxaca and Monterrey.

Although the artists within Arte Cocodrilo produce different work, they all share a common philosophy, as one of its founders Rene Almanza explains: 'The artists that belong to AC have a leaning towards drawing. We live in an image-saturated world; people are used to being bombarded with hundreds of images selling them things or telling them something. This

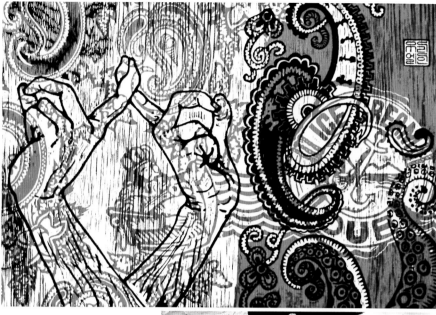

overload of information is too much. Our works are the individual visions of the artists. We aim to generate new, fresh images and create an identity within time and space.'

Monterrey and Oaxaca are very different cities, as Almanza points out: 'Monterrey is industrial, and many of its young artists incorporate conceptual art and new media into their works. In Oaxaca there is more of an emphasis on traditional supports, and new technologies tend to be overlooked in favour of analogue and manual techniques. We believe it's important to combine these two points of view, giving us an accurate thermometer of what is happening in the country.'

Artists within the group often take part in exchanges to mount exhibitions and work together in different cities. This chapter focuses on the work of Daniel Berman, Daniel Acosta and Uriel Marin, all based at a traditional print workshop in Oaxaca, and Rene Almanza, who divides his time between this studio in Oaxaca and others in Monterrey. These artists are all painters and draughtsmen but commonly use printmaking. While their work is contemporary and experimental, through their use of traditional techniques they also keep the heritage of the great Mexican printmakers such as José Guadalupe Posada and Diego Rivera alive.

Daniel Acosta

Daniel Acosta was born in Mexico City but grew up in Oaxaca, where he still lives. He is passionate about maximizing the potential of his traditional techniques and skills and, through his striking, often abstract work, strives to 'stand out in a world that is saturated with low-quality, cheap images'.

'I have been drawing ever since I can remember,' he says. Initially he wanted to pursue a career as a comic illustrator or animator. While studying at Veracruz University, however, he won an exchange scholarship to Bratislava, Slovakia, where he spent three months learning about etching, drawing and illustration. This experience completely changed his outlook, and he decided to devote himself to traditional graphic and printing techniques: 'That period was very important for me. It broadened my professional and cultural horizons, and I learnt from people who have a long and different tradition doing the same kind of things that we do.' He returned to Oaxaca and immediately

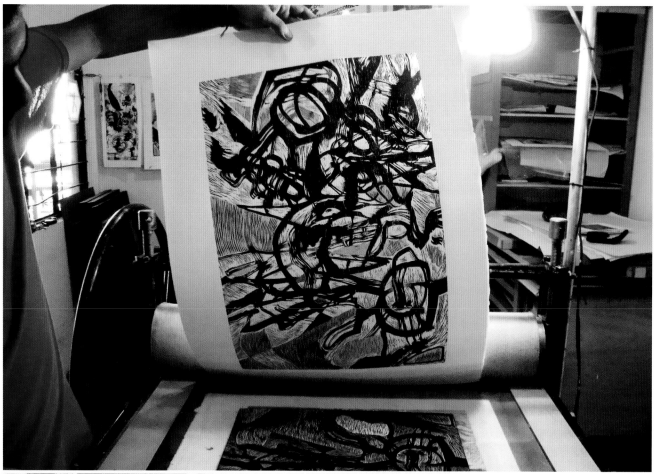

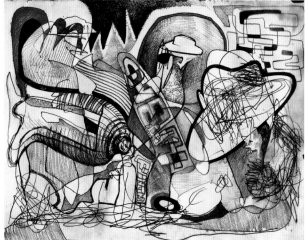

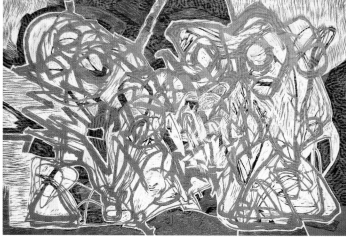

began working with his Arte Cocodrilo colleagues.

Acosta is fascinated by contrasts: 'I try to appreciate the ugly or rough parts of this world as well as the beautiful parts.' His subjects and themes are often diverse, ranging from social issues to imaginary creatures and abstract landscapes. 'Scepticism opens up your mind to a lot of different interpretations; you can accept something as it is or reject it and make up your own

interpretation. This has led me to explore abstraction – sometimes even though the image begins as something concrete, in some parts of the work the focus is on the lines and colours and the graphic impact that the pieces of the image have by themselves. This stimulates the imagination.'

Often viewers are required to use their own imagination: 'There are a lot of messages in my work. Some people will get them and others won't, but that's

normal in art. I think that if there's one overall message in my work, it's for people to use their imagination, to encourage them to think of a story, a face, a memory, or something that keeps the mind engaged.' This active dialogue is an essential element of his work: 'My aim is to create images that are suggestive but whose message is not immediately obvious.'

Drawing is a key process for Acosta, as he believes that this forms the basis

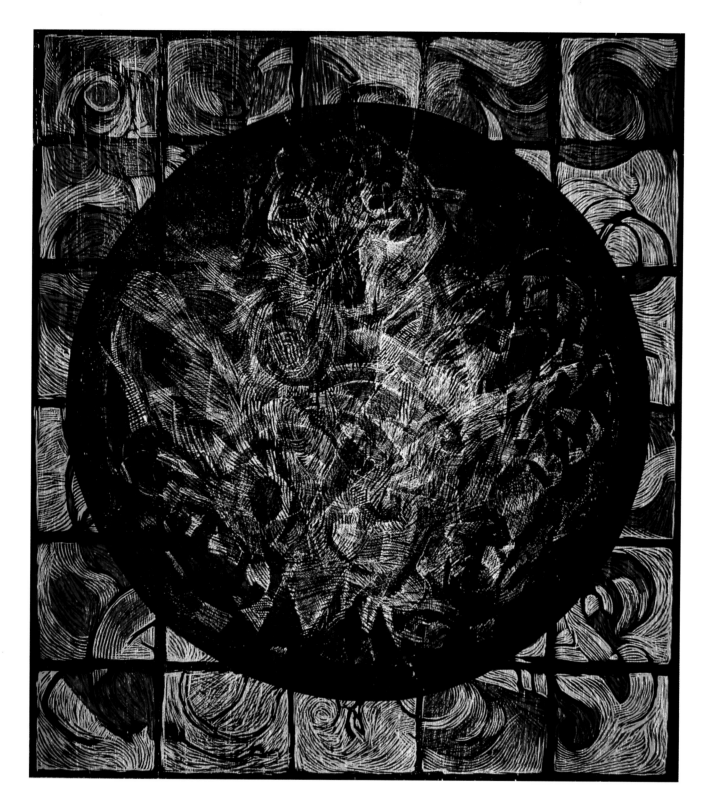

of his work: 'It is where everything comes from.' However, he also enjoys taking his work out of the studio and into the street: 'This is important because it gives you a physical presence and connects the images to the people, which isn't possible over the internet or in an enclosed space.'

Oaxaca, with its creative communities and culture, is an inspiring place to work and brings out the best in him: 'At the moment Oaxaca is full of people from all over the place trying to make it in the art

world. That is not easy but it also drives you on; it forces you to keep on producing work and to look for the best possible ways to show your images.'

Acosta has shown his work in exhibitions as far afield as Tokyo, as well as in his home country and the USA. However, it is the vibrant creative hub of Oaxaca and Arte Cocodrilo that best nurtures his talent for combining traditional techniques with an experimental and contemporary

approach. 'It's a home for artists who care about high-quality images and constant production,' he says. 'I think in general we always search for a basis, like drawing, from which to create new things and images, and we enjoy the traditional side of things as much as the new stuff. Oaxaca is a place where culture and art are becoming a possible way of life with many kinds of expression, and growing stronger all the time.'

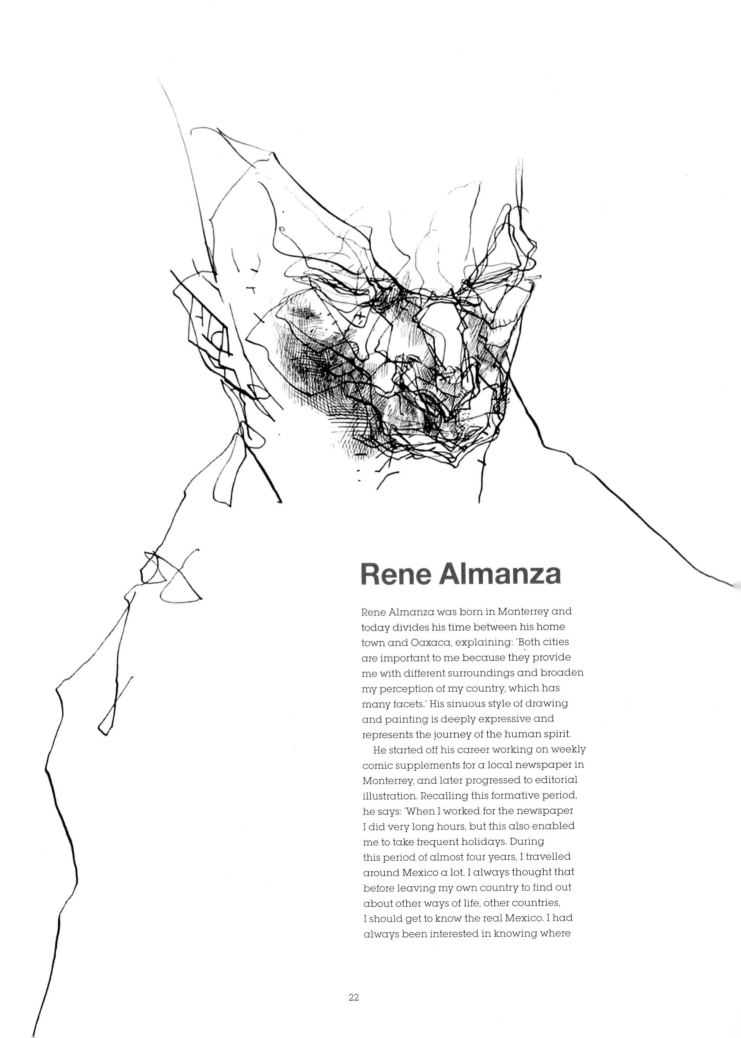

Rene Almanza

Rene Almanza was born in Monterrey and today divides his time between his home town and Oaxaca, explaining: 'Both cities are important to me because they provide me with different surroundings and broaden my perception of my country, which has many facets.' His sinuous style of drawing and painting is deeply expressive and represents the journey of the human spirit.

He started off his career working on weekly comic supplements for a local newspaper in Monterrey, and later progressed to editorial illustration. Recalling this formative period, he says: 'When I worked for the newspaper I did very long hours, but this also enabled me to take frequent holidays. During this period of almost four years, I travelled around Mexico a lot. I always thought that before leaving my own country to find out about other ways of life, other countries, I should get to know the real Mexico. I had always been interested in knowing where

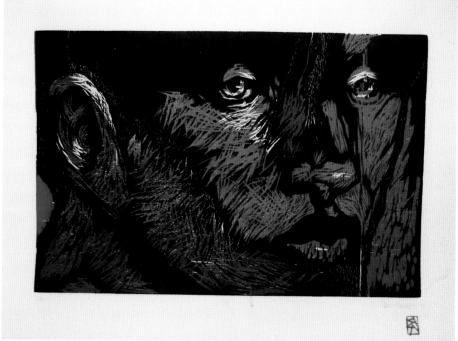

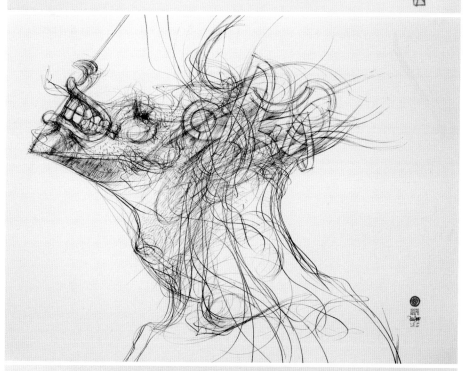

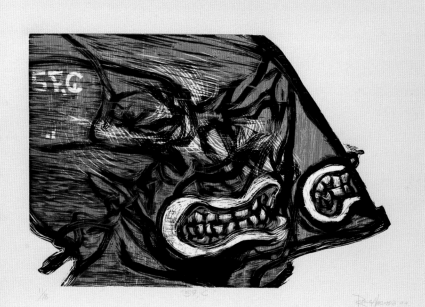

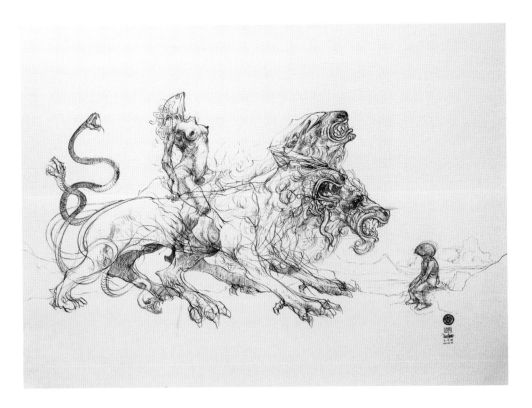

I came from, where I belonged, and these trips made a huge impact on me... My painting is the result of this process: it's a combination of comics, fine art, illustration, and everything I have seen and see every day.'

Almanza's fluid and graceful style of drawing reflects the urgency within him to create. 'When you think too much about an idea and you don't follow it through, the moment is lost,' he explains. 'It should be like a direct hit, transferring the idea straight from your brain to the paper. When I begin to draw I don't know what kind of image is going to come through until the third or fourth line. The image is a reflection of what you're thinking; it's a little bit like the brain working directly with the paper, and this is why the line is continuous, because I try to keep up with the idea so that it doesn't escape me.'

Of his subjects he says: 'In my drawings naked men and women appear in their most basic state, bodies deformed by their surroundings and perhaps also a bit decadent. There are men in search of their spiritual side, men in turmoil and looking to the outside world or within. I try to represent a suspended moment of time and its continuing essence.'

Almanza does not have a set way of working. 'It's always different,' he explains. 'Sometimes the work lends itself directly to the canvas because the idea is immediate and clear. Other times, I can sense that my images have become tired and cold. Then I have to delve deeper. This is something that has preoccupied me all my life. I believe that creating art is a process, a life-long project that is very demanding. It is something you must take seriously. Of course it is fun in many ways and that is the way it should be, but the urge to constantly search for new ideas should be strong. You can be searching all the time, perhaps through drawing, going out on the street, reading a book, seeing images, studying images, always looking for the next step and the next image.'

Often he looks to his own heritage and culture in this search for fresh material. 'My country is rich in culture,' he says. 'We have inherited a culture that is many thousands of years old, and one of the most important historically. Our country, like virtually everything else, is the victim of globalization and consumer culture, but it has strong roots in its past. People here retain many of their traditions, and this is something that has enriched me. In Monterrey I got to know many ways of working with technology as an artist, and in Oaxaca it was the hand-crafted, traditional side that engaged me. I try to make my work a combination of these two parts.'

Connections are a strong theme in Almanza's work – connections between the spirit of the piece and the surface, connections between the two cities that inspire him, connections between the past, the present and the future. One of the most important for him is the connection between his work and the people who engage with it. 'When this happens,' he says, 'I think the purpose of the work is achieved, the ultimate goal: to be seen and to say something.'

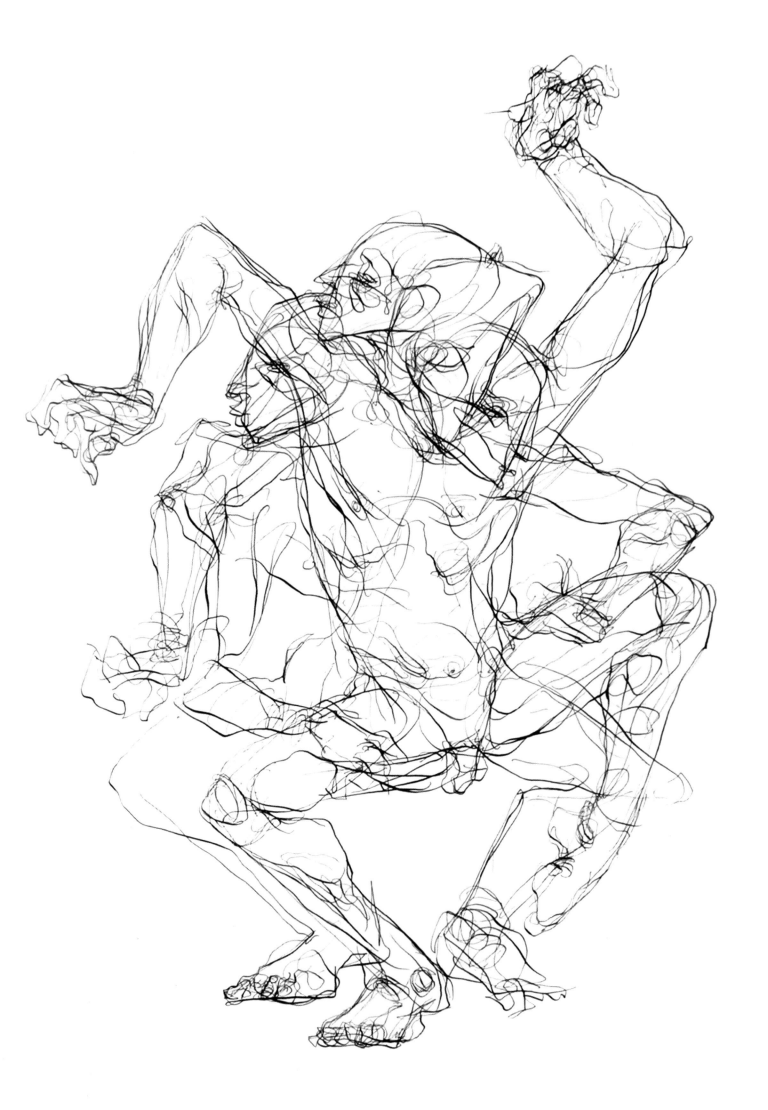

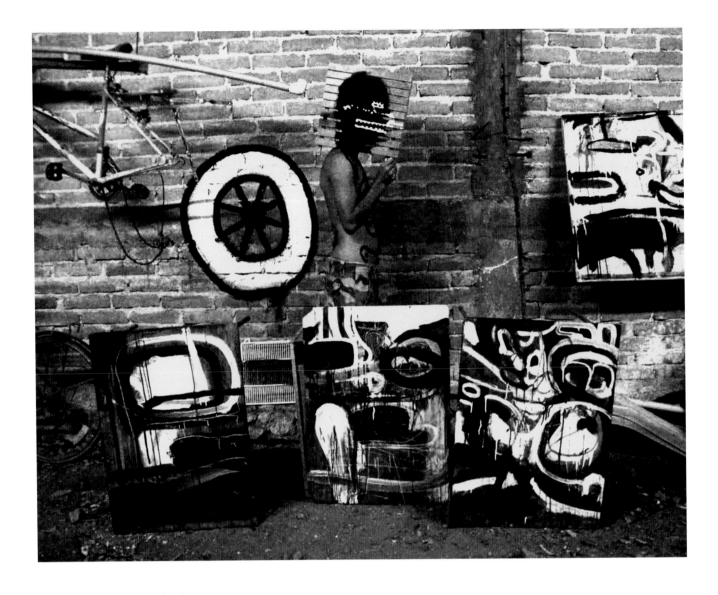

Daniel Berman

Daniel Berman is a painter, draughtsman and printmaker who was born in Veracruz and now lives in Oaxaca. His paintings are full of explosive energy and movement, with flowing brush strokes that evoke organic forms. In his painting and printmaking he exercises complete freedom of form in a semi-abstract way, building up texture and intricate detail. In all these different processes, distorted human figures play a central role, recalling both primitive and folk art.

He showed artistic leanings from a very young age, copying comics along with cartoons and animations from the television. Comic-book art remains a strong reference in his work, and he lists Robert Crumb as one of his key influences. 'My images are currently plagued with references to a certain comic aesthetic, text mixed with images, characters, the idea of a story that's not linear,' he says. 'My intention is to achieve a type of narrative about my own development as an author.'

Berman describes his work as 'codifying my experiences into images', emphasizing the direct influence of his day-to-day encounters and interactions on his working method: 'It's like a constant soliloquy that is a direct reflection of my surroundings. I seek to understand the things that I see and experience. Sarcasm, irony, black humour – these are all aspects of this

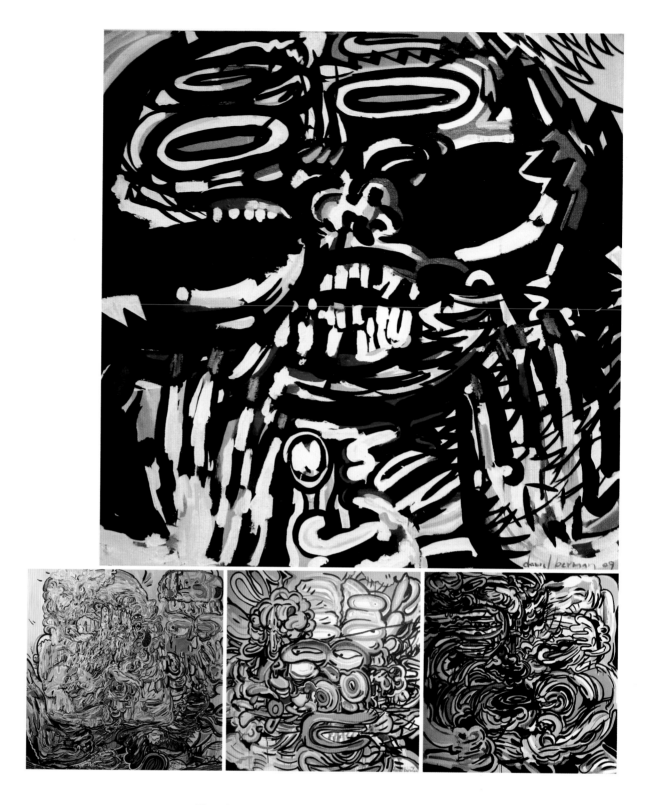

process. There is no specific message in my work other than to function as a mirror. What I do is a direct reflection of my everyday surroundings and, even though I don't make a textural or literal translation of this environment, all of these experiences start to form a narrative or constructive line that allows me to continue producing ideas and images.'

Berman enjoys taking his work to the streets, explaining: 'It is important for me not to be reliant on a pencil or a sheet of paper when I work; I need to be able to go out in the street and work from there. Direct contact with people and being in the city, the country or the environment in general are experiences that broaden one's scope as an artist or an author.'

His working method varies depending on the medium that best suits his expression at the time. 'I try to work in stages,' he explains. 'For example, I may focus on going out in the street to do something – to paint, walk, search for

something – and at other times I devote myself exclusively to printmaking. Ideas that I'm not able to work through in a sketch I complete in a drawing, or vice versa; what I can't achieve there I search for in painting, and so on.' In the same way he builds up his images in stages, adding and removing layers of colour and detail – a process particularly suited to printmaking.

Berman has both a strong global and national cultural awareness that underpins his work, enhanced by his own travels as well as his constant research. 'Elements of Mexican popular culture mixed with elements of global popular culture give shape and content to my work,' he explains. 'My first explorations of Veracruz also deeply marked the way I worked. This was the first contact I had with the traditions of my heritage: the music, landscapes, characters, costumes, culture in general – my initial sources of inspiration. Now new sources of information have also infiltrated and enriched my work, including my online meanderings.' Berman also feels at home in the creative environment of Oaxaca. He explains: 'Oaxaca allows direct contact with traditions so vast that it becomes an incredibly fertile environment in which to create. For me this city's very traditional art is an invaluable source of inspiration.'

Berman's evocative woodcuts and etchings have been exhibited throughout Mexico, as well as in the USA and Tokyo. While he continues to travel, he says that 'it's the day-to-day that makes me work. The impossibility of staying still and cooped up in a room without doing something.'

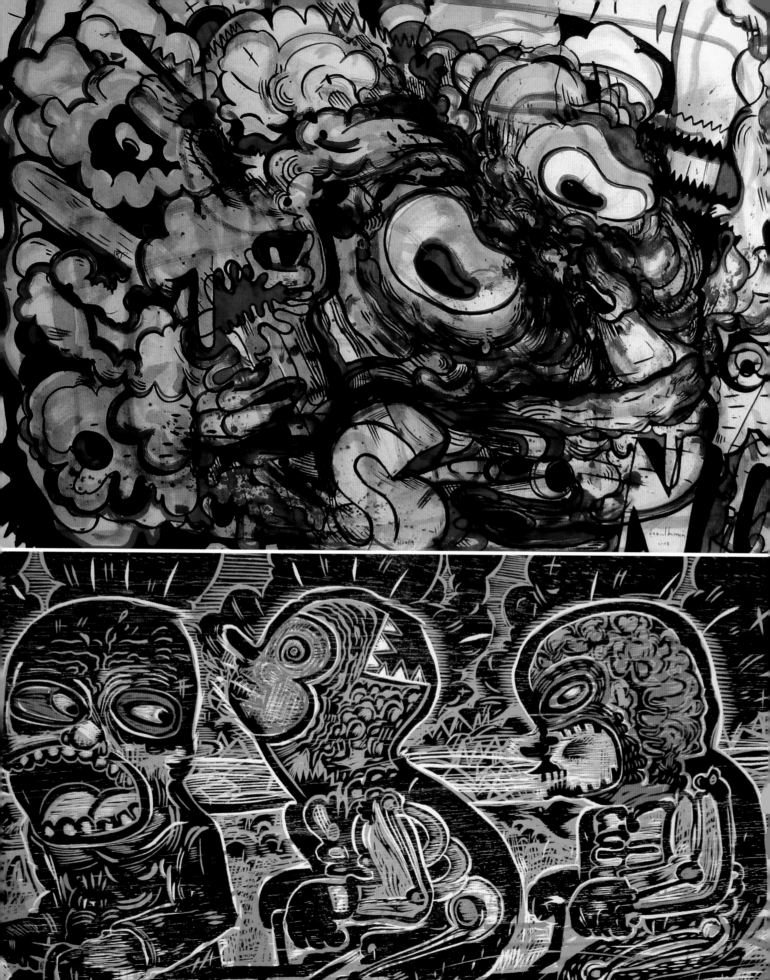

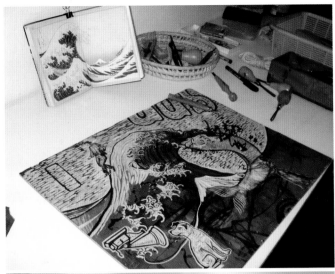

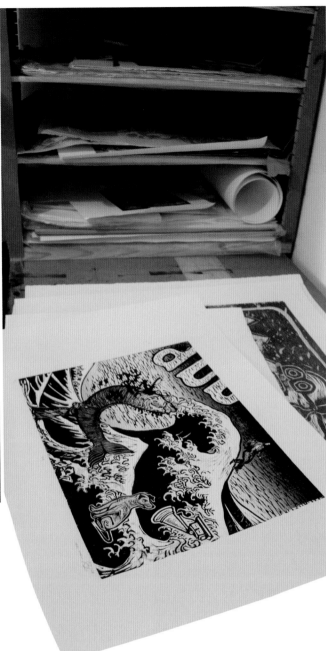

Uriel Marin

Uriel Marin was born in Veracruz, and now lives and works in Oaxaca. While he occasionally works as an illustrator, his focus is on printmaking, particularly silkscreen printing, woodcuts and engraving, through which he produces captivating images that blur the line between traditional and contemporary in both method and expression.

As with the other members of Arte Cocodrilo, Marin uses traditional techniques and believes that drawing lies at the heart of these crafts. Sketches form the basis of his work. He tends to work in series and says that sketching first allows him 'ample room for flexibility'. His mastery of technique is clear to see, and he is careful to produce his work in small runs that protect the integrity of each edition.

There is a visual fluidity in all of Marin's work, and strong elements of ancient Eastern philosophies, the ukiyo-e school of Japanese printing and artists such as Hokusai. He says:

'I am inspired by everyday situations and the people around me; also mythological motifs and the appropriation of graphics and ephemera, like cigarette and beer labels.' Other influences come from closer to home: 'Tapping into our Mexican ancestry can be incredibly rewarding. I like to reconnect with my country's roots through codices, in particular those of the Mixteca region of Oaxaca [the Mixtecs are an indigenous people of this area] because of the beauty of their designs. I appreciate the mastery that they achieved with their icons and system of symbols.'

Marin strives to convey harmony in his work, and the visual impact of his images is key. Layering and colour are used to great visual effect. He explains that his images are intended 'to be read in different stages: first, the image is a magnet that immediately traps the eye; then the different elements of the work are slowly revealed'. He continues: 'The best way for me to express myself is through my images. I try to remember that I still have things to learn as an artist and that I must remain open to experimentation. My attitude when I work is one of continuous exploration. I find support in my relationships with

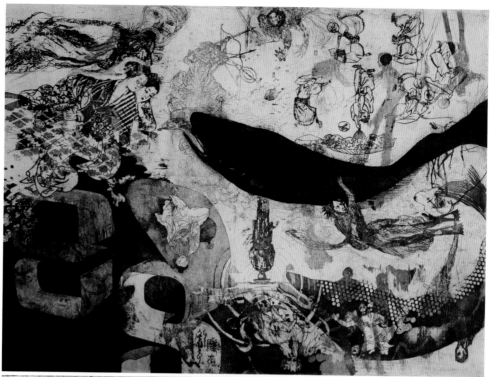

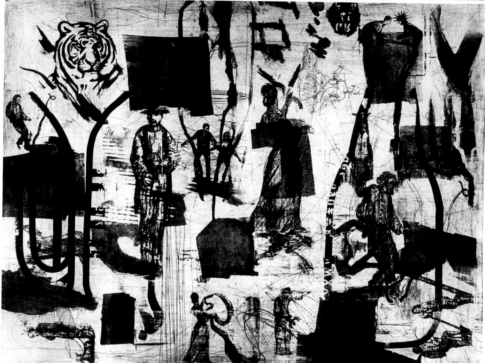

the people I value, and in the human capacity to create.'

Although he concentrates on printmaking, Marin does sometimes collaborate with fellow artists in the street. 'In Mexico murals became obsolete when they were adopted as an artistic function of the state,' he says. 'Their strength and impact diminished. One way of rejuvenating the mural is through graffiti and street art, as a reflection of the social and cultural times.'

Marin has enjoyed successful solo and group shows throughout Mexico and the USA, and appreciation of his work is rapidly spreading to Europe. His distinctive layered style perfectly complements his use of traditional techniques such as multiple woodblocks and etching plates. Meanwhile, the rich artistic and cultural traditions of Oaxaca continue to provide an ideal creative environment, inspiring and motivating him and the other members of Arte Cocodrilo.

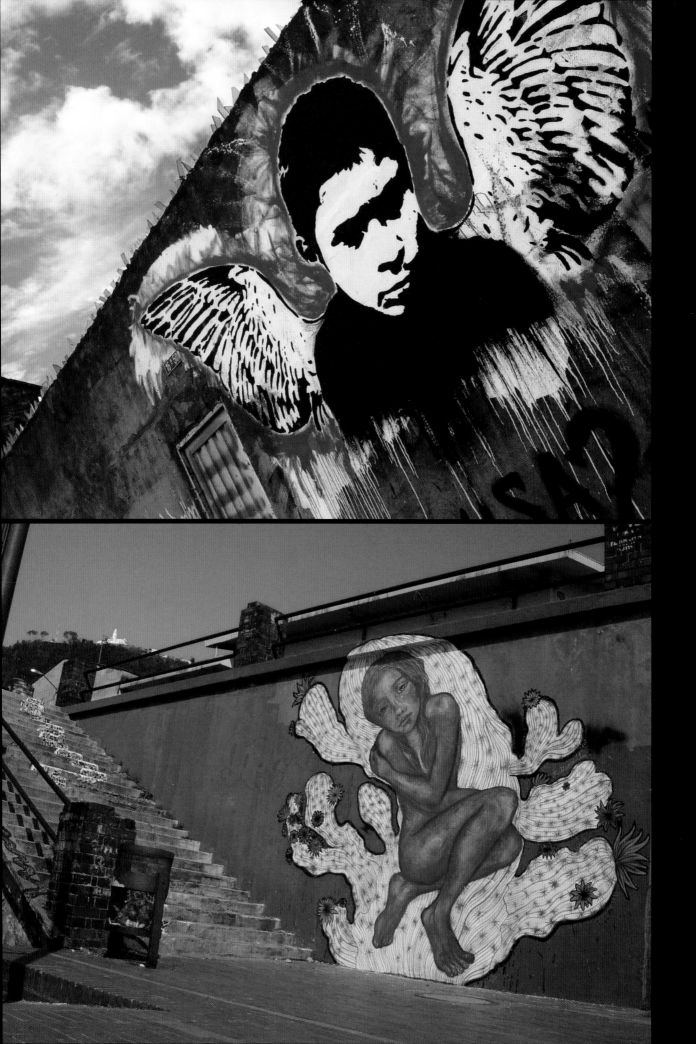

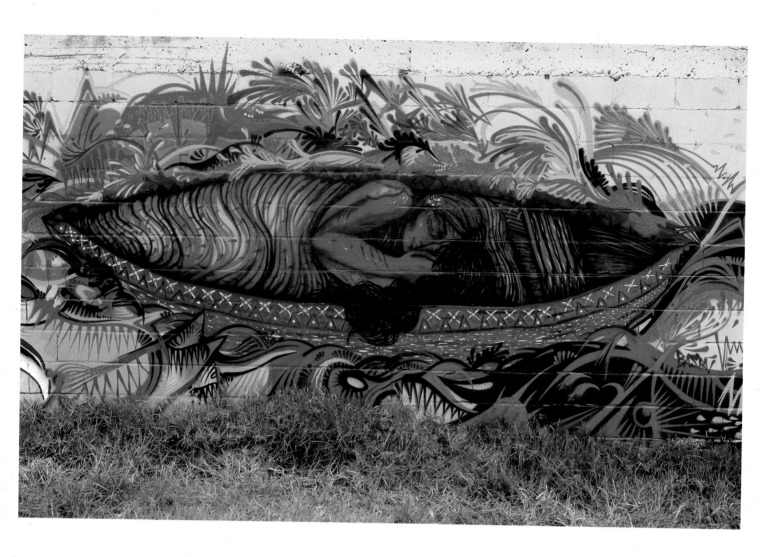

Memories of the Walls
Bastardilla & Stinkfish

The partnership between Bastardilla and Stinkfish developed on the streets of Bogotá, Colombia. 'I think that walking through the streets and rebellion are what brought us together,' Bastardilla explains. 'I didn't paint in the street before I met Stinkfish. I was very shy, even about the bits and pieces I did on paper. We started to watch each other's back while we painted – that has been the key to working in public, although we have sometimes been caught. Now we do quite a lot of our work together. Sometimes Stink travels and takes my work to put up, or I paint his characters wherever I go.' Travel has formed an essential part of this collaboration. 'My street art has enabled me to travel,' says Stinkfish. 'I have been invited to paint in new places around the world. And my work has also travelled – friends

send me their posters, stickers and stencils to put up, and I send them mine.'

Although Bastardilla and Stinkfish work together in many ways, they rarely produce a collaborative painting, preferring to keep a little distance between each other's work. Bastardilla tends to paint figures, often female, and includes elements from nature such as animals and birds. She is also fond of using glitter in her paintings, so that at night they sparkle in the streetlights, making her pieces feel somehow magnetic and alive. Stinkfish paints in a number of styles and frequently depicts figures; often he uses stencils, but he also freestyles and produces more abstract designs. Both generally paint directly on the wall unless it's a risky place to paint or the work is very detailed, in which case they

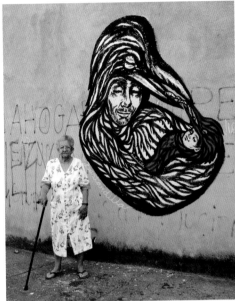

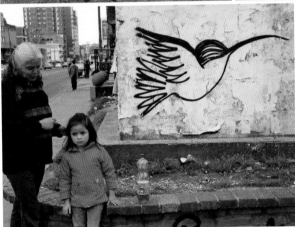

glue handmade paper posters to the wall. On the spur of the moment they draw simple tags: Bastardilla's signature is a hummingbird, while Stinkfish paints faces with spiky teeth.

Stinkfish describes Bogotá as a city of contrasts 'where you can find a horse-drawn, hand-built cart on the main road and, behind it, a long line of luxury cars'. While it is not as well known for its graffiti culture as other Latin American capitals, it does have a rich history of political graffiti, and many young artists like Bastardilla and Stinkfish are creating vibrant work on its streets today. There are few graffiti events, and galleries are generally not interested in the movement, so most of the action takes place on the street. Until recently it was relatively easy to paint without permission, but lately the police have

been intervening. This hasn't put a stop to the graffiti, which takes elements of the traditional political sloganeering of the past but reflects the country's realities in more diverse and creative ways.

Like any country Colombia has negatives and positives. As Bastardilla explains: 'On the one hand, it is a country with many problems: drug trafficking and war, land disputes – not only due to the coca plantations, but also due to its rich biodiversity and natural resources. The government spends little on education and health, but is concerned with arming the military and recruiting more police, all within the inappropriately named "Democratic Security" policy, which offers no security at all and is by no means democratic. On the other hand, there are

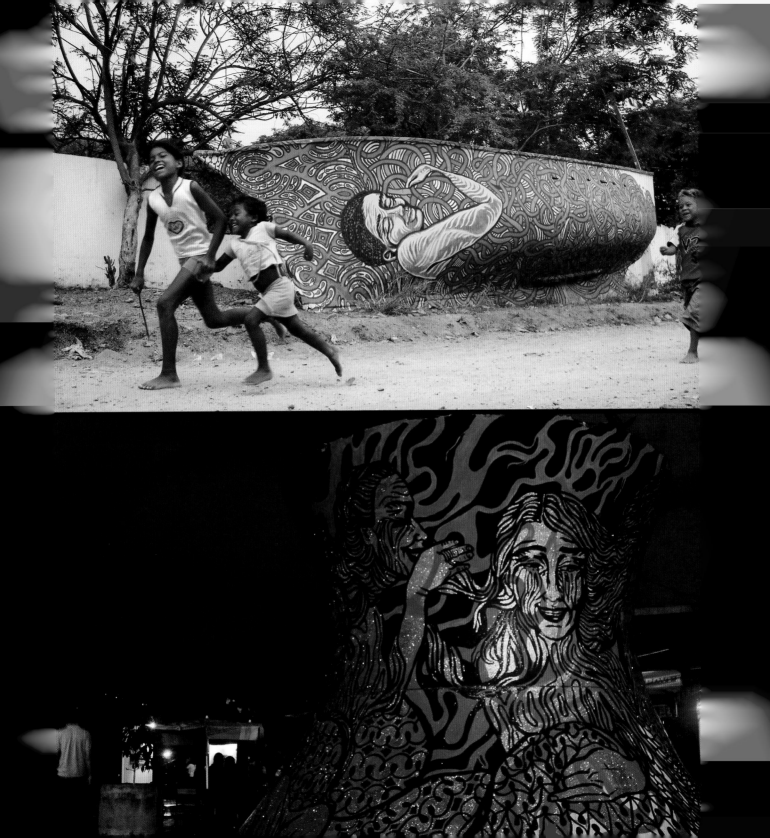

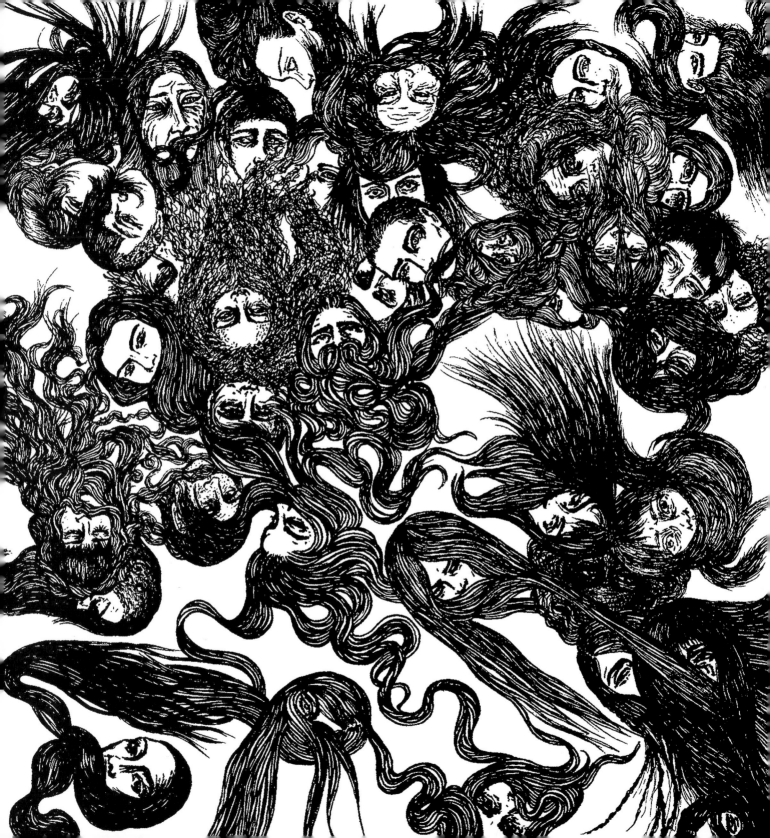

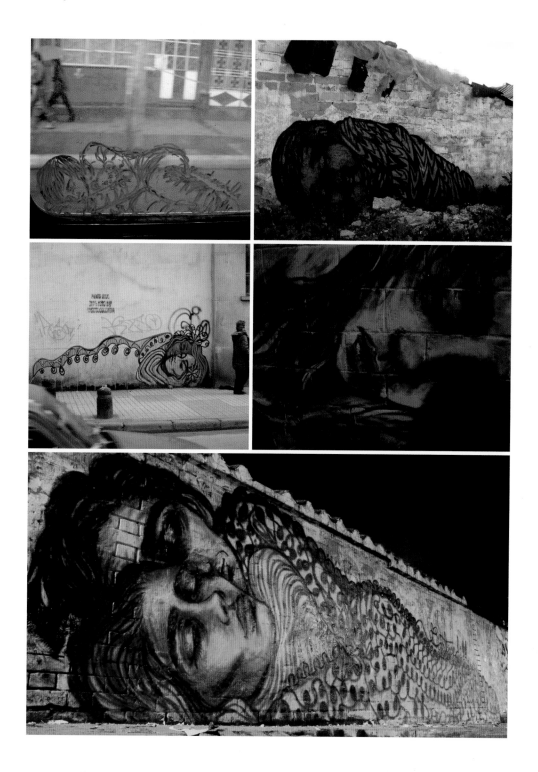

many people who work the land and organize themselves with positive common aims. In several areas, there is an active cultural movement and a resistance to the impositions of a belligerent government. I like living in Colombia. It has a lot of beautiful natural scenery, but there are harsh realities all around us that I can't ignore.'

Bastardilla often tackles social subjects. One example is her depiction of homeless people sleeping rough, which she painted around the city. 'A short time ago, I painted a picture of three people sleeping rough,' she recalls. 'It was interesting as each person viewed the picture on a personal level, according to their own beliefs. One man even said to me that it was satanist and that I should go to church. Who knows what he was thinking! The sleeping figures, of course, represent people who don't have a roof over their heads and are a permanent part of public life. They are pursued by the police and others who want to keep them hidden away out of sight. These

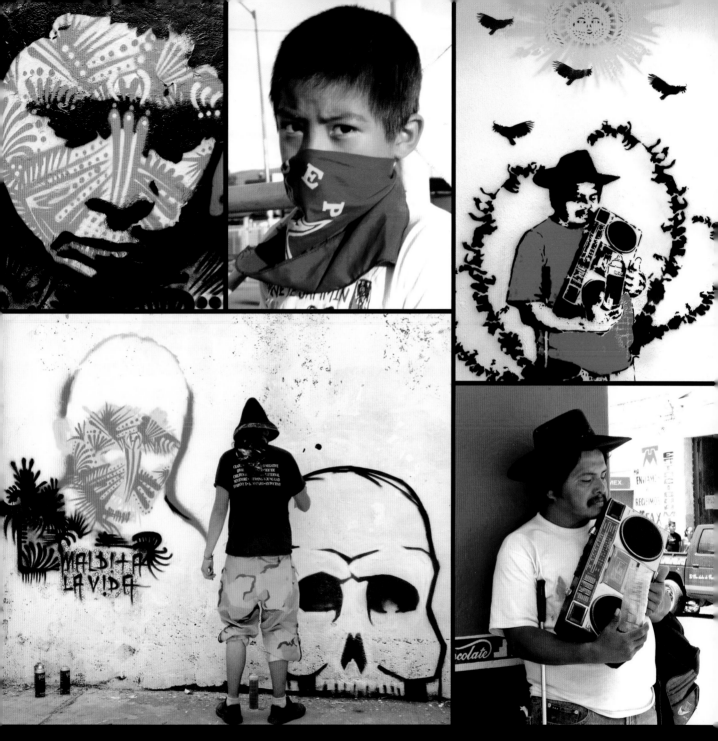

paintings are there to remind us; they can't be moved on, at least not until they are erased.'

Another subject close to Bastardilla's heart is indigenous peoples. There are about eighty indigenous communities in Colombia, speaking over sixty different languages and living in areas of exceptional natural resources. Multinational organizations, the government and paramilitary groups have been violently driving them from

their land. The result is the extinction of cultures, people living in absolute poverty and without access to their land. In Bastardilla's own words: 'What I really care about is the living culture of those communities, their experiences and ways of thinking, to show the problems they face and the qualities possessed by these people, their valuable knowledge and connection with the land, their environmental management and their views of the world.' In practical

causes by working on documentary films on the subject.

Although sharing similar views, Stinkfish's approach focuses less on explicit messages and more on the political act of creating graffiti itself: 'I am interested in putting free images into circulation. Some are forms and colours that I like. Others are based on my own

participation of a community, taking part and sharing on the street, with those who are simply passing through and those who live there, the street vendors and artists, the police, people handing out leaflets, housewives, children.'

Since 2003 Stinkfish has regularly participated in projects and events organized by fellow artists, universities,

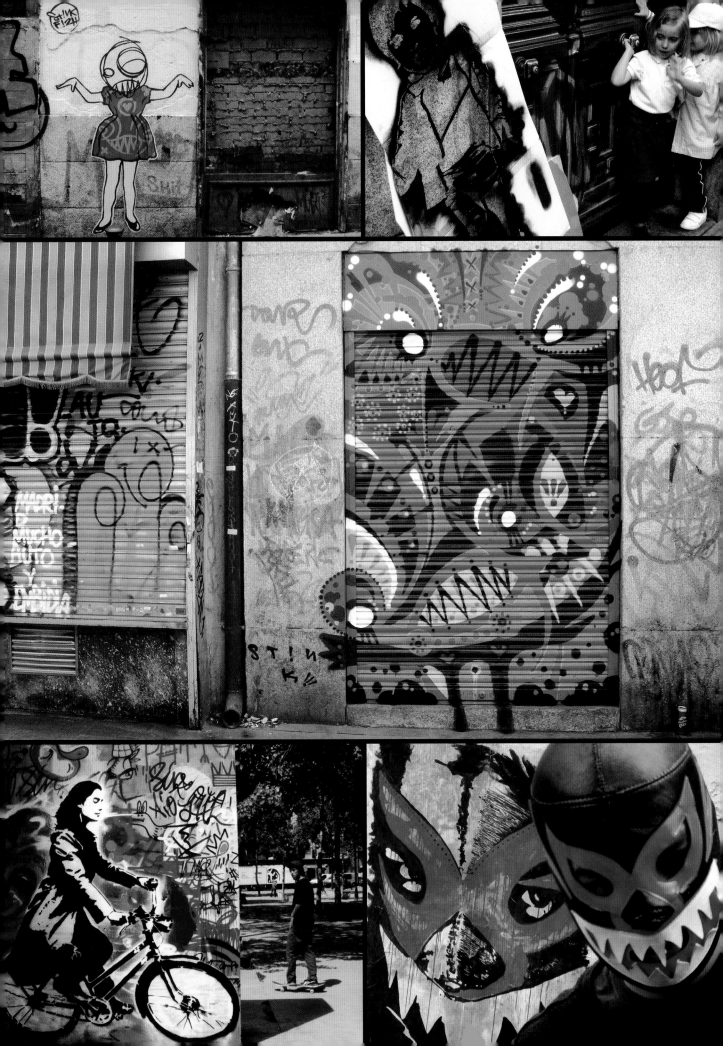

and private and government institutions. In 2007, as part of the Excusado Printsystem stencil collective, he took part in a project in Oaxaca called Stencil Latin America, together with the Mexican collective Arte Jaguar. The project involved a face-off between two Latin American stencil groups in Oaxaca, a town with a long trade union history and an established indigenous, student and farmer population. In 2006 the local opposition rose up; they took control of the city, ejecting the police and the army by force, and at the same time covering the streets with anti-government, pro-revolutionary images. The central government ordered that Oaxaca be taken by force, using assault groups and ruthless action. A year later, the

Stencil Latin America project staged exhibitions and street works to celebrate the stencil movement that took to the streets during the almost two months of independence and to commemorate the victims. The groups from Oaxaca and Bogotá came from different backgrounds but had the Latin American street ethos in common.

In 2008 Bastardilla and Stinkfish travelled to Guatemala City to work on a film about a fictional graffiti artist, painting the murals that form the backdrop to the film. 'It was an interesting experience participating in this kind of project, in a country where graffiti is only just beginning to emerge on the streets and almost 90 per cent of the population is indigenous,' says Stinkfish. This

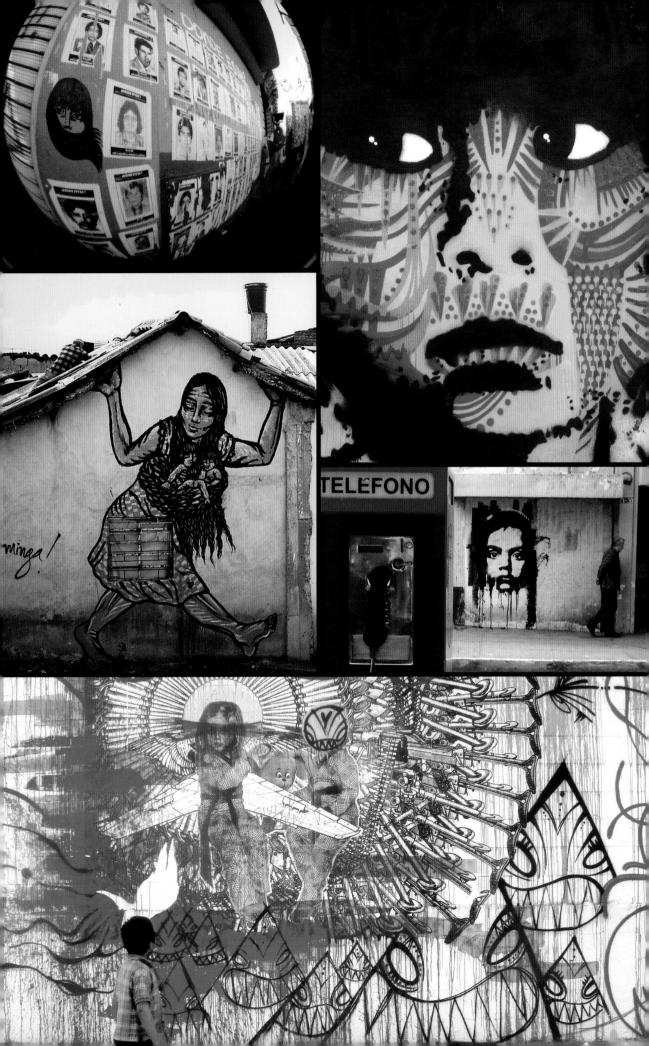

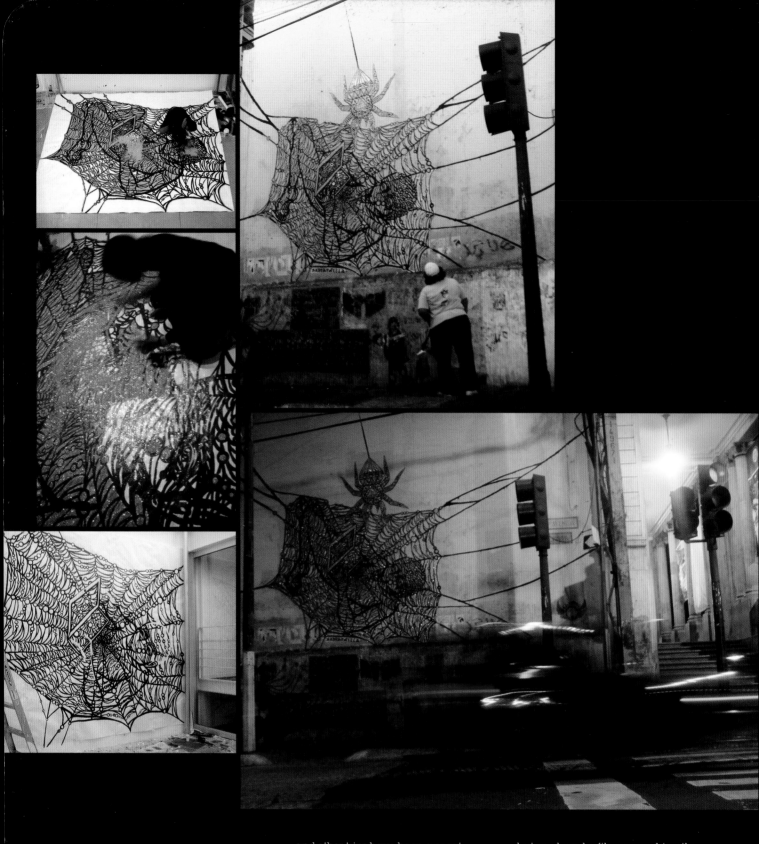

and other trips have been a great
source of inspiration, experiencing
new things, exchanging ideas, stories
and information. With this idea of
exchange in mind, in 2009 Bastardilla
and Stinkfish organized an exhibition in
Bogotá called 'Memoria Canalla', which
focused on graffiti and urban art using
memory and heritage in the city as a
starting point. With the support of the city
they not only organized the exhibition,
but produced a film researching the
city's graffiti history, and were able to
invite guest street artists from around
the world to visit over a period of several
months. Artists such as Blu from Bologna,
Onesto from São Paulo and graffiti
photographer Martha Cooper were
able to create art in the city and give
talks. If you can't travel the globe to see
street art, you could always try to bring
that world of street art to you!

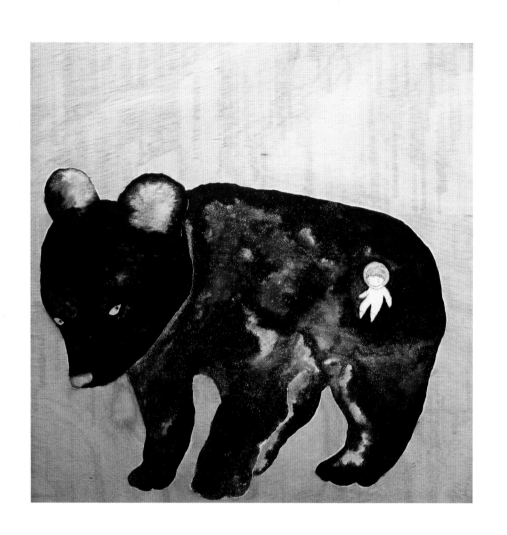
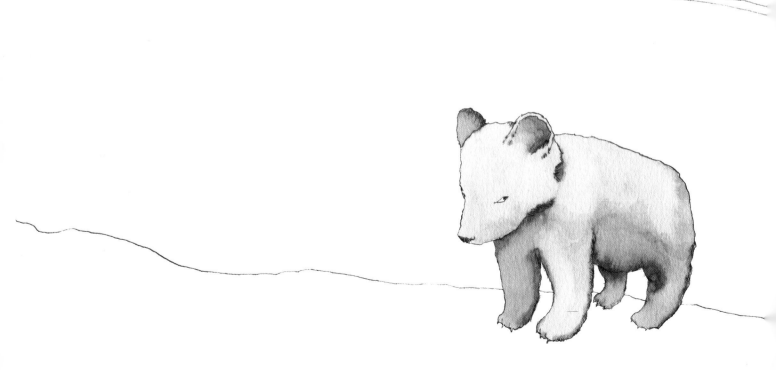

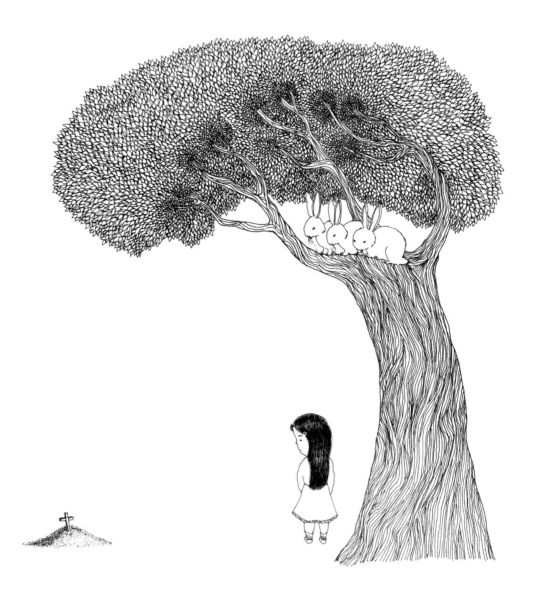

Made in China
Thais Beltrame

Thais Beltrame creates beautifully simple line drawings, mostly in black and white, to illustrate her own poignant stories. Her paintings and drawings have a childlike charm and often feature children as central characters. In her own words: 'I like to think that I create in a similar way to a child, and see the world at times as they do. I have never enjoyed drawing adults. The world seems a lot more interesting when you look at it through the eyes of a child.'

Thais was born and raised in São Paulo, and drawing was an essential part of her own childhood. She loved drawing on books, on all the blank pages she could find. It was a form of escape, and she was often so busy with her inner world that she barely noticed what was going on around her, although she still played outside with the other kids.

At the age of nineteen she moved to San Francisco to study, and later to

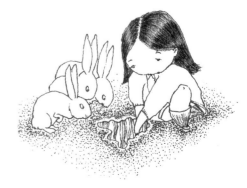

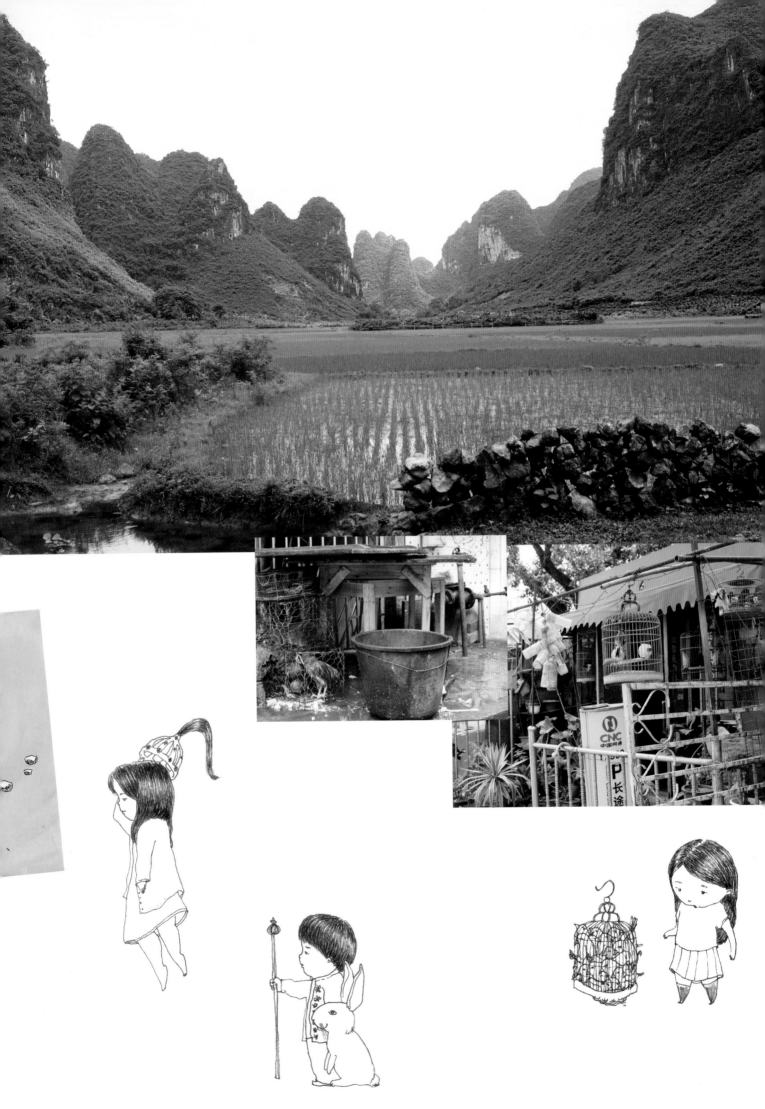

Chicago. She returned to her home town, after nearly seven years away, having gained a degree in art and design but with little idea of what she wanted to do. One day she picked up a magazine by one of the biggest publishers in Brazil and got in touch with the art director. She illustrated the monthly columns of the magazine for the next three years.

In the meantime a high-school friend and graffiti artist invited her to paint with him on the street. Thais discovered that she really enjoyed the act of painting outside, being exposed to all kinds of things, socializing and having fun. The creative process had always been a very solitary activity for her, and she was surprised at how well they received her work. Eventually, through painting and exhibiting with other artists, her work became more widely known. Today she is a member of an art collective called Famiglia Baglione, which exhibits in galleries and museums around the world.

Before Thais became involved with the magazine, she spent some time working for an airline and made her first trip to China, which had a massive effect on her. It also inspired her first group show with Famiglia Baglione, 'Made in China'. With an artist friend and a National Geographic guide she travelled around for nearly a month, starting in Beijing and making her way south. By the time they crossed the Li River and reached Yangshuo, nestled among mountains, it felt to Thais like a strange dream.

Although China was such a different country to those she knew, she felt a strong connection to it, especially the countryside. There was something about the simple way of life, unchanged for centuries, that appealed to her. And she saw qualities in Chinese culture that she sought to replicate in her own work:

the silence and contemplation, the importance given to 'small' things, and the understanding of negative space. On her travels she sketched the things she saw and wrote down her ideas. For example, the sight of hedgehogs trapped in a cage outside a restaurant made a deep impression on her and inspired a beautiful drawing in which she set them running free.

Whether sketching or creating a detailed drawing, Thais remains strictly intuitive, allowing her instincts and true emotions to guide the line. As she explains, 'Some people might think that this makes no difference, but it does; it makes all the difference in the world. There is this philosophy in Chinese painting: each stroke must be precise and certain; there is no going back and erasing it, there is no fixing it; you must take it as it is, as in life.'

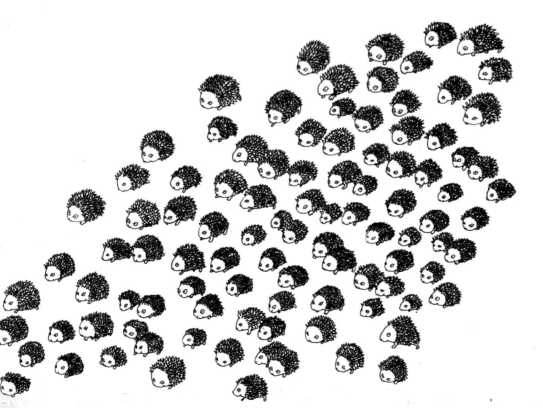

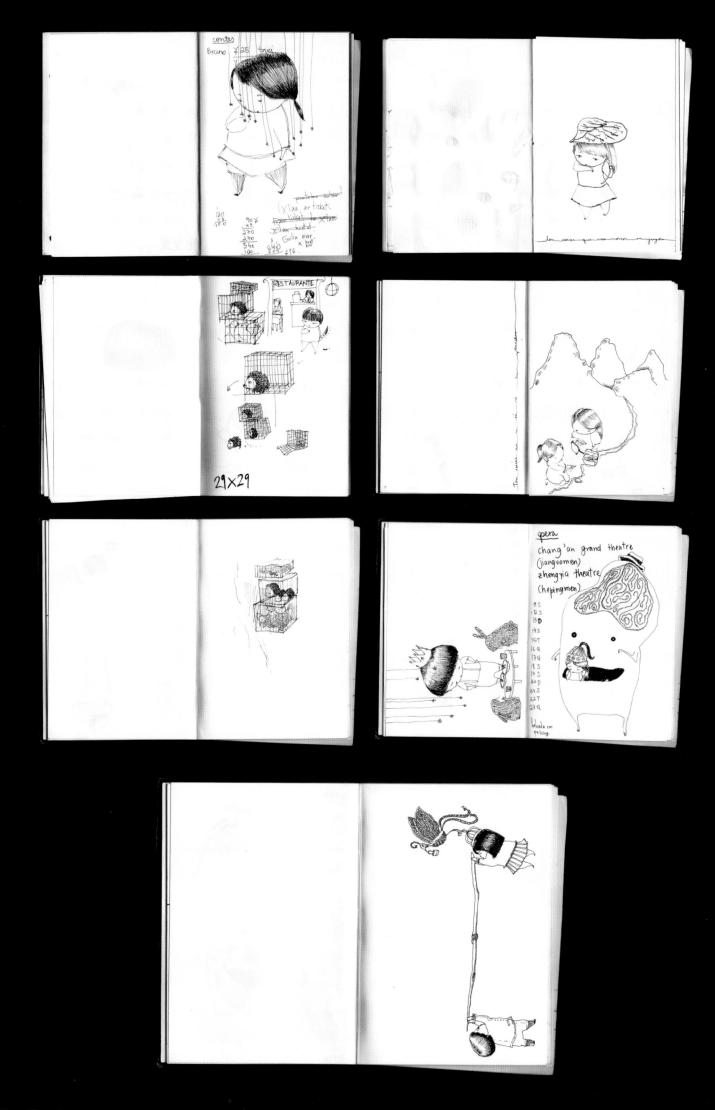

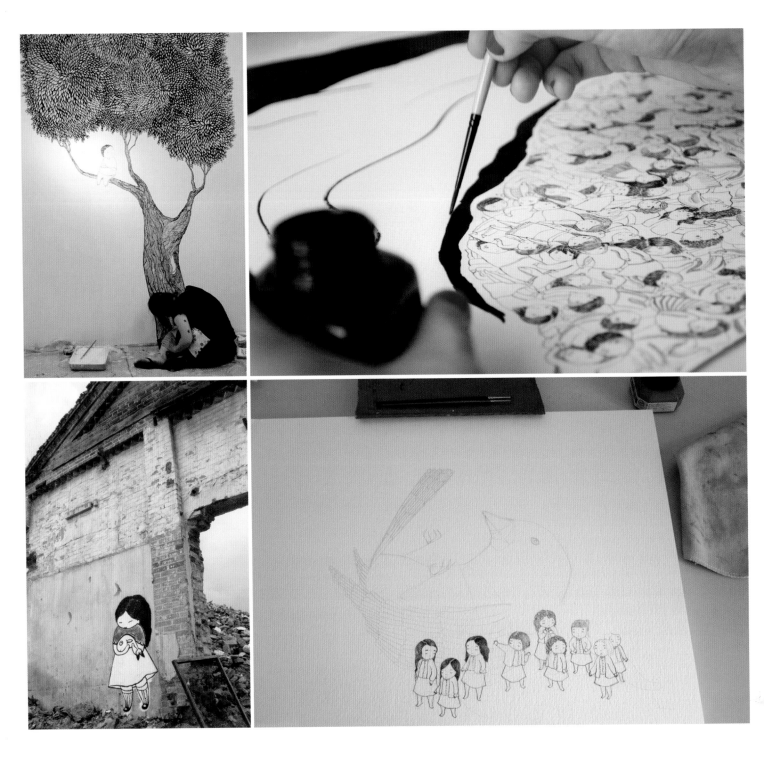

She also considers the negative space in her works: 'I've always loved negative space because it contains so much; sometimes a lot more than the entire drawing. All of these decisions are by no means conscious; once I've realized it's something bigger, more powerful than me, I've given up control.'

In addition to children, nature is also a recurring theme in Thais's narrative artworks. On the surface these two themes seem quite innocent, but she uses them to explore both light and dark topics. As Thais points out, 'Children can be very cruel, and even sophisticated in their cruelty, but they are very sensitive as well; their emotions are raw. They will often express exactly how they are feeling. Somehow we lose this quality, this honesty with ourselves and with the world. In a way I feel like childhood is always with us: that strong fear of being abandoned, the pure joy for certain things, the real dreams and wishes – it's all there.' Thais's narratives are a way to reconnect with childhood feelings, both joyful and sad.

'Nature is very cruel as well, and very dark,' she goes on to explain. 'All of the animals that pop up in my drawings are a result of these mysterious feelings and emotions that lie deep in our

unconscious. They tell stories of things that are destined to happen, the inevitable, death. Often I draw rabbits, foxes and bears, which inhabit the old world of fairy tales. Through the books of Carl Jung and Bruno Bettelheim, I found a direct link between the type of work I was doing, and the world and meaning of fairy tales. The original fairy tales are all quite ruthless and based on archetypes, which populate the collective unconscious. I believe much of my work comes from such realms, juxtaposing dreams and memories alike.

'Another piece of literature that helped me to understand my work is the *I-Ching*, an ancient Chinese text and guide to self-understanding. The imagery is simply beautiful; it encourages the nobler side of man using elements such as trees, mountains, lakes and storms to depict states of being and warn against possible mistakes. The metaphors are quite simple but immensely rich. For instance, there's a passage about how careful a young fox must be when crossing a road covered in thin ice; this represents all of us when confronted with new situations and challenges in our lives.'

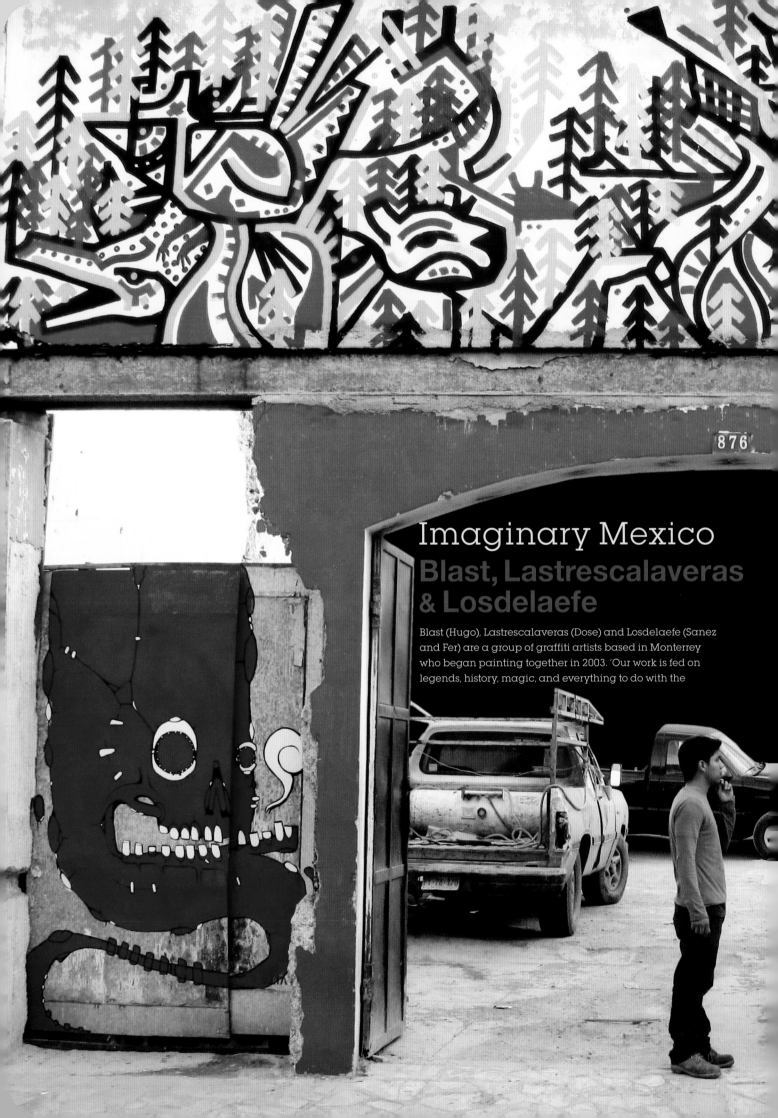

Imaginary Mexico
Blast, Lastrescalaveras & Losdelaefe

Blast (Hugo), Lastrescalaveras (Dose) and Losdelaefe (Sanez and Fer) are a group of graffiti artists based in Monterrey who began painting together in 2003. 'Our work is fed on legends, history, magic, and everything to do with the

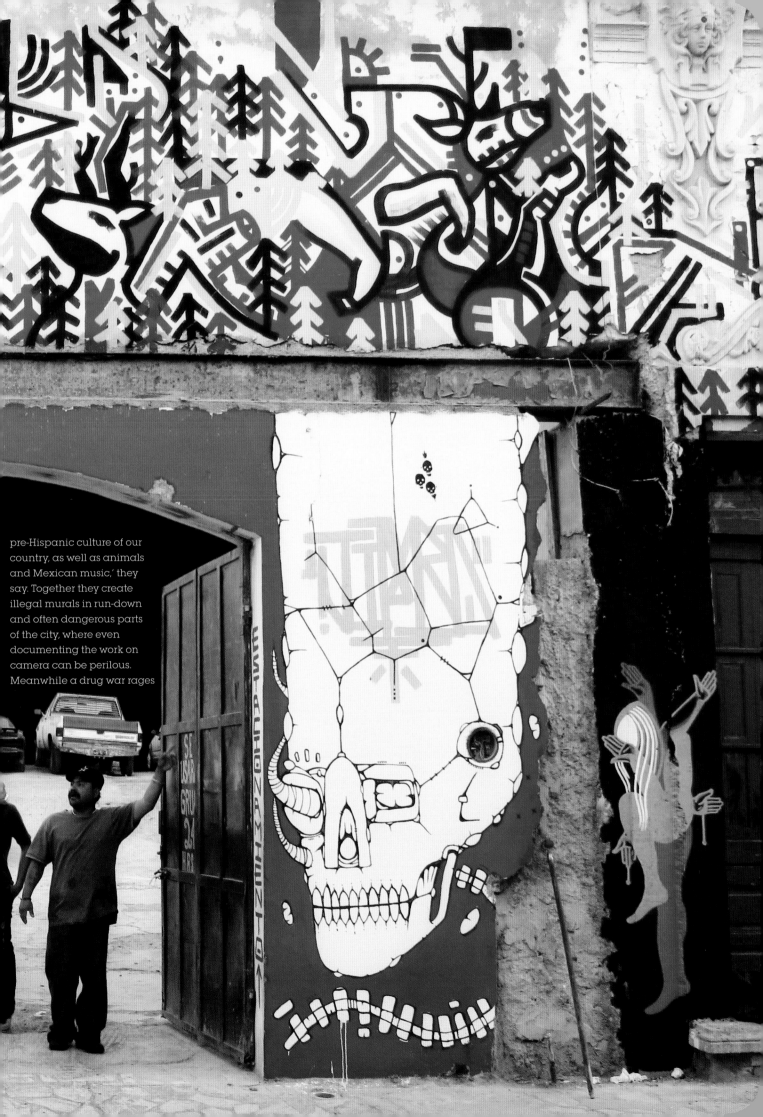

pre-Hispanic culture of our country, as well as animals and Mexican music,' they say. Together they create illegal murals in run-down and often dangerous parts of the city, where even documenting the work on camera can be perilous. Meanwhile a drug war rages

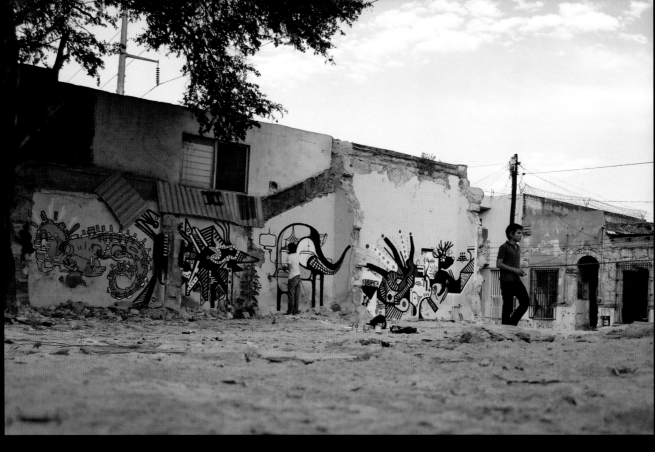

on the street between the traffickers and the army.

Due to its proximity to the US border Monterrey is heavily influenced in its graffiti and wider culture by its American neighbour, whereas the smaller towns surrounding the city continue to preserve certain traditions. 'The graffiti scene here has a unique style, more gang-related, and a unique style of bombing, pure damage, but for some years it has been growing in different directions,' says Blast. 'There are a lot of writers now, and I think there will be more and better works in a few years.'

'The graffiti in Monterrey is old – from the mid-1980s,' Dose adds. 'We also have a type of local graffiti called *ganchos* and the people who do it are called *gancheros*; their role is similar to the *pichadores* of Brazil, and *ganchos* only exists in our city. The New York style of graffiti – pieces, throwups, tags and all that – arrived here in the early 1990s, but the two styles continue to coexist.'

Recently artists from the group have joined forces with local collective Arte Cocodrilo. Rene Almanza, one of AC's founders, believes it is vital to include graffiti artists in the collective: 'The artists in AC who work specifically on the street have given us an important vision. We share it and believe it is an important language that has influenced us all in our work… The fact that a painter can go out on the street and experience the language of graffiti and then go back to working indoors will surely enrich him or her, and vice versa.' This collaboration with other artists has encouraged Blast, Lastrescalaveras and Losdelaefe to experiment with techniques such as printmaking, which has given them a wealth of new ideas that they have then taken back to the streets.

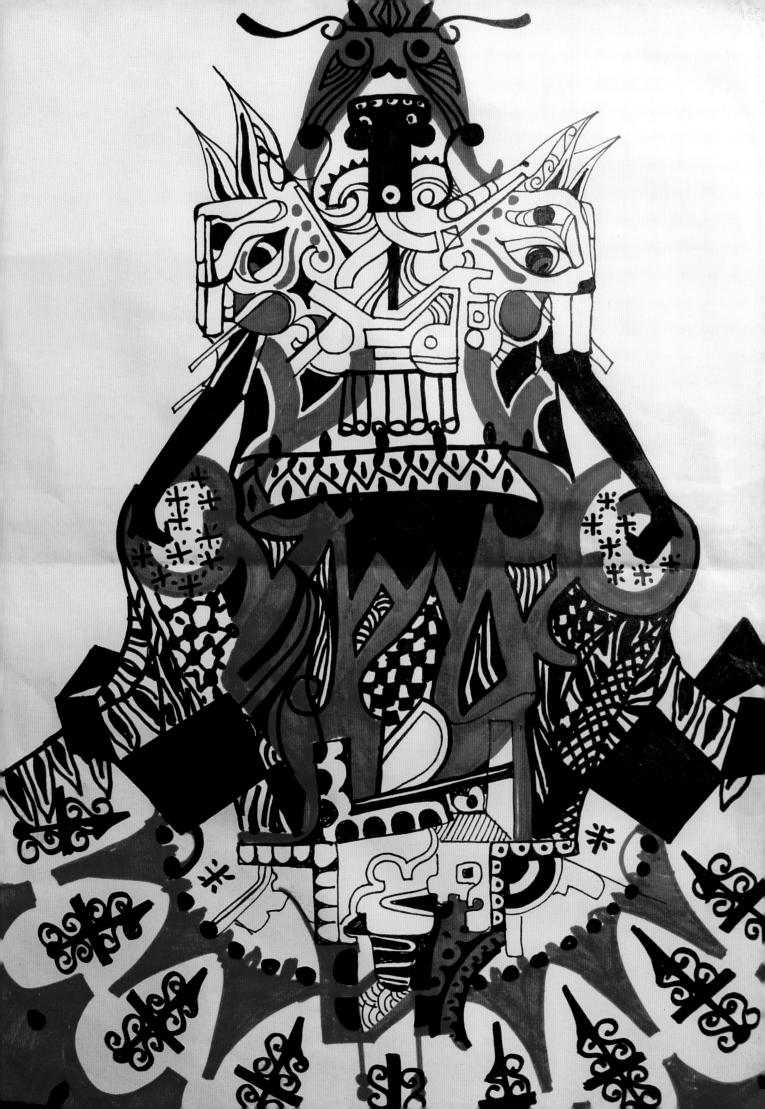

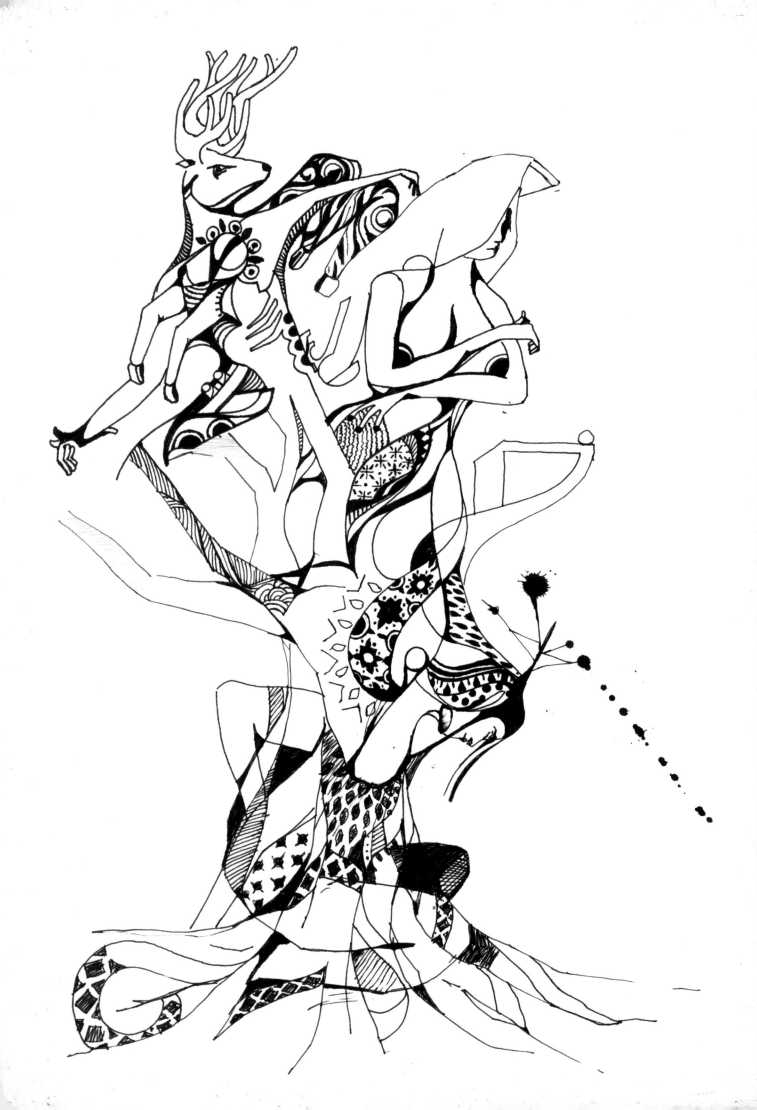

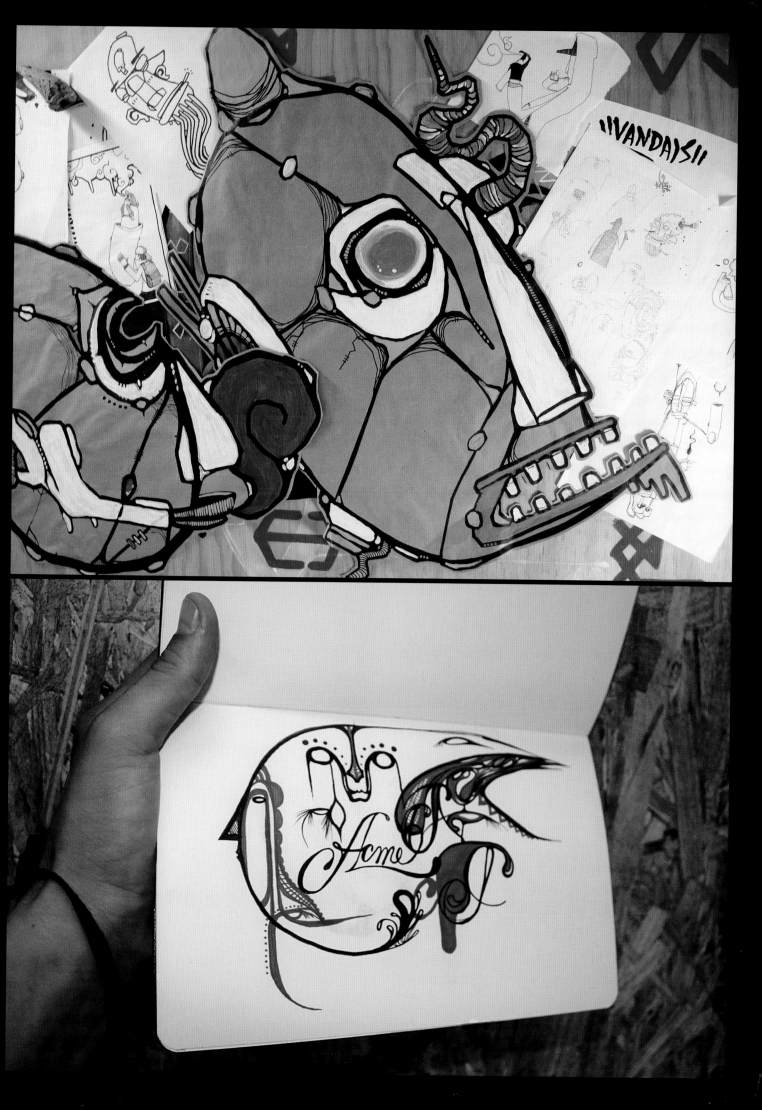

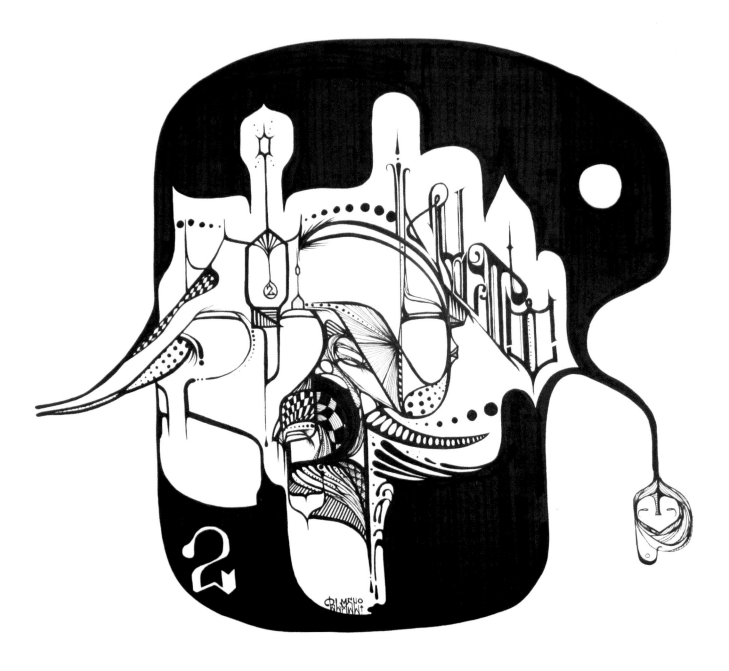

Blast

Blast initially began painting in the hip-hop style in 1998, aged sixteen. He is primarily self-taught and developed his artistic skills by drawing, learning from friends and painting on walls. Through graffiti he was inspired to study graphic design, which in turn affected the way his style developed; it became more character-based, with typographic elements. Now he experiments with a mixture of media such as cardboard, wood, spraypaint, acrylic paint and ink to create his work on walls and in the studio.

Blast's figures, executed with strong, clean graphic lines and decorative elements, have a mystical quality and are reminiscent of spirits or gods. Many are masked, and Blast employs this device in the same way that 'ancient civilizations used masks to acquire other personalities, or become gods, or simply represent an idea, a human feeling'. These characters can also serve as alter egos to reflect his feelings at a particular moment, he adds: 'They are an extension of me.'

His Mexican ancestry is a rich source of inspiration, offering him 'a lot of history and tradition... the mixture of cultures. There are a lot of places in Mexico that are magical, Oaxaca, Xilitla, Mexico City, Real de Catorce... I am stimulated by the things that I see there, their natural beauty, the people and the traditions.' He is also inspired by aspects of day-to-day life in the city, 'the little things that you see when you're on the bus', as well as contrasts and extremes, for instance love/hate or peace/chaos. A number of well-known artists have also made a deep impression on him, such as the Spanish–Mexican Surrealist painter Remedios Varo, the Dutch creator of fantastic worlds Hieronymus Bosch, and the British Surrealist Leonora Carrington.

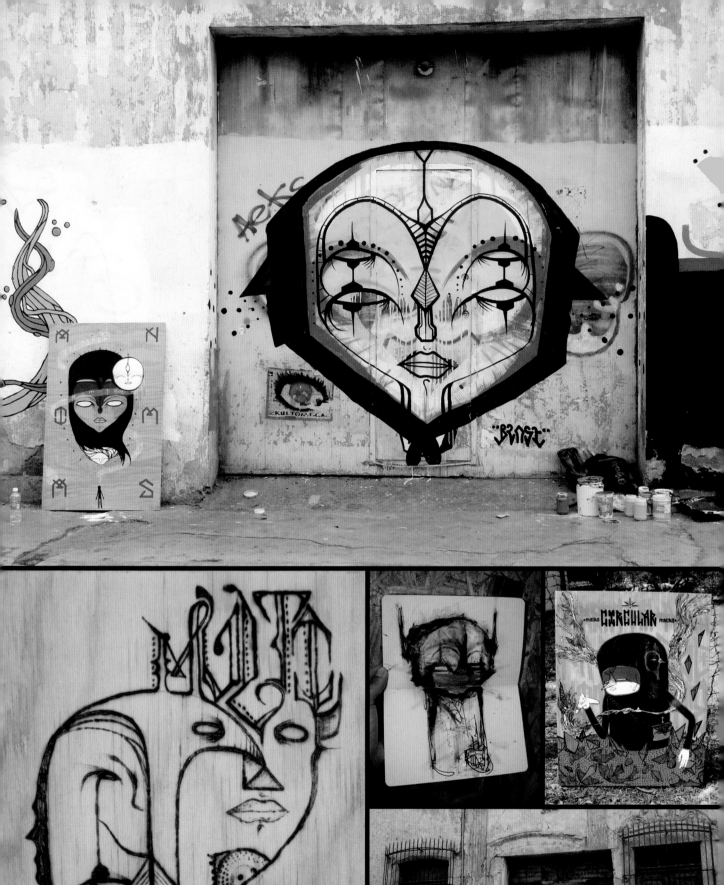

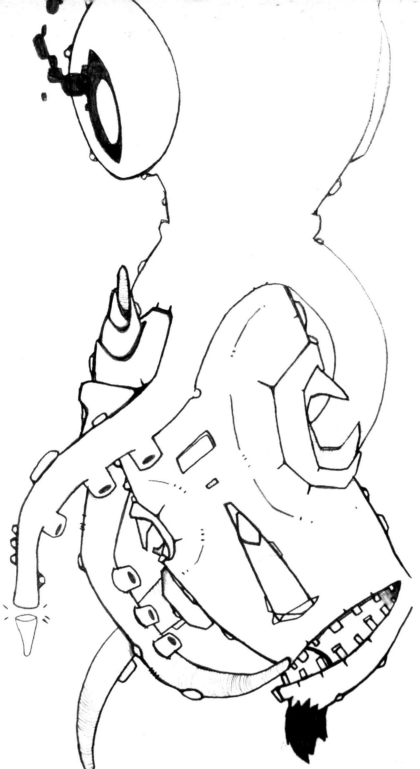

Lastrescalaveras

Lastrescalaveras (or Las Tres Calaveras, 'The Three Skulls') chose this name to pay homage to his father and his brother and to connect the three of them with his artwork. In 2008 his father died of a heart attack, and in the same year his younger brother was also killed in a motorbike accident. The three skulls have come to symbolize his relationship with death. 'I am not afraid of death', he says, 'because it is inevitable and unpredictable. I only respect it.' He has been painting graffiti since 1997, originally under the name Dose, which is how most of his friends still know him.

Animal forms such as reptiles and organic shapes are also key themes in his work. His style, which has a surreal comic art feel, is characteristically segmented; figures are often made up of sections, which fall apart and mutate so that arms become tentacles or a hand becomes a cactus. Inspired by science and nature, his creations are figures of pure fantasy, free forms that sometimes mix the organic with the inorganic, for instance microorganisms with microchips. He says that the majority of the ideas in his work 'speak of the liberation of the mind and the spirit, to be able to untie your hands and feet and have the power to go where you want'.

Despite his talents he doesn't consider himself an artist yet, saying: 'I see myself as a graffiti writer, as someone doing different things, experimenting a little.' With his imaginative characters, he is getting closer to expressing a personal vision and philosophy. 'Reading and learning about Mexican culture', he says, 'through authors such as Julio Cortázar filled my head with ideas that I have been developing over time, from my earliest days as a graffiti writer. I really like the pieces and tags, but I wanted to give my characters their own identity with elements of my country. That's what I am trying to do.'

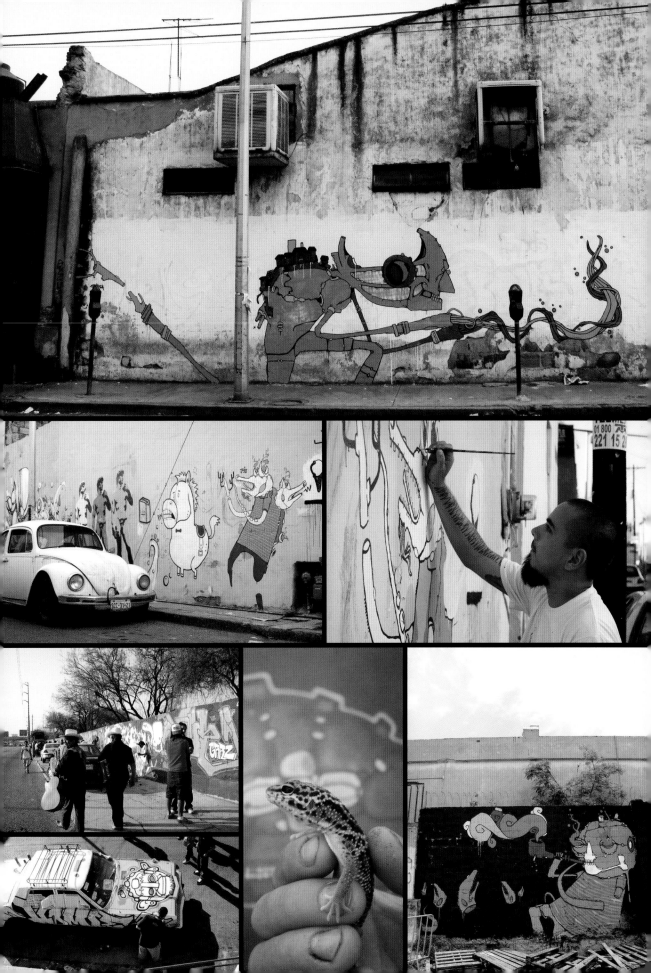

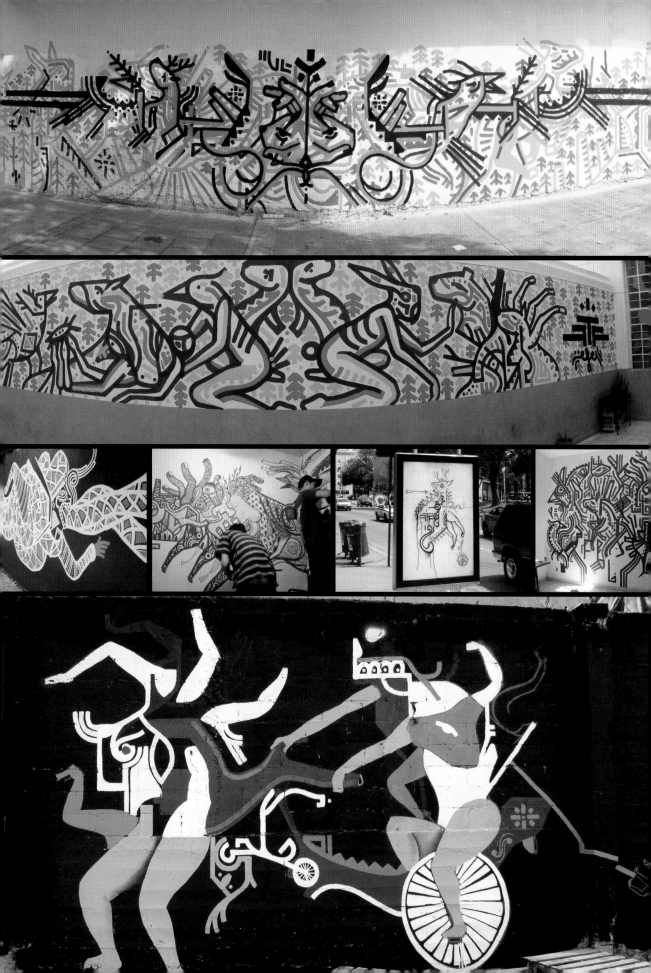

Losdelaefe

Losdelaefe ('The F Team') are a pair of artists, Sanez and Fer, who paint in Monterrey with the aim of creating 'our own national identity in our work'. They have no formal training and developed their skills by painting graffiti in the street. In producing their designs they often refer to books on art, national history and Mexican underground culture.

Their paintings are very bold, using flat colour and clear outlines that are reminiscent of pre-Hispanic sacred art. 'Our work is grounded in drawing, rather than painting,' they say. 'Our main purpose is to discover new forms and different compositions. We do not study colour much – we are more interested in texture – but we prefer strong colours like red, black and white. We also like to use paint rollers for expediency.'

Animals such as birds and deer that appear as sacred symbols in pre-Hispanic art often feature in Losdelaefe's decorative patterns and compositions. 'Pre-Hispanic cultures perceived the universe with infinite possibilities,' they explain. 'That's how we see our work.' They are particularly interested in the way ancient cultures derived power from nature, for example their use of plants in medicine. When passers-by see their walls, they are left to make their own interpretations: 'It is more about transmitting sensations than communicating an idea. We would appear to be telling stories, but in reality it is the people who interpret our works who make up the stories. The interpretations are always different – for us that is the imaginary Mexico.'

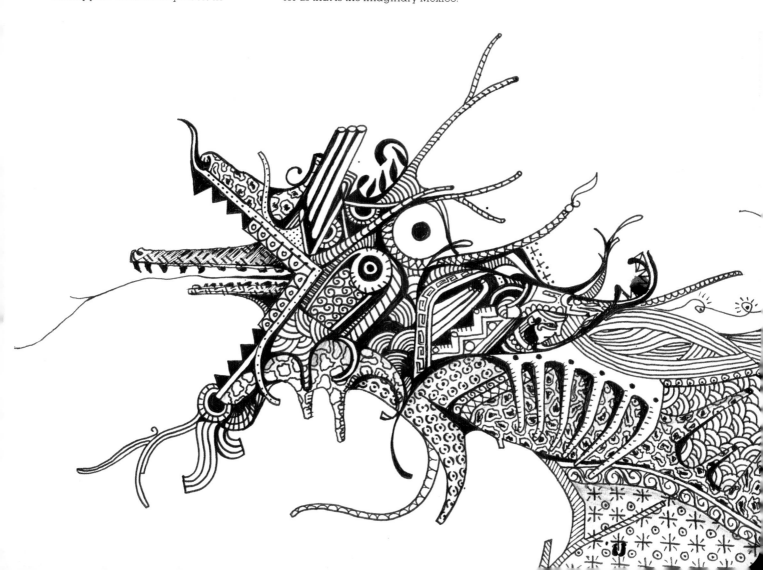

Latin America on the Back of a Cat

CharquiPunk

CharquiPunk (aka Sebastian Navarro) lives in the historic port of Valparaíso in Chile, where his murals and graffiti can be found throughout the city's labyrinthine streets. He is a well-known ambassador of graffiti for the city, painting with local artists such as Inti Castro and La Robot de Madera ('The Wooden Robot') and visiting artists from other countries, as well as promoting mural art to local communities. He is also a well-respected figure within Latin American graffiti as a whole, having travelled to many different cities across the continent to paint.

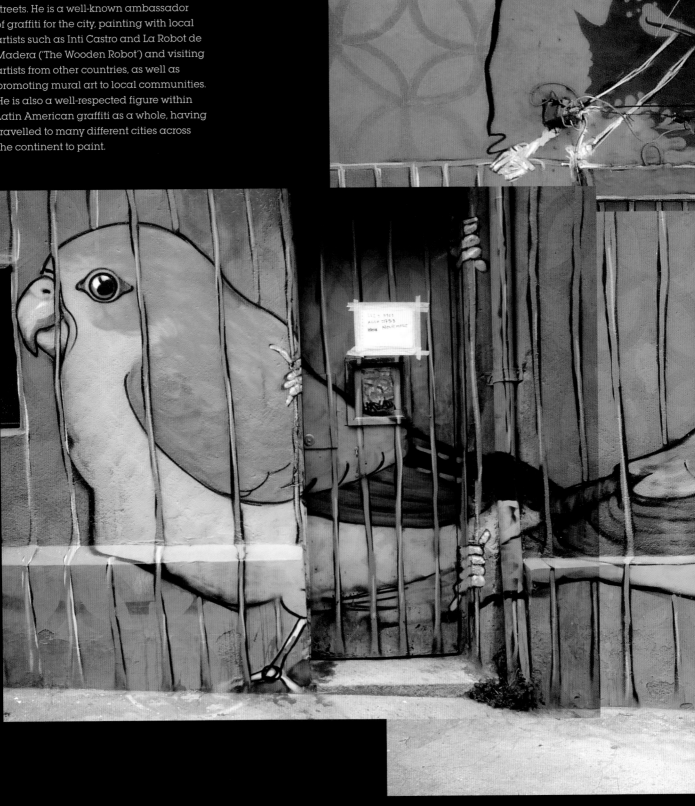

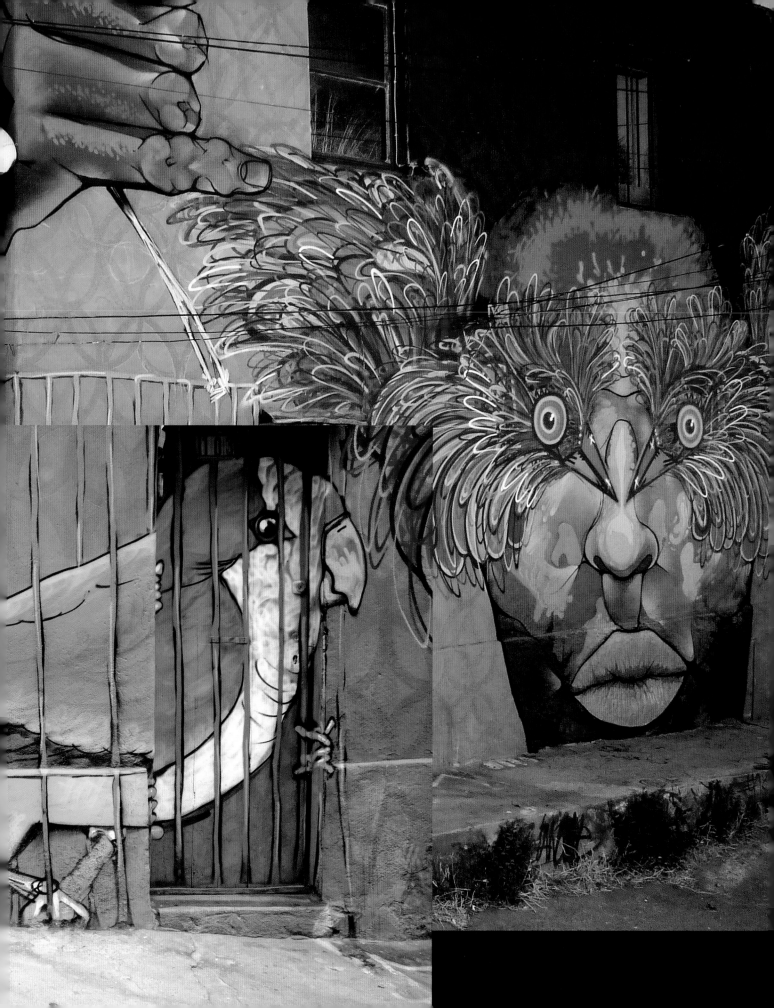

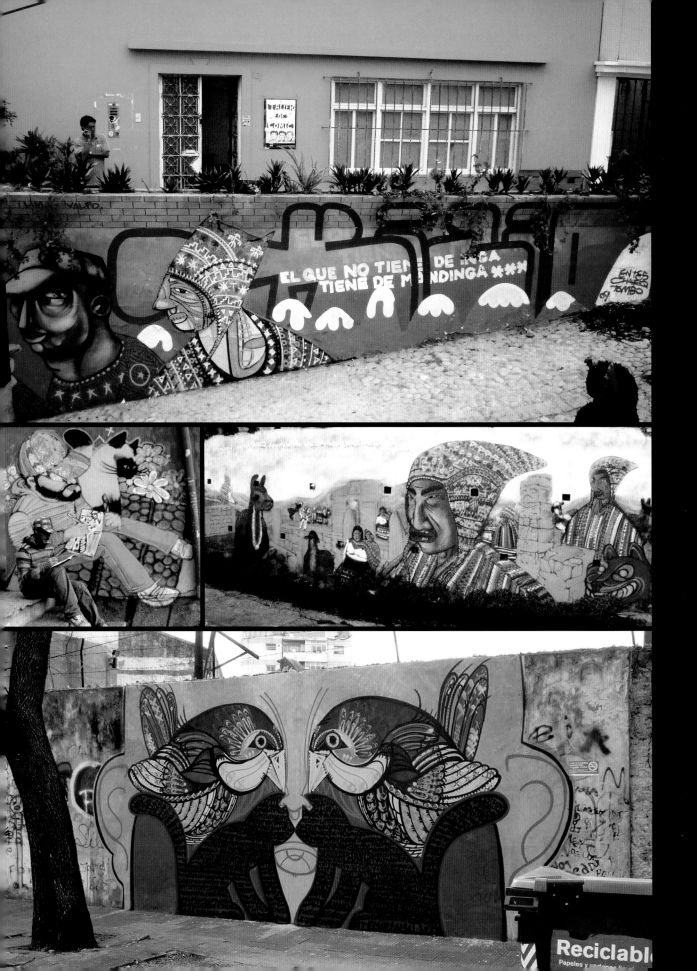

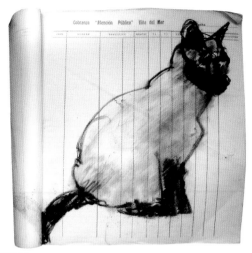

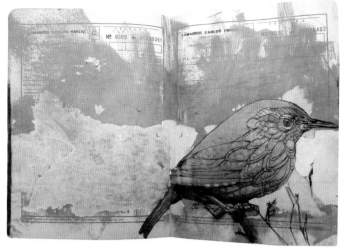

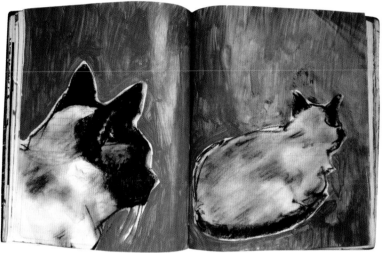

CharquiPunk is a self-taught artist and between 1993 and 1998, while studying industrial design, he devoted a lot of his spare time to sketching and drawing in pen. He first experimented with colour on walls, initially practising at home in his garden but later moving on to the street.

The majority of CharquiPunk's vibrant paintings in Valparaíso and other cities have a local or social context. His images celebrate resident characters such as fishermen, street sellers and musicians as well as indigenous peoples, and they are inspired by everyday life and pre-Hispanic art. In his own words: 'Lately I have been choosing my subject matter in the context of wherever I am painting. I'm trying to bring the culture of that place to the wall. I believe that graffiti can be used as a tool: it can be used to educate people about lost cultures or those close to extinction; it can bring those cultures to life, so that they don't get lost, or at least the graphic awareness of the subject doesn't disappear.'

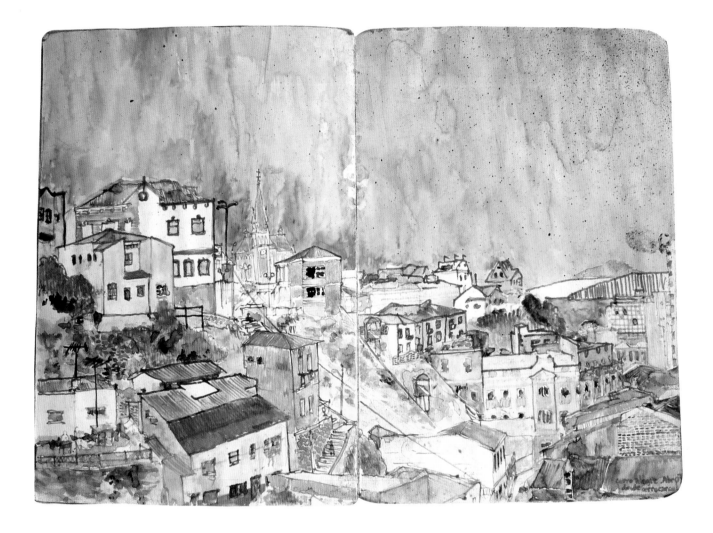

The artist's travels on a shoe-string budget have taken him to Bolivia, Argentina, Brazil, Colombia and Peru – almost an entire tour of South America. Most of these journeys have been about personal exploration: making new friends, getting involved in cultural events and finding out what each city had to offer. Collectively these journeys are in some ways reminiscent of Che Guevara's famous trip across South America by motorcycle (except without the motorcycle); in the same way they have

given CharquiPunk first-hand experience of life throughout the continent, with all of its affinities and histories.

Pre-Hispanic culture holds a particular fascination for him: 'I believe that all the countries in Latin America are linked through common roots. All of them suffered a merging of the original culture with the Spanish, following colonization of the new continent. We were all colonized, and a new religion was imposed, and at the same time a syncretism occurred in every country

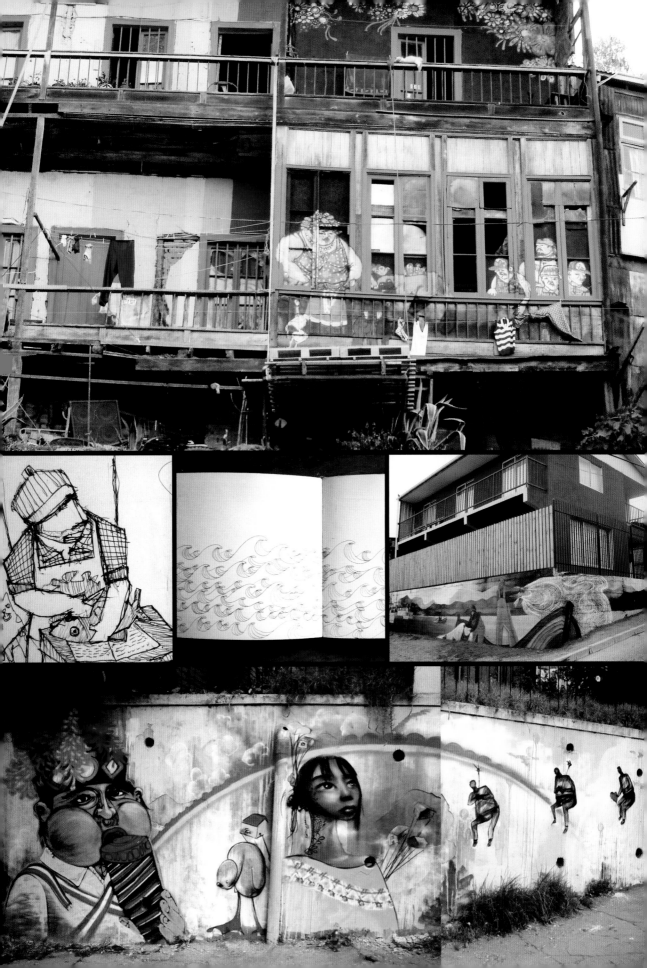

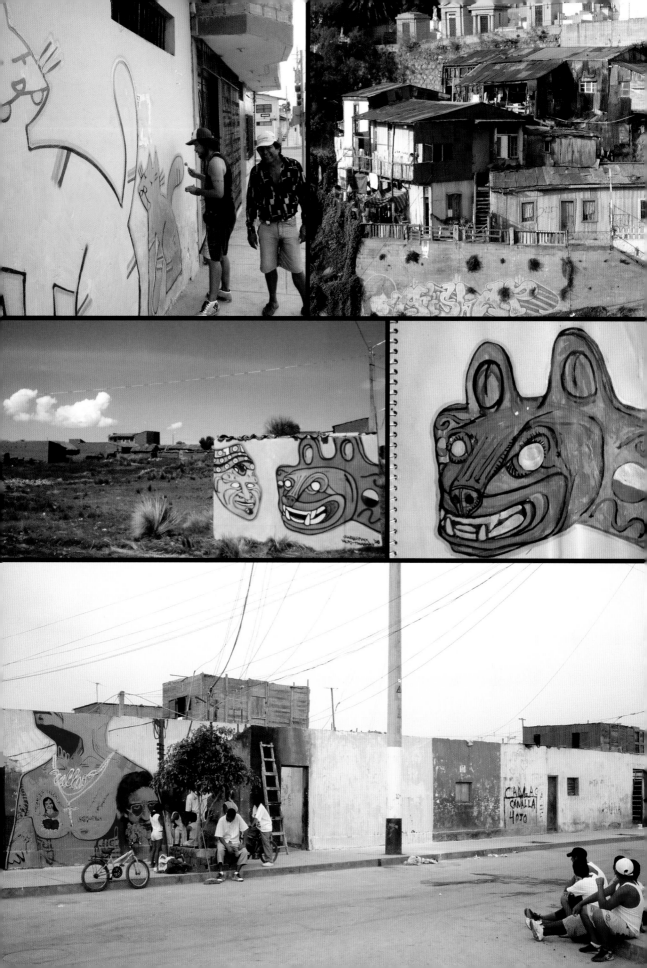

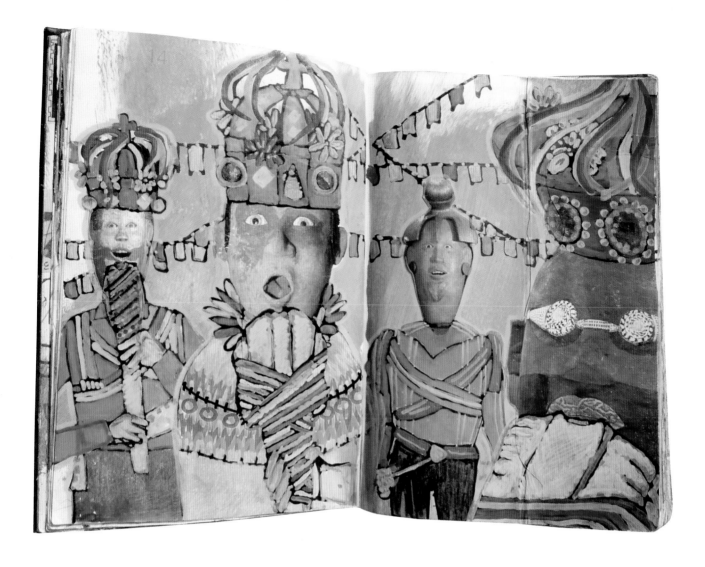

trying to preserve the original culture. Sometimes there have been mutations, but it's this syncretism that has united Latin America in a unique history. In my journeys I try to discover the forms that each original culture adopted during the syncretism and how it behaved, looking at their differences and similarities.'

There are some parallels between CharquiPunk's paintings and Latin American muralism, an art movement originating in the 1920s that paid tribute to the history and heritage of indigenous peoples. Although he feels more rooted in graffiti than in mural tradition, he points out: 'I'm trying not to separate myself from graffiti. I feel that my work is closer to graffiti than to muralism, mainly by the act. It's something that you try to make quickly, generally in a day, and usually without permission. It's mainly the attitude that is linked to graffiti as well as some graphic elements and the use of colour in a Pop way.' However, he does feel some connection to the sentiments of Latin American muralism: 'Like the great

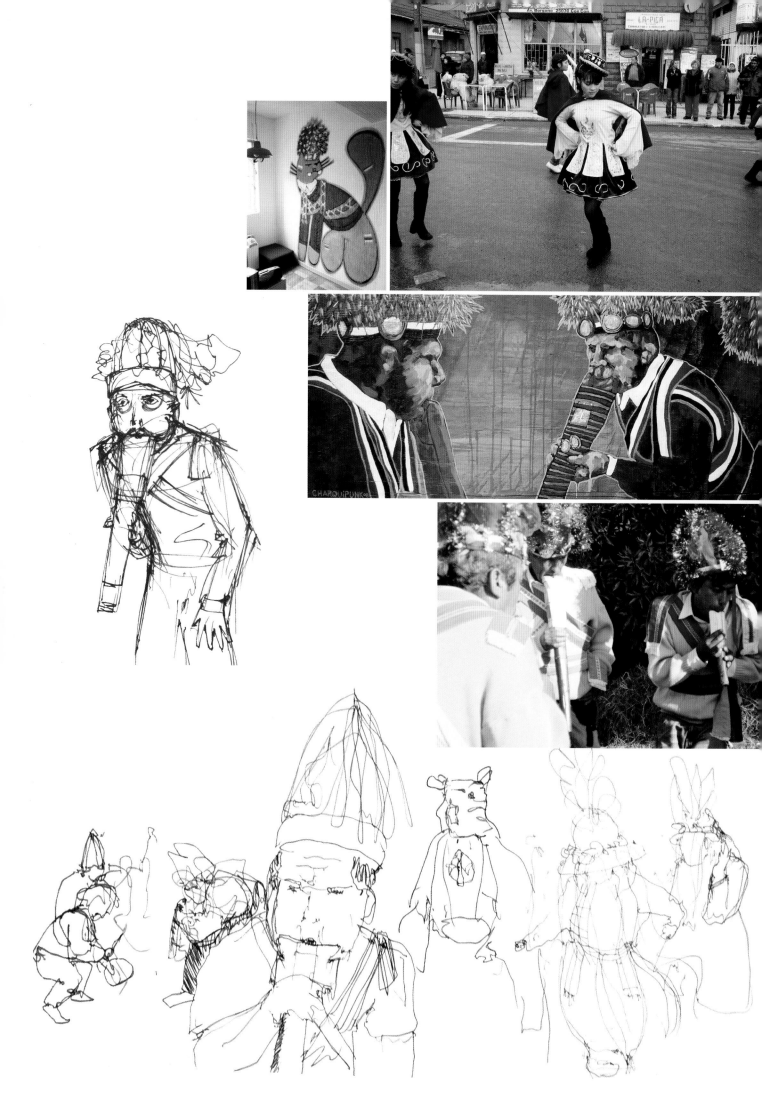

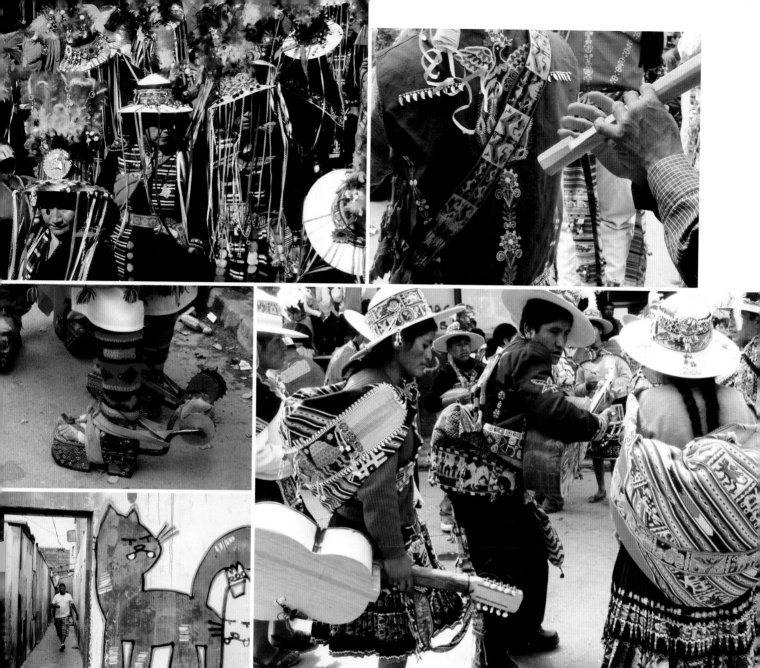

exponents of Latin American culture such as José Marti, José María Arguedas and José Carlos Mariátegui, I feel that the only way for Latin America to go forward is to recognize its origins and show its true self to the rest of the world. We need to stop looking to others as if we had no heritage of our own.'

Growing up in Valparaíso, with its steep hillsides looking out over the Pacific Ocean and its rich history, heavily influenced CharquiPunk's work. The city's diverse immigrant population

has also contributed to its unique vibrancy, which he reflects in his free and decorative style. While its historic quarters and weather-worn walls have provided a great support for his art, they have also seen his work change over time: 'Every year I add a different form to my style. One year it's dots; the next, lines. It may be in the combination of colours, or in the use of texture. Over the years, I have accumulated an arsenal of techniques that together make up my style. At the moment my

inspiration comes from the textures of Andean textiles.'

As CharquiPunk's painting style has evolved, so too has his use of sketchbooks. He takes a sketchbook with him on all his journeys. Full of notes, funny drawings and detailed sketches, these sketchbooks are a fascinating diary of his life and travels. Depending on the time available, he uses them in different ways; drawing freely whatever comes to mind, sketching his surroundings, planning a painting or sometimes using newspaper cuttings to build up a collage of pictorial ideas.

At his most playful and fun are his pictures of cats, which he has painted all over his home city as well as further afield. While a lot of people see them as fantastical self-portraits (and perhaps subconsciously they do reflect his character), this is not his intention. They started off as a homage to a cat he once owned and became his signature – an unofficial icon for Valparaíso. There also tends to be a positive message in many of CharquiPunk's graffiti pieces; even when his works highlight social or political injustice, they seek positive action.

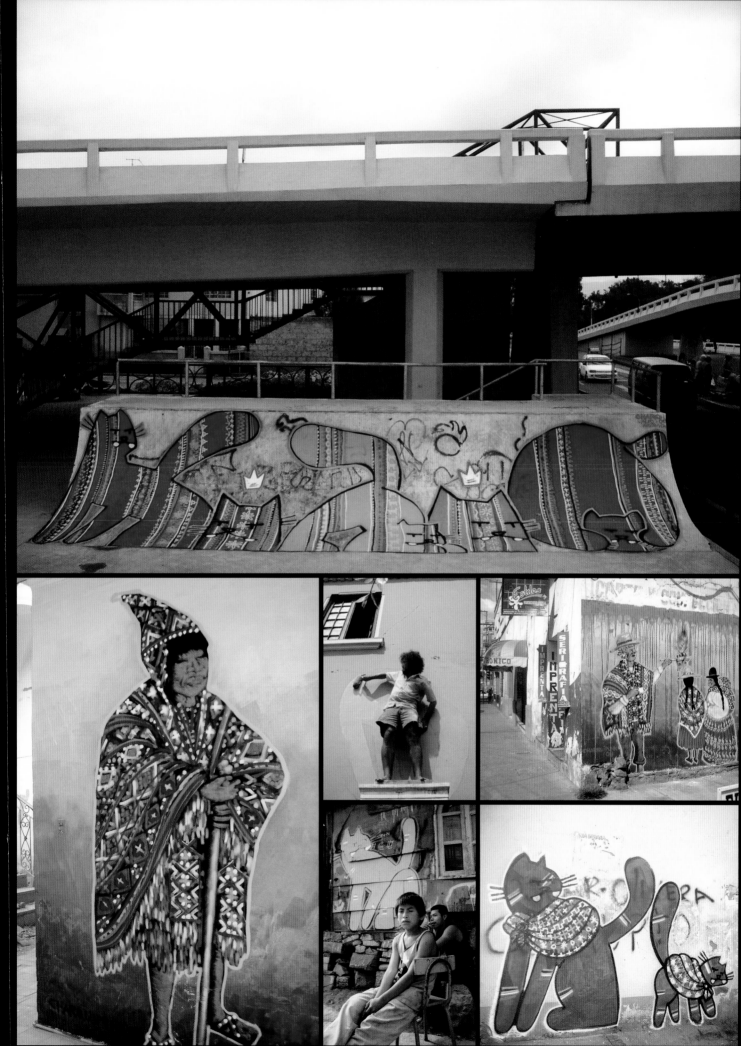

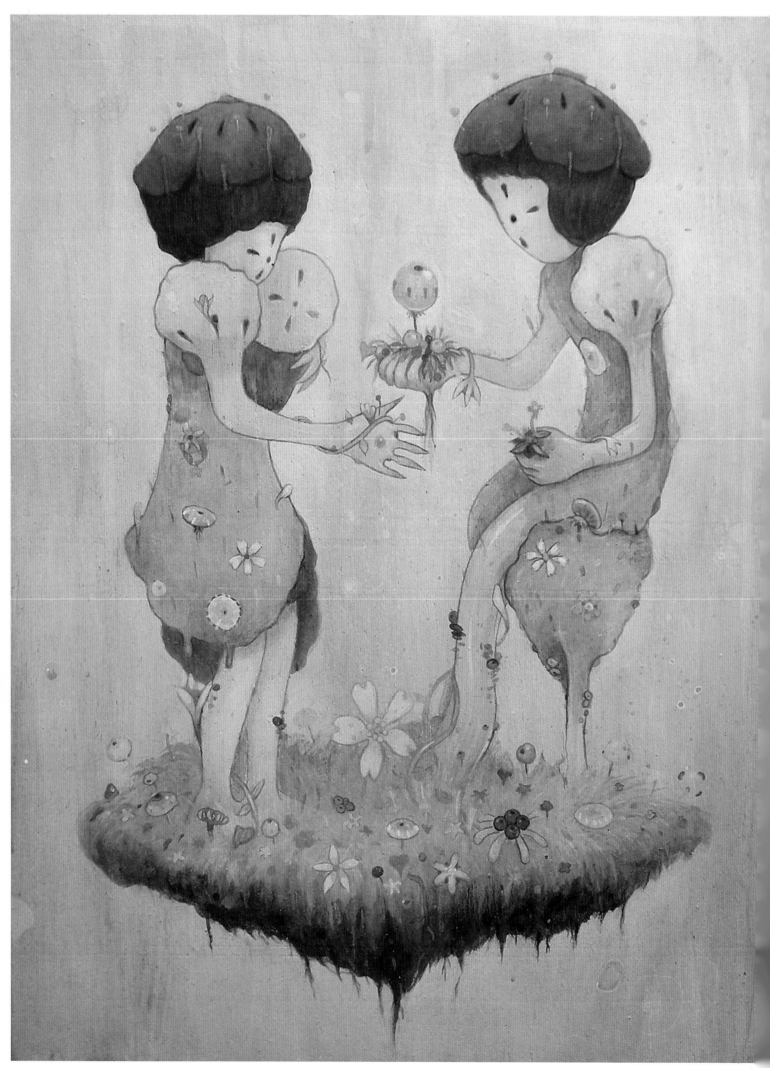

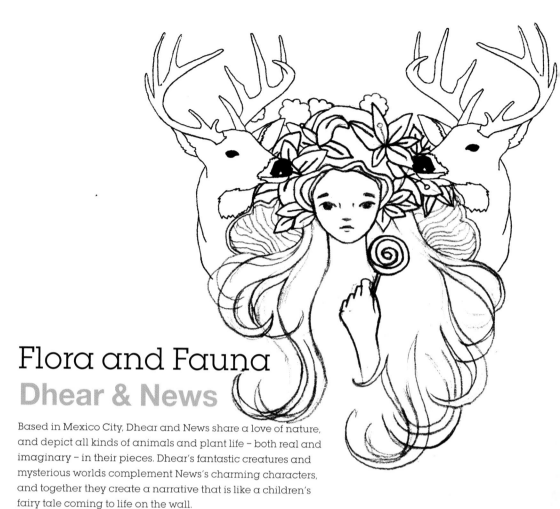

Flora and Fauna
Dhear & News

Based in Mexico City, Dhear and News share a love of nature, and depict all kinds of animals and plant life – both real and imaginary – in their pieces. Dhear's fantastic creatures and mysterious worlds complement News's charming characters, and together they create a narrative that is like a children's fairy tale coming to life on the wall.

Although they have had few opportunities to travel abroad, they have collaborated with many visiting artists from Europe and South America such as 123klan, Fefe and Fafi, learning and sharing from each experience. If money were no object, they would travel around the world together painting graffiti. In addition to collaborations, they both balance freelance design work with many self-initiated projects, including their own exhibitions.

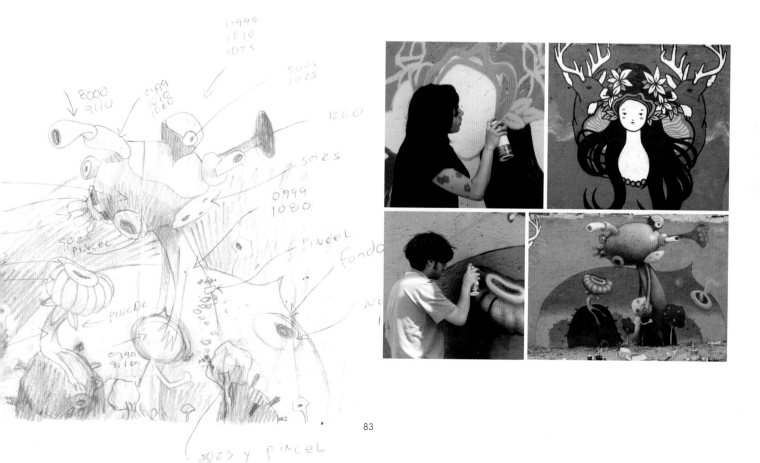

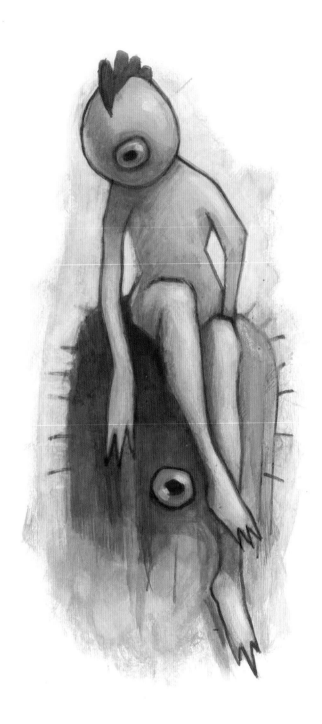

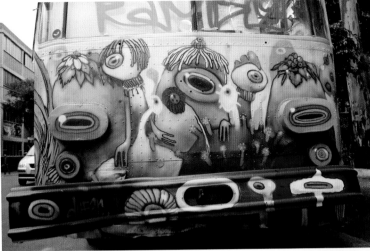

Dhear

Dhear was bitten by the graffiti bug as
a thirteen-year-old high-school student,
and began painting every weekend.
Soon he became interested in all kinds
of painting, from fine art to illustration.
He considers himself an autodidact –
learning from other artists' work, exploring
new ideas, and applying graffiti
techniques to his studio and design work.

He likes to let his imagination take over,
creating monstrous letterforms, other-
worldly characters, or abstract forms
drenched in rich colour and light. 'Painting
humans and "real" things is a bit boring,'
he says. 'Sometimes I end up doing that
kind of thing for a living, but I prefer to
create characters and letters.' Although
his characters tend not to be human, they
still convey human emotions. They are, he
says, 'a reflection of my different moods;
sometimes they are stories in my head
that I don't tell anyone. Still, I enjoy seeing
people trying to decipher them. Most of

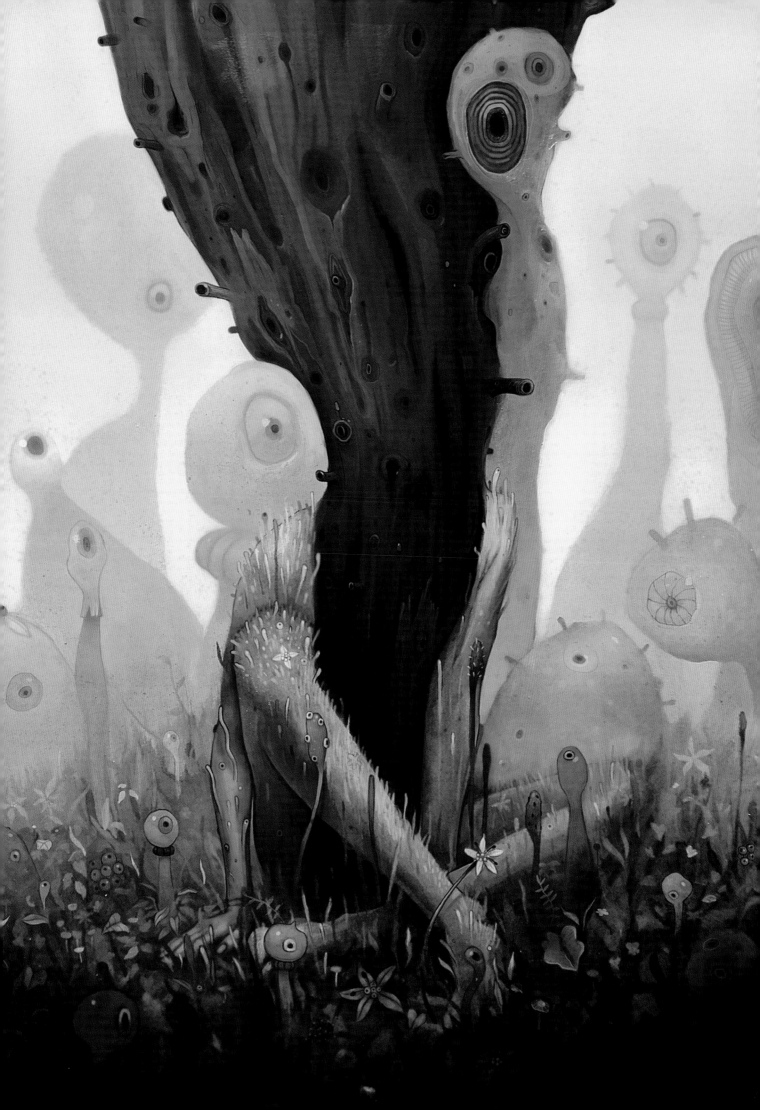

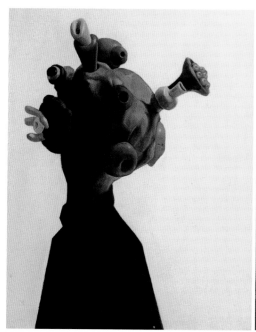

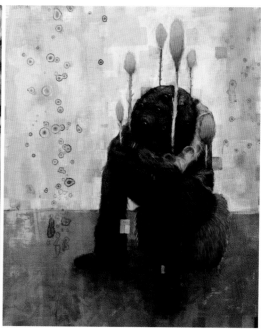

my work is untitled, depicting things that don't exist in this world.'

Dhear's paintings immerse the viewer in a lush universe where new unimagined life blossoms and grows. He explains some of his influences: 'I have been interested in nature and science fiction since I was a kid – films such as *Alien*, *The Thing* and *Invaders from Mars*, as well as dinosaurs, flora and fauna. I have a collection of branches and seeds, and strange stuff that I have found. There are hints of all these things in my work. Hayao Miyazaki's movies and his characters also had a great impact on me when I was sixteen… Everything in life inspires me. I'm addicted to movies, animation, documentaries, photography, the internet, of course, and everyday things.'

He particularly admires the great French comic-book artist Moebius, graffiti artist Sat One, the pioneering cartoonist Winsor McCay and writer Franz Kafka.

Mexico City is a buzzing cultural centre with a vast population. In Dhear's words, the popular misconception of Mexicans as 'charros [Mexican cowboys] with sombreros, eating nopales and going to the Aztec pyramids and lucha libre' is a far cry from reality. His work is influenced by the city and the realities he sees around him every day: 'peddlers on the subway, the extreme contrast between the rich and the poor, walking from an over-polluted place to a green space in the same city.'

Dhear finds painting in the street with friends so much fun that he would quite happily do it non-stop

for a month if he could. His elaborate pieces take time to build up, with their subtly fading colours and forms, so he paints in places such as quiet residential streets, off-the-beat areas where he can work in peace and where art is appreciated. In the studio he is equally meticulous, sketching his ideas on paper before moving on to painting. Sometimes he makes clay models of the figures in his sketches, which he then photographs as a three-dimensional reference for light and shade. Even when he has completed a painting there is always the temptation to then scan it and enhance it in Photoshop. It's exhausting work, he says, but satisfying when he's happy with the results.

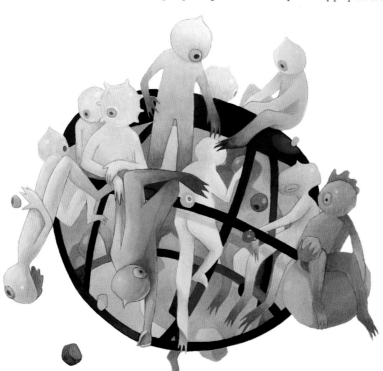

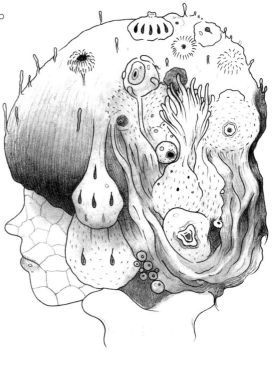

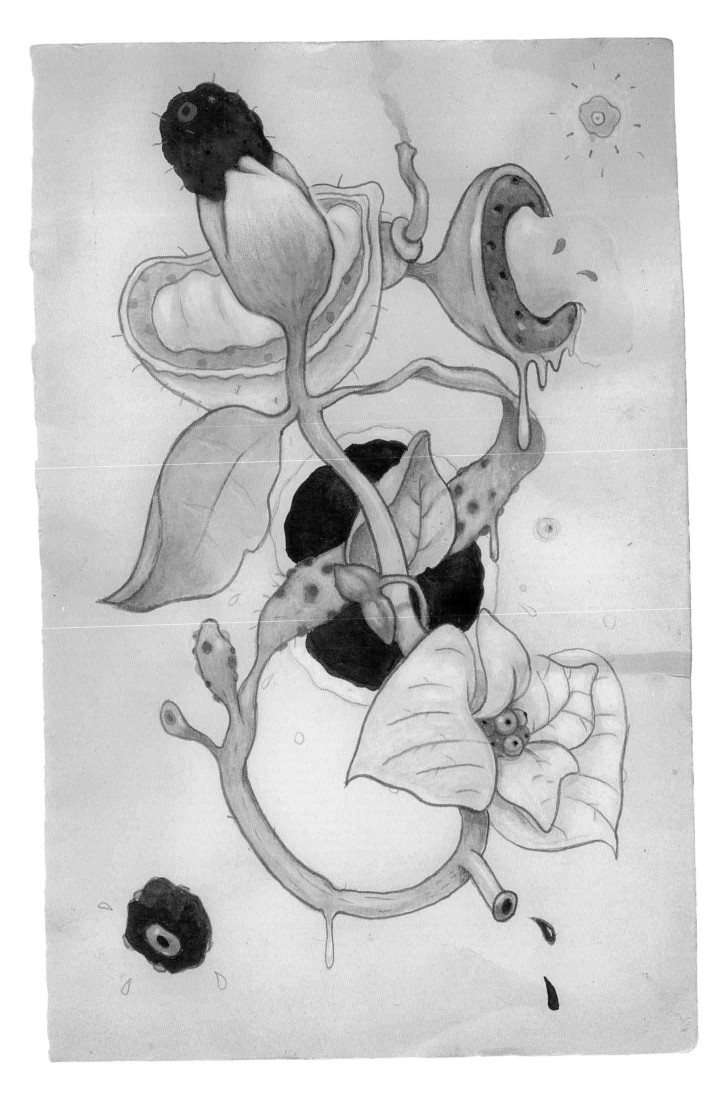

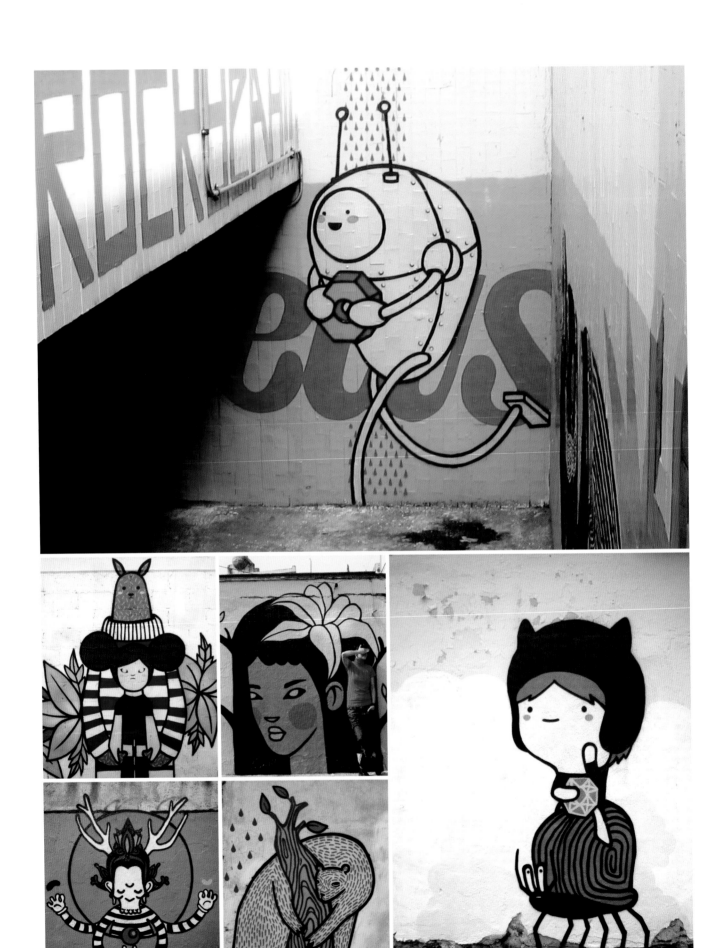

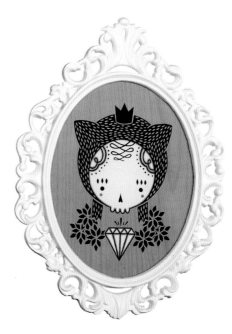

News

Painting has been one of News's passions ever since she was a kid. Through graffiti she learnt how to paint in a more disciplined way than she had ever done in art classes at school. Although she uses lettering, she finds it more interesting to convey her ideas with characters, confessing 'my letters have never been pretty'. Like her painting partner Dhear, a lot of her work is influenced by nature: 'I try to communicate the relationship between humanity, flora and fauna, and depict a place in which they are all mixed up and live together peacefully; a place where a giant fish has a girl for a pet, and where

a young woman falls in love with a deer. Simple things enriched by colours.'

Animals hold a particular fascination: 'I've always loved animals, especially the furry ones. I feel terrible when they die, or when I see documentaries about endangered species, and the conditions they have to live in. Another thing that impresses me about all animals is the gifts that nature has granted them; the long neck of the giraffe, the chameleon's camouflage, their striped coats, their scaly skin, it is just amazing.' This love of animals lies at the heart of her work, as she celebrates through painting the variety and beauty in nature.

On the wall News's characters are enchanting, elegantly drawn with an appealing use of flat colour. It's a world that has come to exist through a fusion of playful inspirations, which she lists – among others – as cartoons, Art Nouveau, pop culture, femininity, rabbits and ice cream, as well as artistic heroes such as Audrey Kawasaki, Miss Van, Yoshitomo Nara, Mark Ryden and Camille Rose Garcia. Her sketches tend to be small, and sometimes she digitally enhances them. However, she loves the excitement of bringing one of her sketches to life on an old wall in a deserted street.

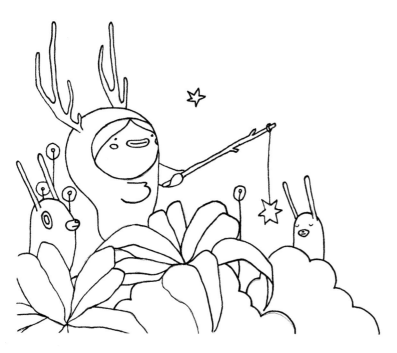

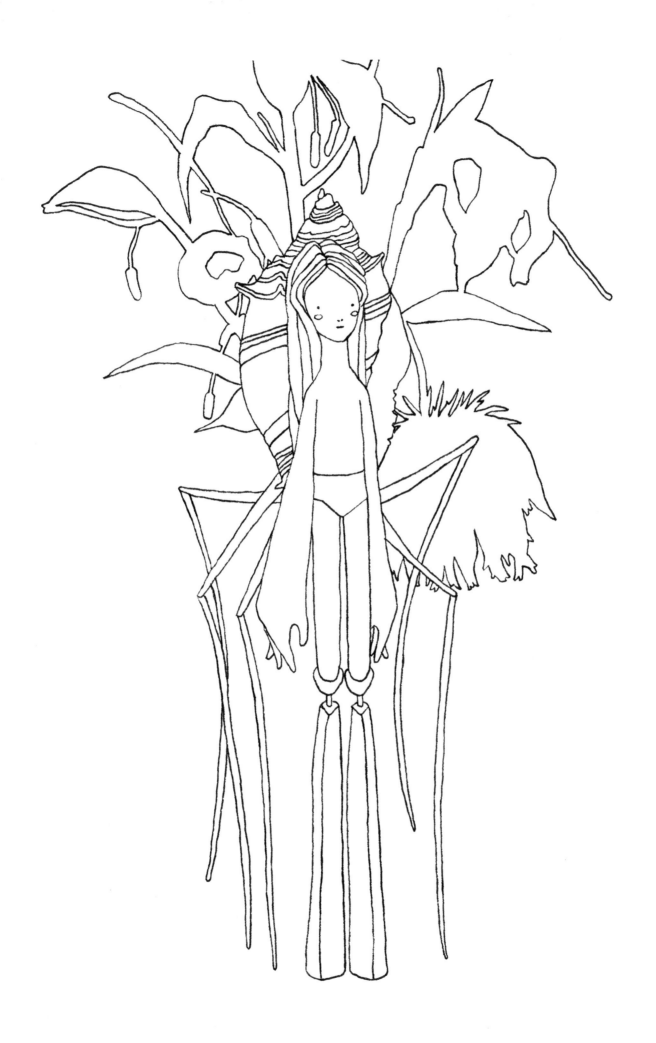

Talking through Images
Dran

Based in Toulouse, Dran is a multi-talented artist who has, to use his own words, spent his whole life 'talking through images'. He converses through a wide variety of media, including installations, paintings, drawings and publications, and conveys his original and ironic viewpoint in all of his work with an enchanting mix of absurd humour, emotion and poignancy.

His formative years gave him a grounding for life, for which he is thankful. As he explains, 'I come from a working-class family, with parents who had to get the first job they could find, so that their children could study and find proper jobs – and being an artist didn't count as a proper job! I'm grateful that I've seen all sides of life. I wouldn't have the same things to say if I'd been surrounded by the world of art when I was just a kid.'

Dran was particularly passionate about illustrated books when he was

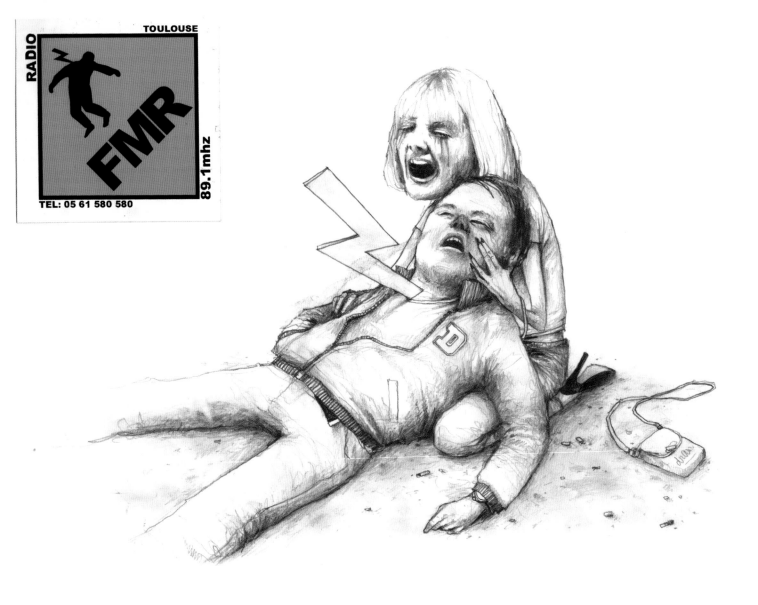

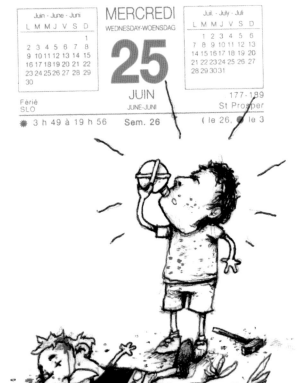

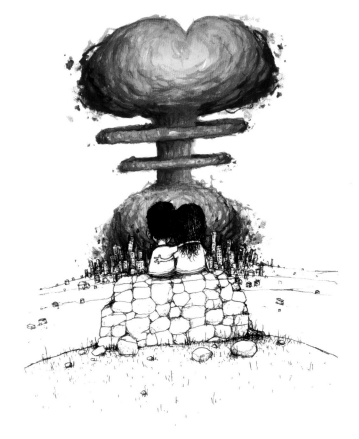

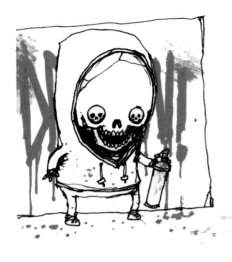

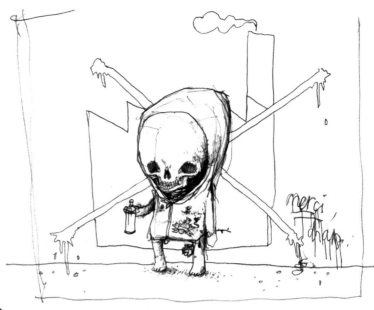

growing up: 'Comic-book artists were my role models between the ages of eight and twelve; they were like the art teachers I never had. I'd try to imagine who they were and how they got their amazing skills. I thought that they must be really happy. They really set my imagination working.'

He was eight when he first met someone in class who drew just because he wanted to. Seeing the notebooks full of sketches Dran was so blown away that he started to draw too, in class, at home and on the street. His dad was also a fan of comics, and through him Dran discovered the cartoonists of the 1970s and '80s, such as Richard Corben, Bill Sienkiewicz and Dave McKean. 'The artists who talked about personal stuff in a coded way, and used black humour, those were my favourites,' he explains. 'Black humour wasn't very popular, it had coarse connotations, but to me it was a way of telling things like they are, less

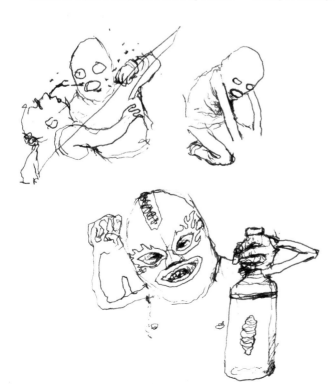

Fig 1

sugar-coated than the rest, and closer to my own version of reality. It could make a real impact.'

As a teenager graffiti became his next big love, giving him the same feeling that comic books had done. He began looking at the work of local graffiti artist Tilt (Truskool), which seemed so new to him it could have come from Mars. He discovered that friends were also writing tags and keeping blackbooks, and

gradually overcame his shyness as he began to draw and paint in front of other people. For him, 'It was a huge blast of adrenalin. It was like leading a double life.'

At art school he had his first taste of drawing from life, which taught him new ways of looking. During this period he also began to travel abroad and paint graffiti with artists such as San from Madrid. He also designed flyers and

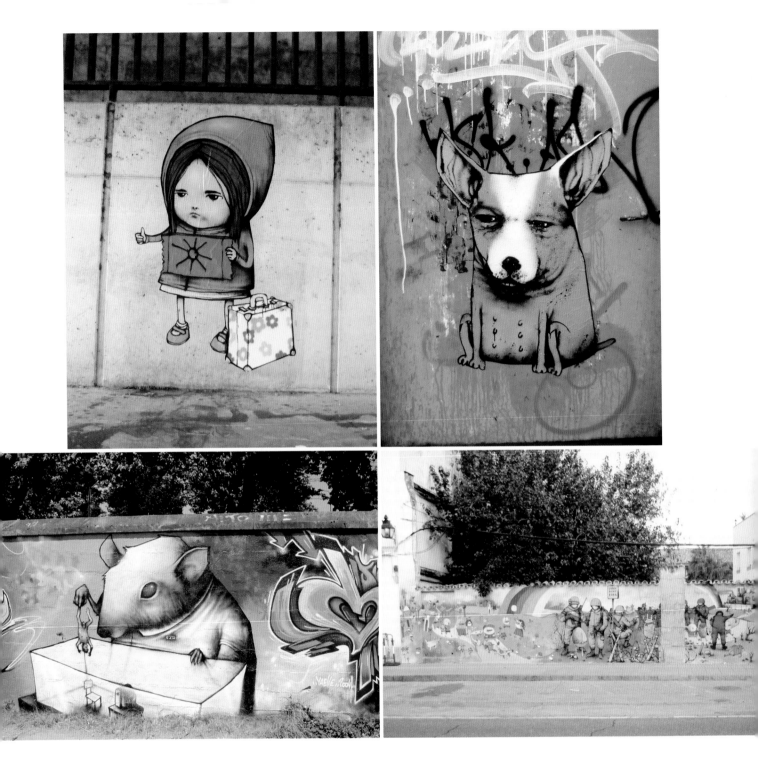

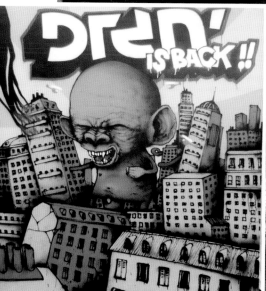

record sleeves, and painted club decor. Towards the end of his studies he began to work on more personal projects, including installations in abandoned factories, and several series of funny sketches parodying everyday events which were later published.

Characters have always been central to Dran's art. At first, because he worked spontaneously without plans or sketches, potato-headed characters suited him well: he could concentrate on their expressive faces while their little bodies acted out a scene, which often involved some form of self-mutilation to grab people's attention. He had no real direction at this point, but a trip to Spain changed all that. He came back wanting something else; his characters got bigger and represented figures in wider society.

Since leaving art school Dran has continued to work on projects both independently and collaboratively. He has also produced a monthly comic strip called 'La vie stupide au bureau' ('Stupid office life') for the satirical magazine

CQFD, which he has found rewarding. 'When you see that people are looking forward to your little comic strip, you realize you're doing what you dreamed of doing as a kid,' he says.

Dran aims to bring a human quality to all his artwork, using lines that are shaky and blotchy and a subject matter that he feels a connection with. His celebrated series of works on cardboard boxes reflects this approach. Each illustration grew out of phrases found on cardboard, which sparked off the idea. It made him think about a number of subjects, such as the 'little people, the ones we don't see or speak to, who are hidden away on the margins of our consumer society'.

A cardboard box is a symbol of consumerism and waste. 'Sometimes', says Dran, 'I find a great one and it's like a gift. When I found the box with the slogan "Good bread for everyone!", someone interrupted me and said "Hey, what are you doing?" I replied that I was just looking for boxes, and he was relieved because he'd thought there was still some bread inside. It turns out that an old woman he knew had already

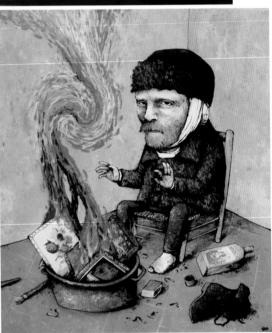

taken whatever was left. It's anecdotes like this one that have given my boxes their meaning. I'm not exploiting poverty, I'm championing it; it wasn't so long ago that I was there myself.

'The black humour isn't there just to be cruel. People do understand that. I used to wonder whether they would, back when I was showing the boxes for the first time, and I was afraid of causing offence. But the people most affected by the issues that I was depicting, to whom the boxes had been worthless originally, turned out to be the ones who loved the boxes most and wanted to talk to me about them. That really touched me and gave me a lot of motivation.'

Recently, Dran has concentrated on painting on canvas. Although not completely new to him, it felt like an unknown territory: 'Without getting self-conscious about it, I simply wanted to take my non-culture and put it in an art-history context. I wanted to speak through different media, like my books, and for them to be for everyone, not just for connoisseurs.'

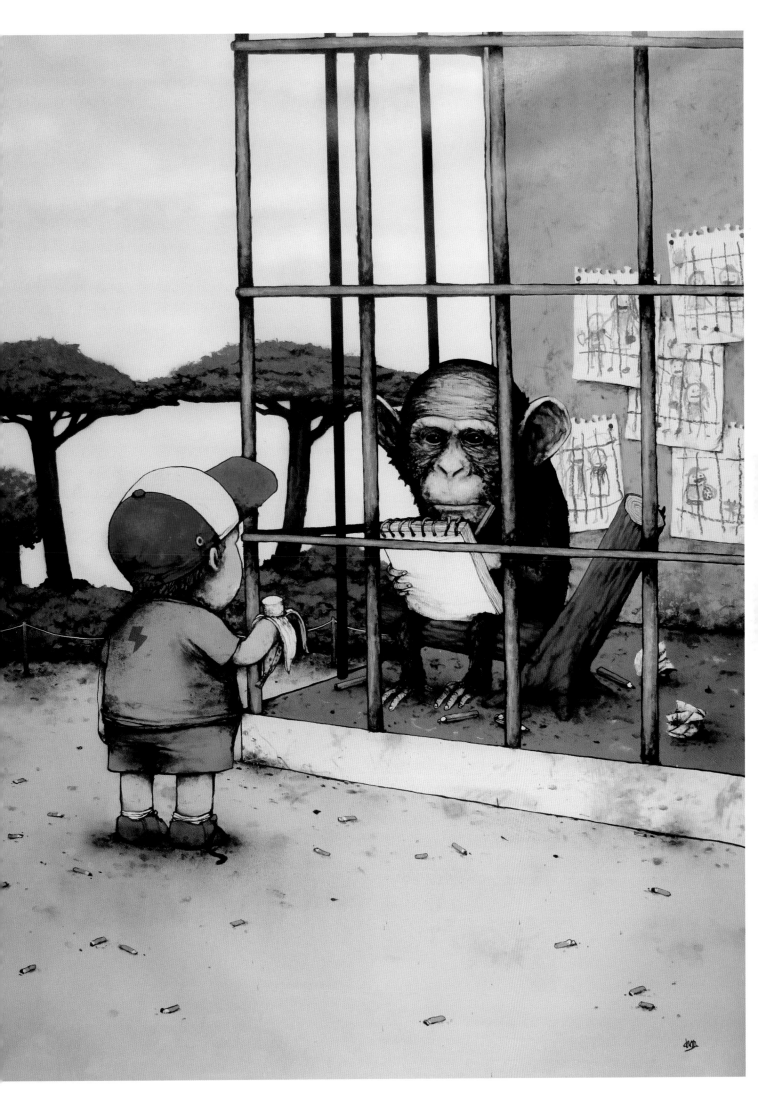

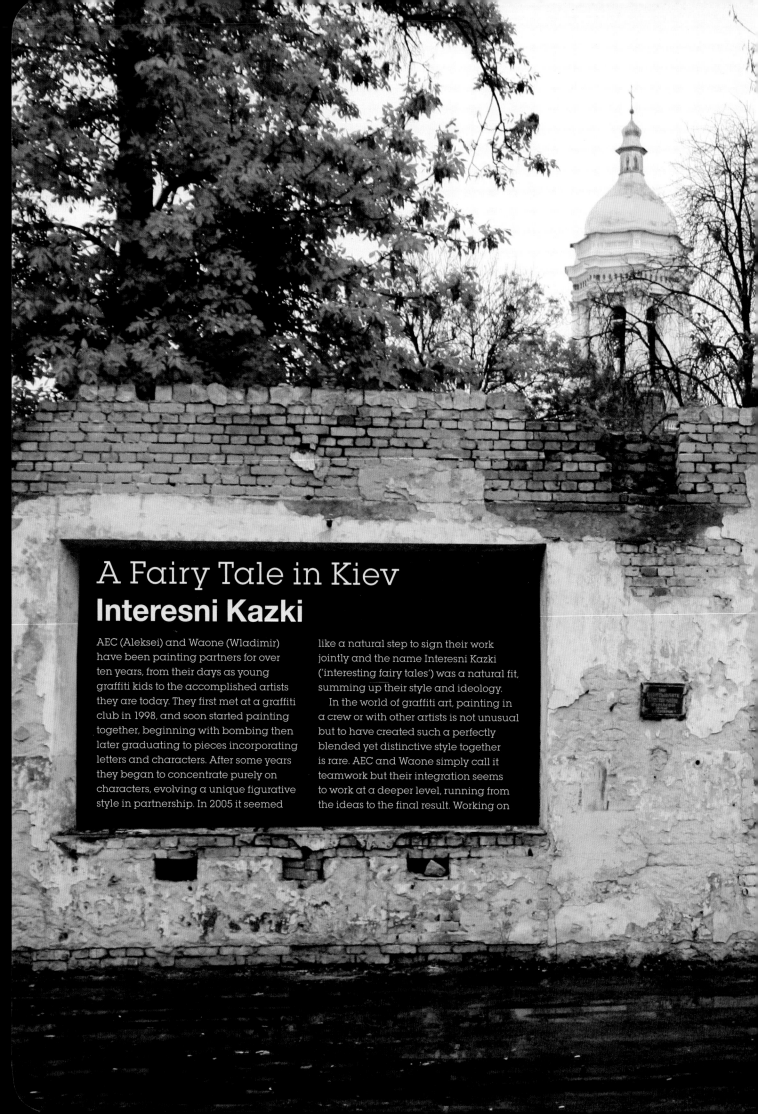

A Fairy Tale in Kiev
Interesni Kazki

AEC (Aleksei) and Waone (Wladimir) have been painting partners for over ten years, from their days as young graffiti kids to the accomplished artists they are today. They first met at a graffiti club in 1998, and soon started painting together, beginning with bombing then later graduating to pieces incorporating letters and characters. After some years they began to concentrate purely on characters, evolving a unique figurative style in partnership. In 2005 it seemed like a natural step to sign their work jointly and the name Interesni Kazki ('interesting fairy tales') was a natural fit, summing up their style and ideology.

In the world of graffiti art, painting in a crew or with other artists is not unusual but to have created such a perfectly blended yet distinctive style together is rare. AEC and Waone simply call it teamwork but their integration seems to work at a deeper level, running from the ideas to the final result. Working on

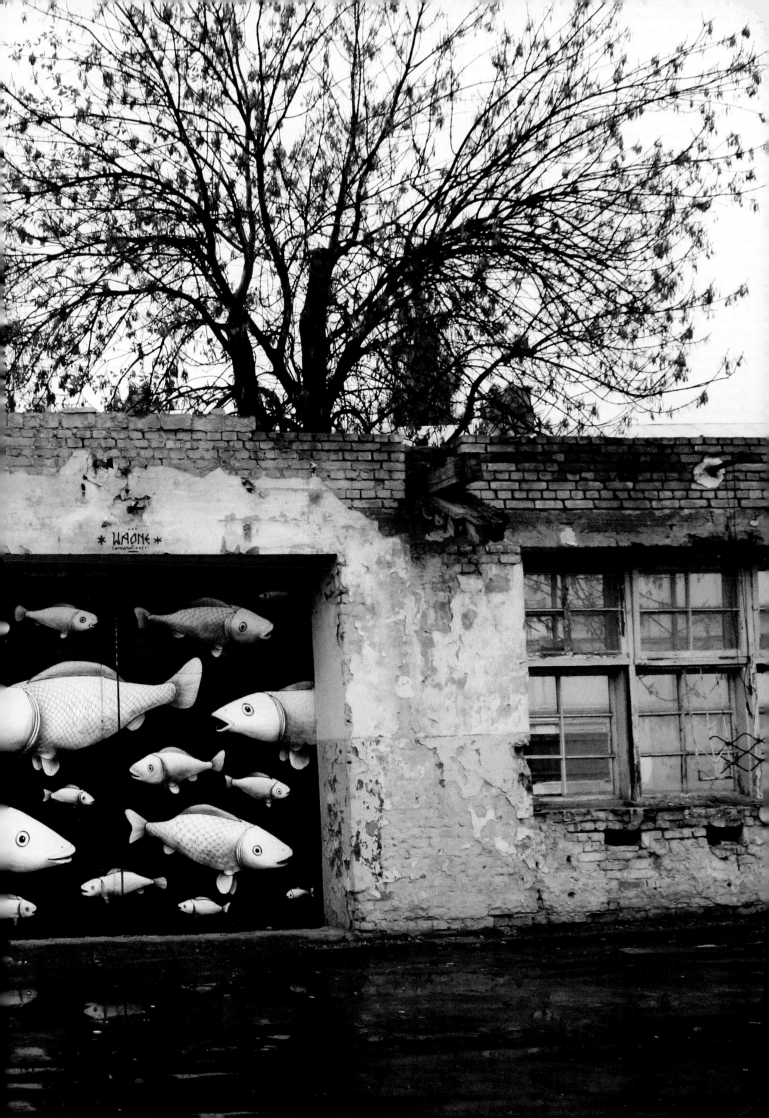

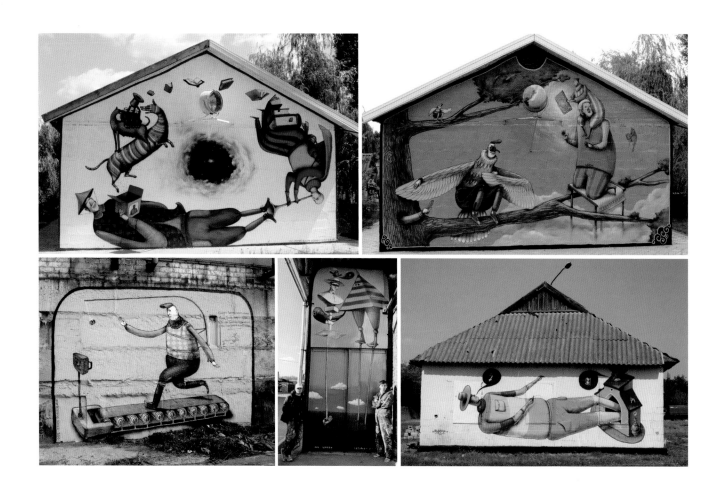

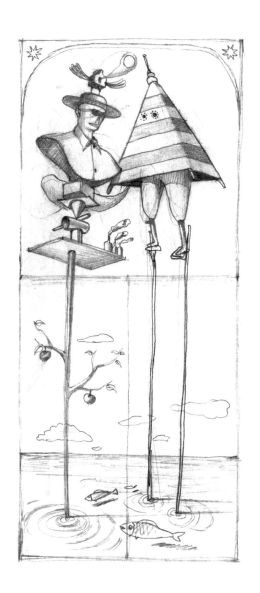

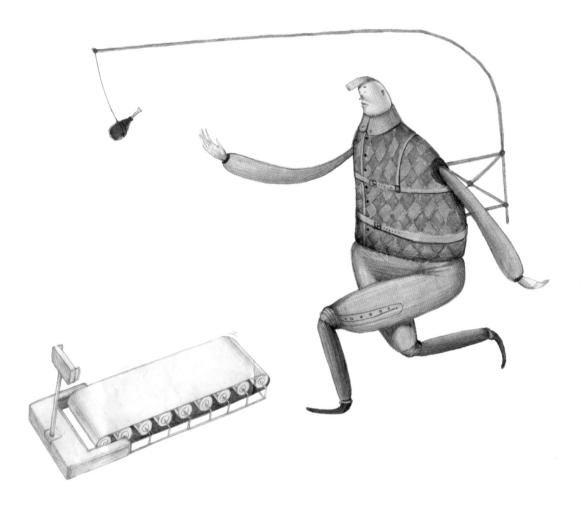

different parts of a piece, each partner complements and spurs on the other, adding to and changing the composition as they work. The results are a glimpse into their fairy-tale world, like episodes from an alternative universe to which only they possess the key.

From giant murals to smaller street paintings, viewers are transported to a different realm, and although the characters change – from strange machines to giant heads or flying fish – they all seem to fit into one colourful world. It's a place where anything can happen, but while it appears fanciful, to the artists it is also a mirror of the real world, illustrating eternal truths. They use fantasy to look at reality, to comment on people's lives, their desires, passions and problems. One example of this is a street painting by AEC, showing

a costumed man running on a treadmill. Ahead of him dangles something on a string, unobtainable – an image that everyone can relate to.

While their images operate on many levels, the world of Interesni Kazki has the timeless atmosphere of a children's storybook. This connection, they claim, is subconscious rather than conscious; for them childhood is 'a lost paradise' and their work reflects this. The connection between what we create as children and what we do as adults is something that many artists share. Recalling his own childhood, Waone says: 'As a kid I created whole worlds using plasticine models, made costumes for them, and props that fit with the historic era in which they lived. There were primitive Stone Age people, pharaohs of

ancient Egypt, knights from the Middle Ages, pirate ships and Cossack warriors as well as modern businessmen, soldiers and the Mafia. Now everything is different as a grown-up, but the same fascinations remain, an interest in people and their environment.'

Growing up in the Ukrainian capital Kiev has had its own particular influences on AEC and Waone's artistic outlook. Life there is full of contrasts, with extremes of luxury and poverty. The problem, they say, is that art and culture are not seen as important or profitable. The focus is on business rather than the arts, as can be seen in the city's industrial landscape. In Ukraine there is practically no street art, so the majority of their work is done at their own expense, although they have been lucky in finding some commissions for murals and interiors. But despite these difficulties, they count their blessings; what was once a hobby is now becoming a way to make a living.

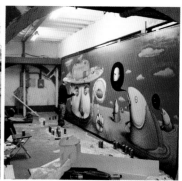

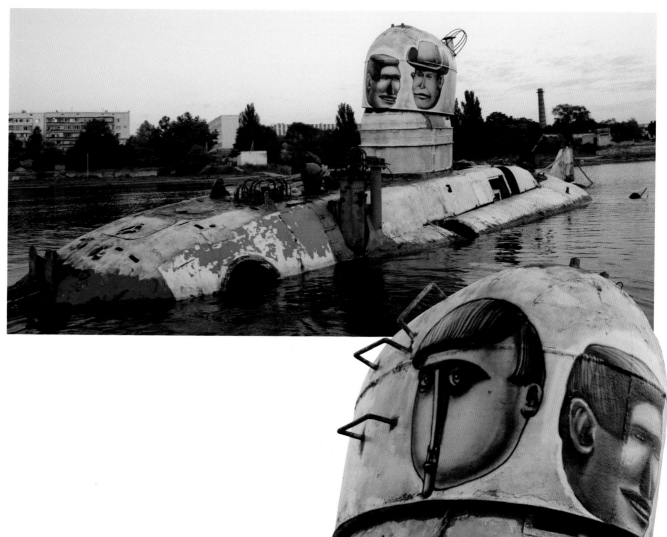

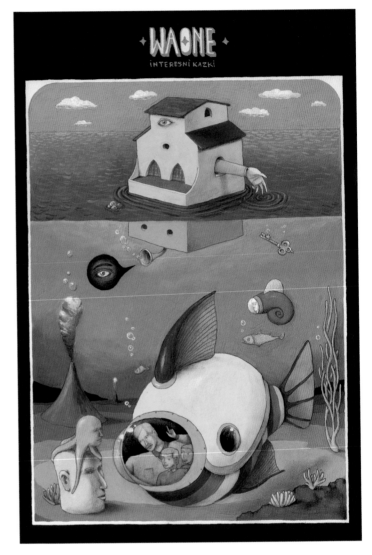

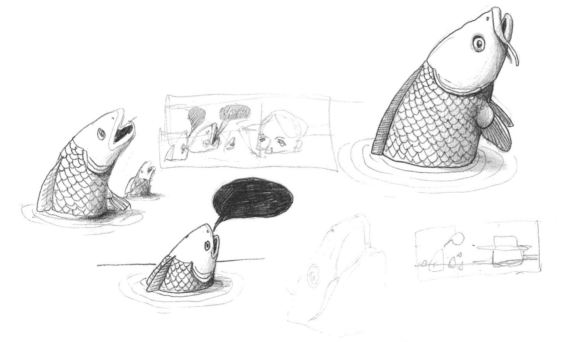

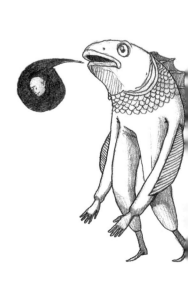

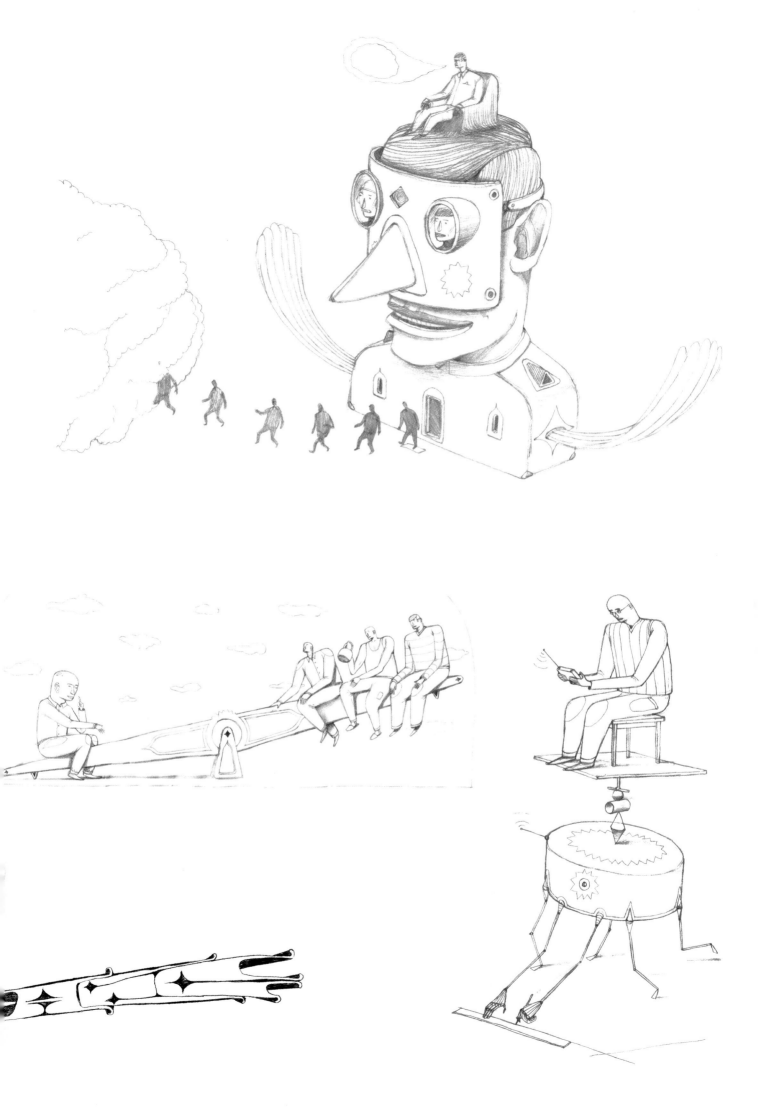

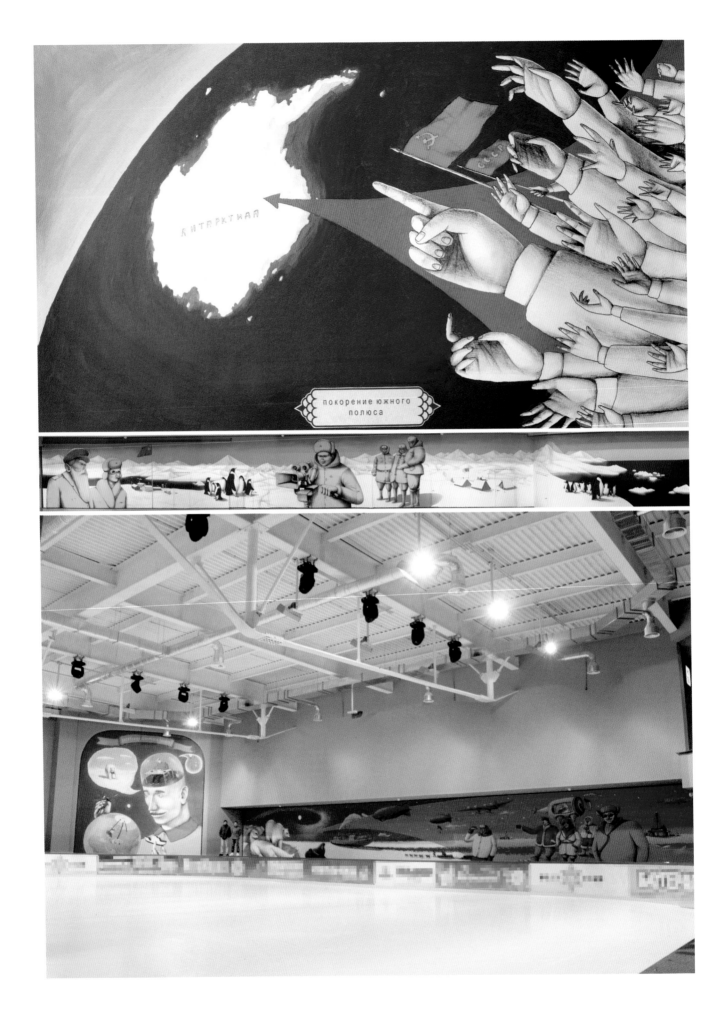

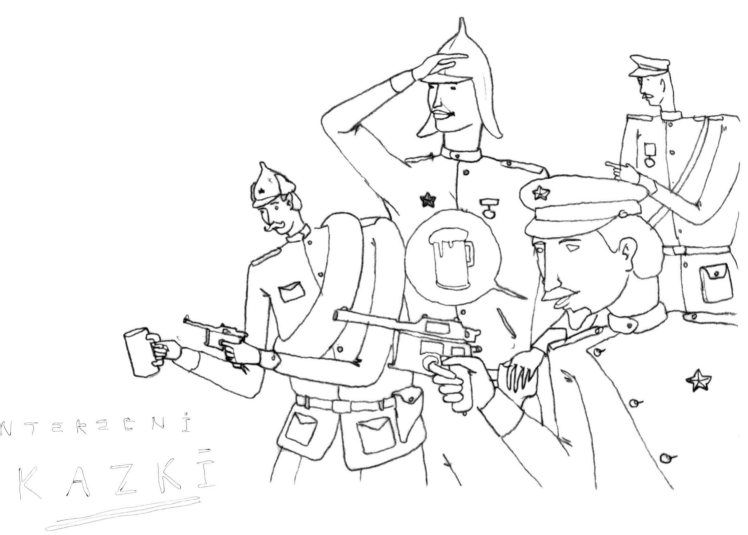

INTERACNI

KAZKI

Ukraine was formerly part of the Soviet Union but in 1991 it became an independent democracy. According to Waone, 'The modern independent Ukrainian nation is a nice combination of words, but no more than that. In fact, Ukraine depends on different outside factors, though it has great potential. The Soviet legacy has been tough for us, and the mindset of the Ukrainian people has changed. From being an independent and proud people, they became passive, interested in nothing but their daily needs. Other traits they inherited from the Soviets included idleness, profanity and addiction to alcohol.' Some of their work directly comments on this legacy, depicting the deceitful and insidious

nature of the Soviet Communist party and the damaging consequences for Ukraine. For Waone and AEC this heritage is extremely negative, but they also see it as an opportunity to learn lessons from the past.

They are nonetheless proud of their cultural heritage and their graffiti roots. While they still paint graffiti letters sometimes for fun, letterstyle alone isn't able to convey their ideas, so most of what they paint is what they term 'art graffiti' or mural painting. At the heart of AEC and Waone's work are their beautifully strange and stylized characters. However, style itself is not as important to them as what the figures convey. Style for them is simply the

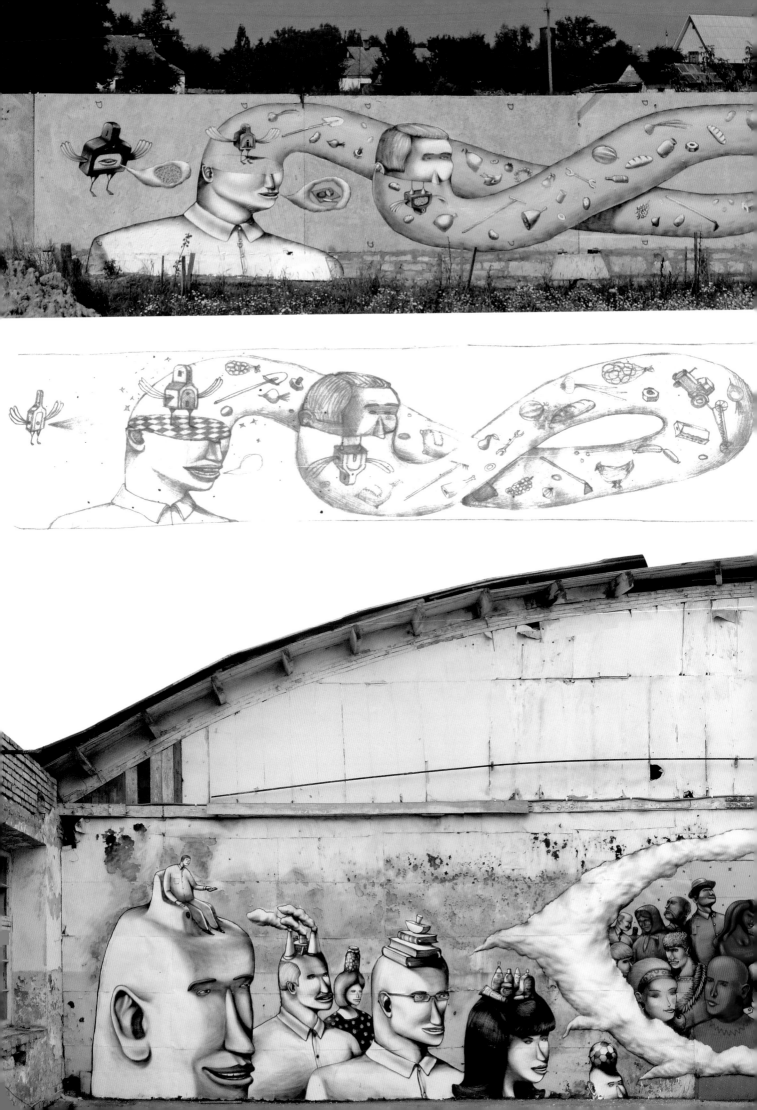

natural process of turning their ideas into images. Waone describes it as a wish to 'paint something in a fairy-tale way – reflecting the national spirit and culture of our people'.

In part their style was also influenced by the act of painting outdoors and became more refined after they began to produce a greater number of interior murals. One striking commission was a set of murals for an ice rink, depicting the capture of the North Pole by the Soviet Union in the first half of the 20th century. Many people saw parallels between this historical event and contemporary Russia's desire to expand its northern border in order to access the valuable hydrocarbon resources of the Arctic.

While they continue to paint interior spaces, abandoned factory buildings and crumbling walls still provide an important stage to frame their images and bring their fairy tales to life.

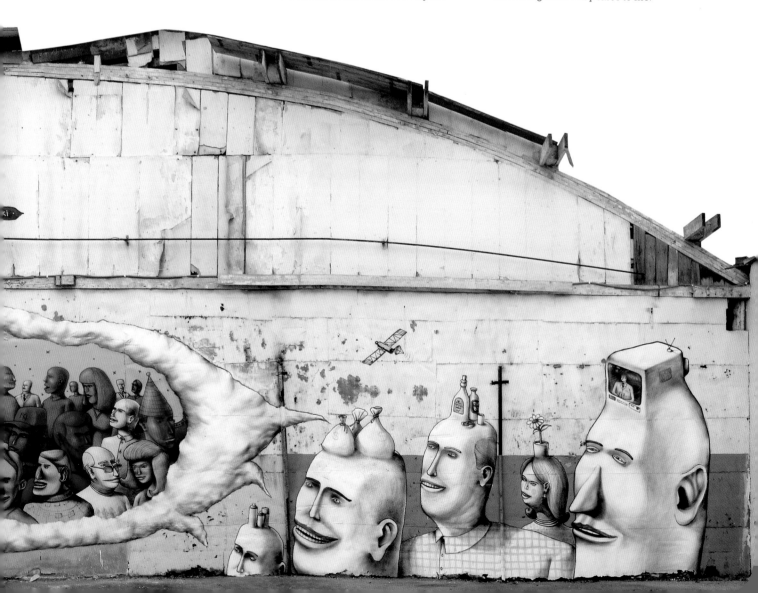

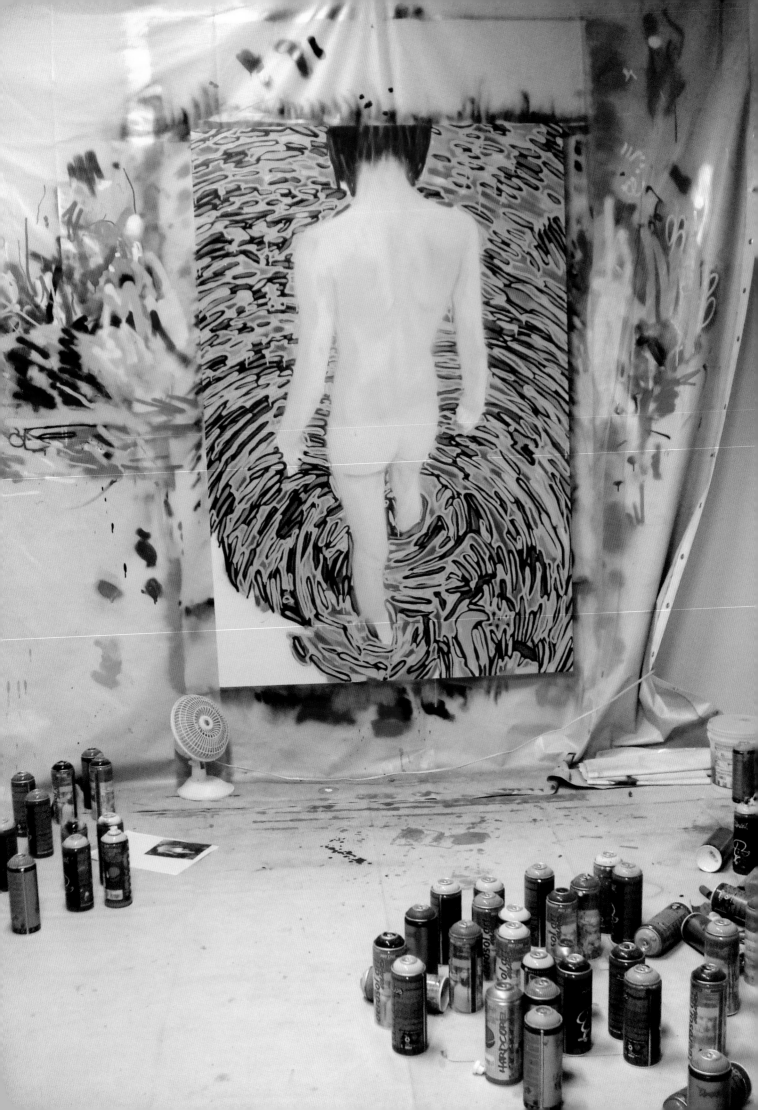

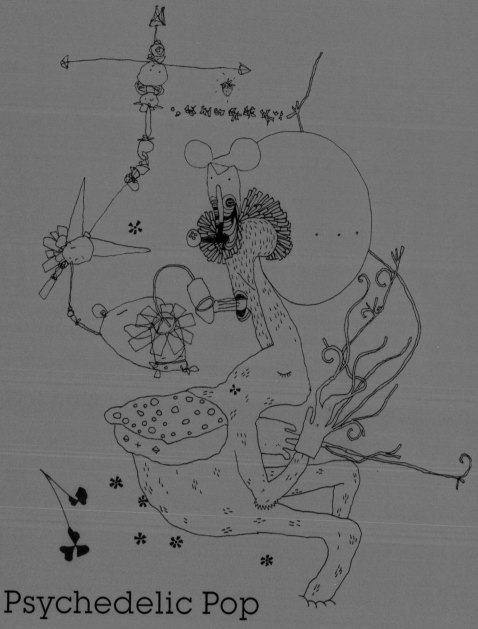

Psychedelic Pop
Ramon Martins

Ramon Martins is an innovative Brazilian painter, whose work is equally at home in the street as it is in galleries. Like a psychedelic magpie he uses an eclectic mix of styles and subject matter, such as cartoons, figurative art, comics, Pop art, Japanese culture, fantasy and abstract art, and a variety of media, from spray-paint, acrylic paint and watercolour to found objects – sometimes combining all these elements in one image. His chosen methods fuse together to produce expressive and vibrant images that are a celebration of line and colour. He says: 'I mix my references and overturn cultural values as if they were all the same.'

Ramon was brought up by his grandmother in the state of Minas Gerais, north-east of São Paulo, and describes this period as 'a golden age in a loving environment, and close to nature'. His grandmother took him to various churches and religious parades, and these memories have stayed with him. Spiritual references often appear in his work, although they are 'independent of religion'. He says of his childhood: 'Most of the time I was having fun in the streets, taking whatever life offered and exploring. Alternative movements such as skateboarding, rock and graffiti were more appealing than studying Portuguese, mathematics and science.'

He obtained a visual arts degree but describes the period after university – when he was working as an art teacher

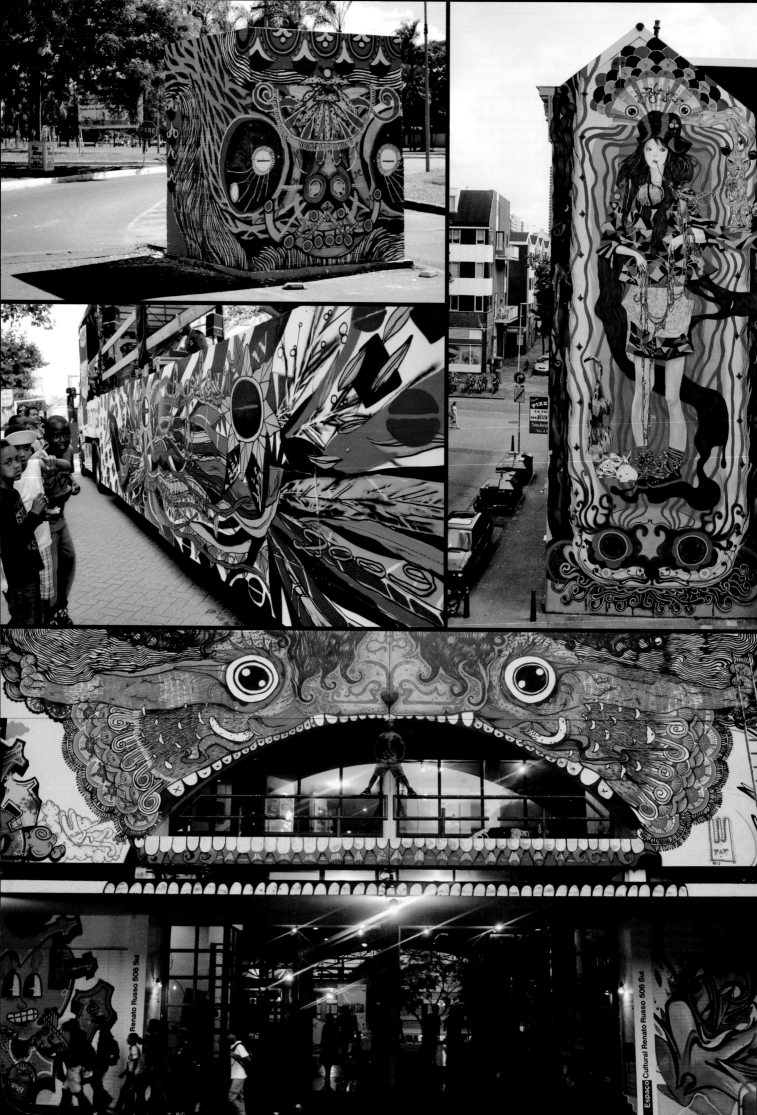

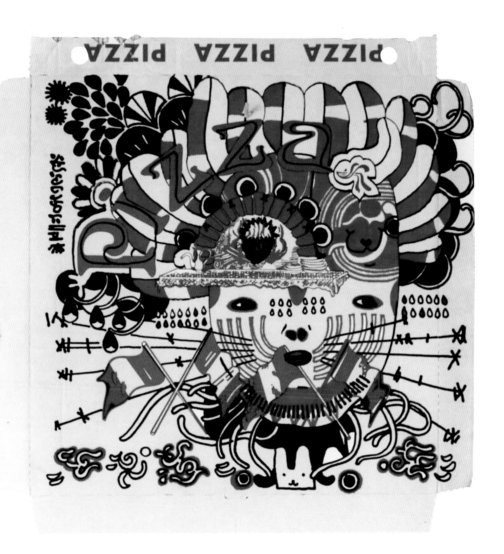

and deciding what to do with his life – as 'a time of great tension'. He quit his job and threw himself into his art. 'At that time,' he explains, 'I was going through a phase of doing my work on abandoned buildings and demolition sites. I was creating my own independent exhibitions in these spaces, and the publicity had to be done very quickly because the work never lasted long.' He was keen to make contacts and be proactive in his artistic career: 'Being an artist is not just about having good artwork and thinking that you will have the world at your feet; you must be tuned into sharing experiences, and exploring your own needs. You have to be open to possibilities as they arise.' He travelled

to São Paulo and Rio de Janeiro to make art and contacts, but it was at home in Minas Gerais that he received his first 'big break'. He was invited to exhibit at the Leo Bahia Gallery, which introduced his work to collectors for the first time.

Since then, Ramon's career has gone from strength to strength, and his work has been exhibited in galleries, art fairs and museums throughout Brazil, the USA and Europe. Yet he still remains passionate and loyal to the streets, where he continues to work prolifically. The camaraderie among artists is very important to Ramon and to his work ethos, along with the sharing of ideas, motivations and even techniques. For example, he found that he could

produce a sharper line by inserting a syringe into the nozzle of a spraycan, and he shared this discovery with other artists. As he explains, 'I'm not precious and don't view my work as untouchable. Part of my artistic attitude is linked to ideas of collectivism, ownership, interaction and misdemeanours. These principles are very strong in the culture of street art, where artistic friendship is important and where I feel I primarily belong. I want to remain a part of this cultural exchange, where I can get a more direct return. So you could say that my art is an excuse to make friends.'

Ramon's method of working is reflected in his style. 'I have a very explosive way of working,' he says. 'I like space, with people talking, loud music, food, disorder, sometimes working on

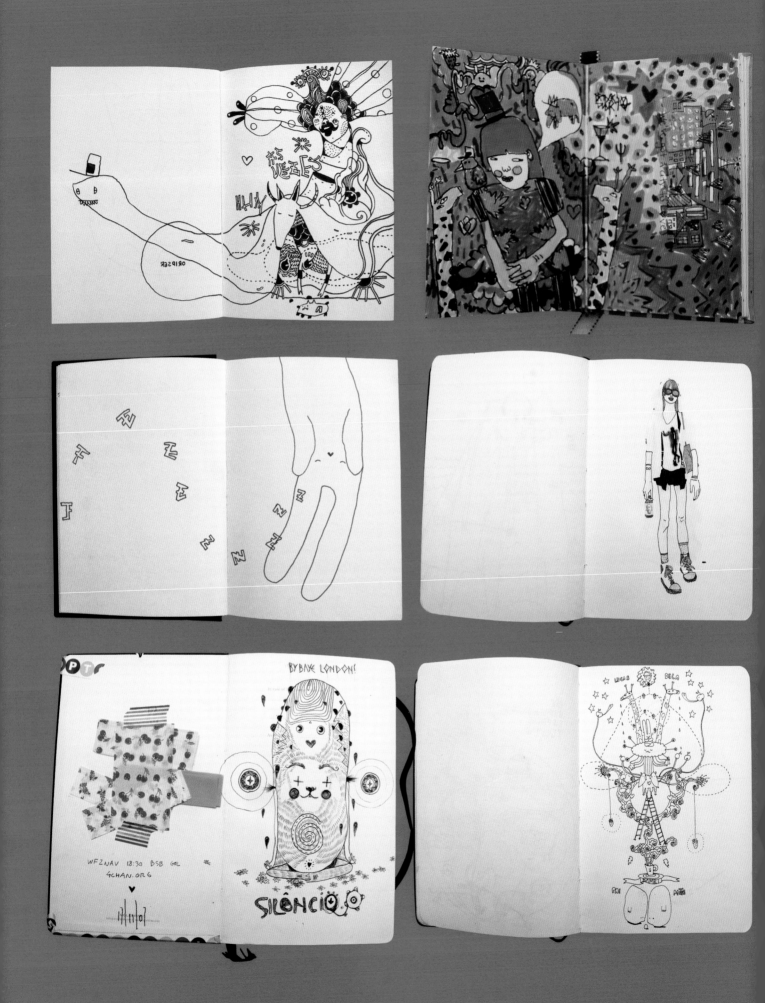

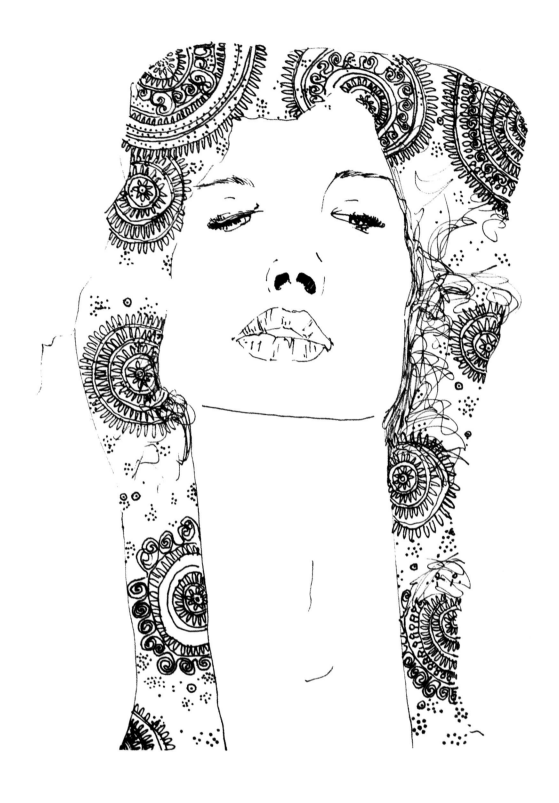

several paintings at the same time.
I don't follow a linear method of
production; I respect outages and
intervals as the work demands. I love
the creative process, the trials and
challenges that each job presents. I like
to try new things and to find creative
solutions. Usually I do not rest until I have
finished whatever I am producing.
I finish one work by creating a new one.

The process is like breathing. Endless. I
love it when I realize that I am immersed
in the creative process, working silently
and fluidly, as if I have entered a trance
and passed into another reality, with one
foot here and the other foot there.'

Ramon draws on his surroundings,
and has been particularly influenced by
his travels around his home country: 'The
fish only knows what water is when it is

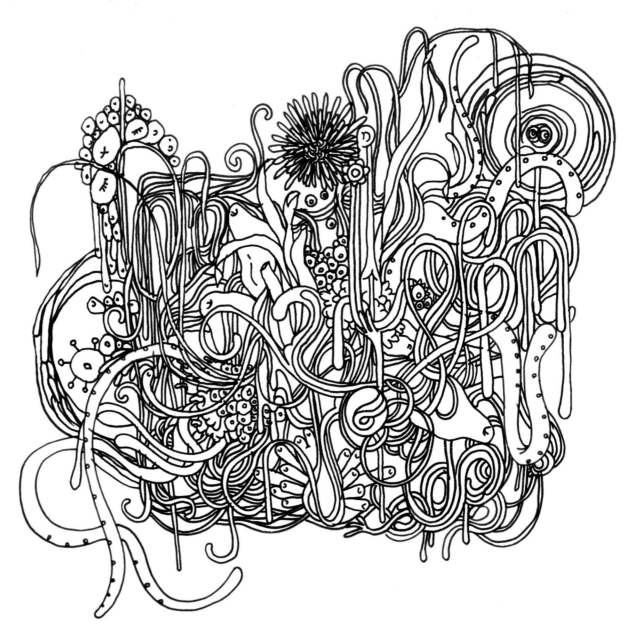

out of the water. In order to understand your own culture, you have to take a step back from it. Brazil is culturally a very rich country; wherever you go, you can't fail to notice its unique characteristics and diversity. When I arrive in a new city, I want to experience the daily lives of its inhabitants. I drink it in, take ownership and appropriate it. I like to create a sense of displacement.' His artistic

role models include Gustav Klimt and Egon Schiele. 'I admire artists who push the boundaries of society and refuse to be slaves to artistic convention,' he explains.

'My influences are linked to how we adapt to situations, how we respond to them. We all have our own energy, and it comes out in our actions. Thought should be a tool we use and not something that

126

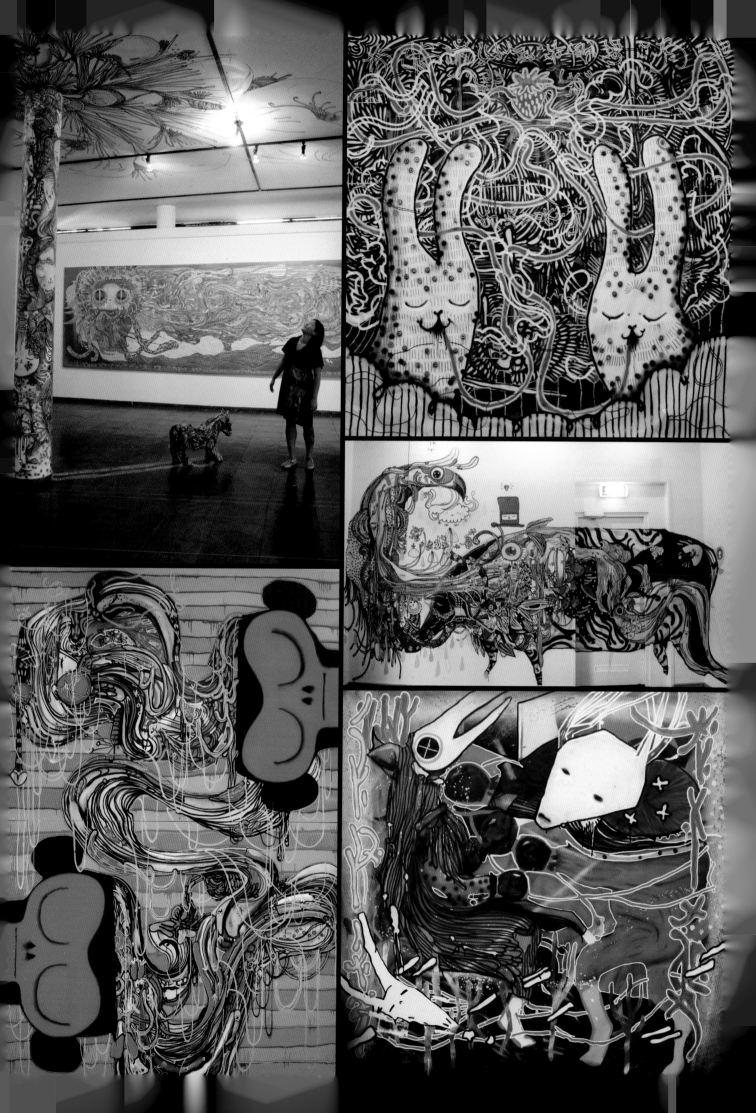

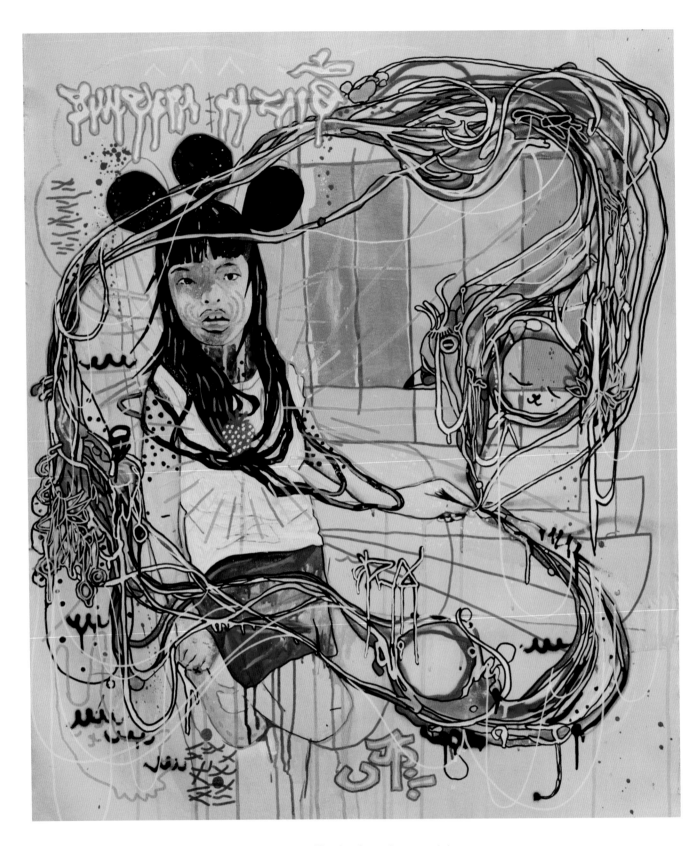

controls us; we must know how to silence our thoughts so that our energy can flow better. Everyone can draw a line, not just the simple line you use to write a letter, but a line that is an extension of the body, a line that has its own characteristics and that every individual can use to express himself. Look at how nature creates organic shapes and patterns, and the infinite colours we witness over

the course of the day. Learn to appreciate the spontaneous beauty that we all have at our fingertips. The connection with nature is what keeps us sensitive to our world.'

Ramon recently returned to São Paulo to immerse himself in the vibrant chaos of this huge city and follow his instinct to create, which is fuelled by 'something alive in me, more alive than I am'.

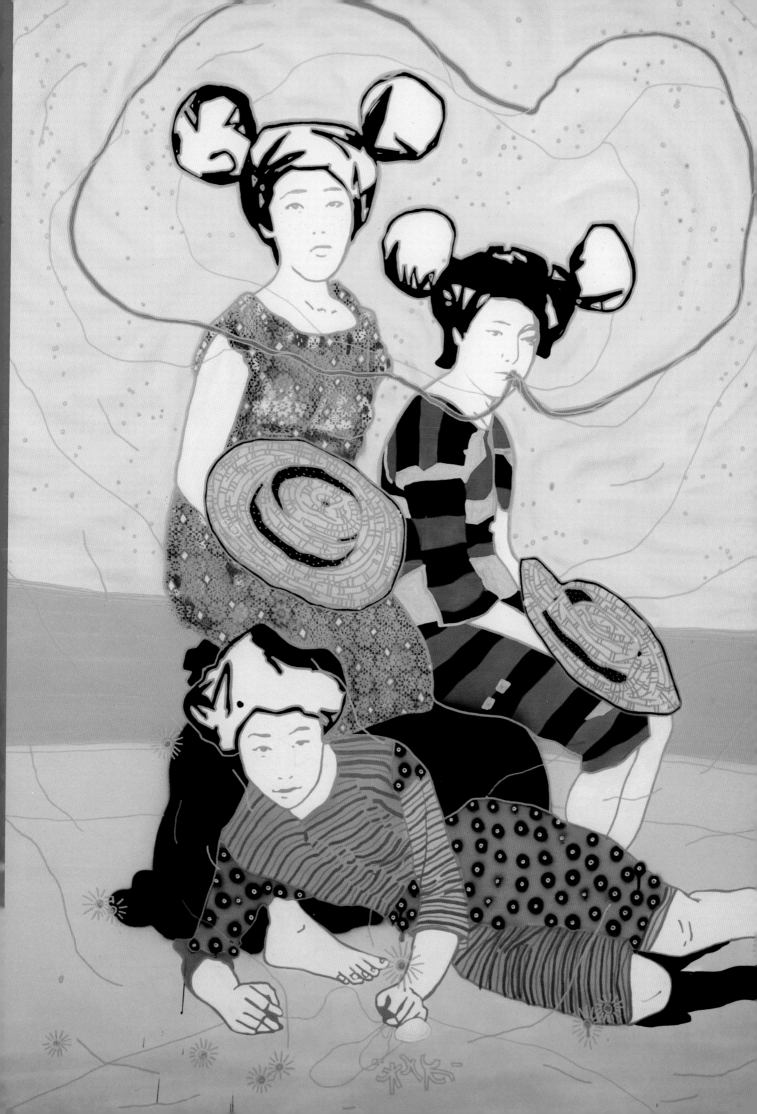

Between Ghosts and Masks
Neuzz

Neuzz is an artist and illustrator based in Mexico City. His work, often painted in forgotten and abandoned areas, draws on the darker side of traditional Mexican imagery and is infused with his own personal history and experience.

At the age of five, Neuzz had to leave his neighbourhood in the north of Mexico City after it was hit by an earthquake. He and his family moved in with his grandfather, who introduced the young Neuzz to the work of the renowned Mexican engraver José Guadalupe Posada and the painter Rufino Tamayo. He also regaled him with tales of his own very traditional childhood in Oaxaca, where he grew up in a jacal (thatched wattle-and-daub hut). His grandfather told him stories of mystical creatures, witches and *nahuales* (guardian animal spirits) that wandered the streets howling and preying on the people who lived there. Neuzz recalls: 'We never knew where reality ended and fantasy began...

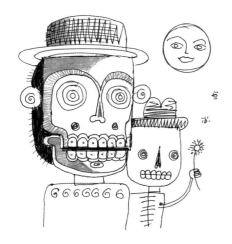

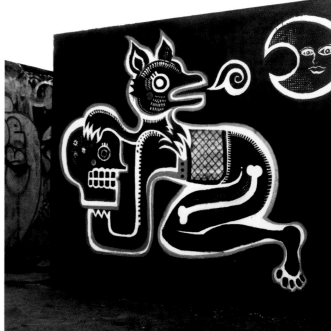

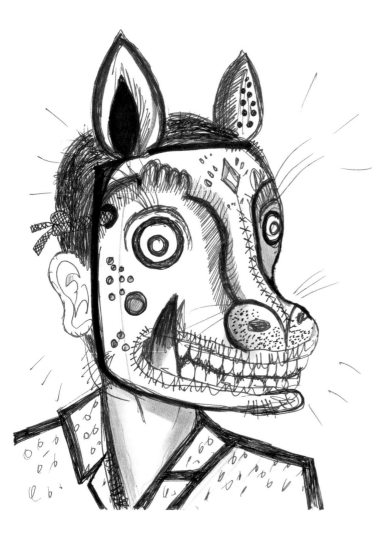

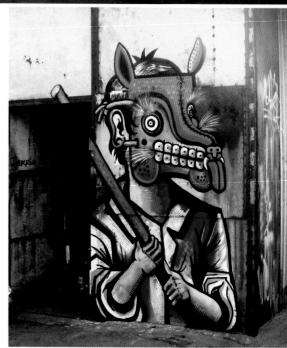

These stories sparked my imagination and led me to think about the world beyond our everyday lives.'

Despite a degree in graphic design, Neuzz is largely self-taught as a visual artist. He was fascinated by the work that sprang up overnight in the streets of his neighbourhood, and was seventeen when he first tried it for himself. Initially he painted tags and quick drawings, describing the process as 'something visceral and organic, with little thought'. He then began to meet other writers and crews and they shared skate videos, b-movies, music and magazines, as well as their styles and experiences. They congregated in a multicultural area known as Tianguis del Chopo in downtown Mexico City, where the city's punks, skaters, music lovers and graffiti writers would hang out.

Some time later Neuzz was introduced to graffiti on an international level, which had a profound impact on him. A friend gave him a copy of the French magazine *At Down*, which he found so inspiring that he still has the original magazine. It featured work by Daim, Stak, ESPO, Loomit, La Mano, Sixe, Toad and Space Invader among others and, he says, 'made me realize that graffiti is a global term. Through this magazine I got to

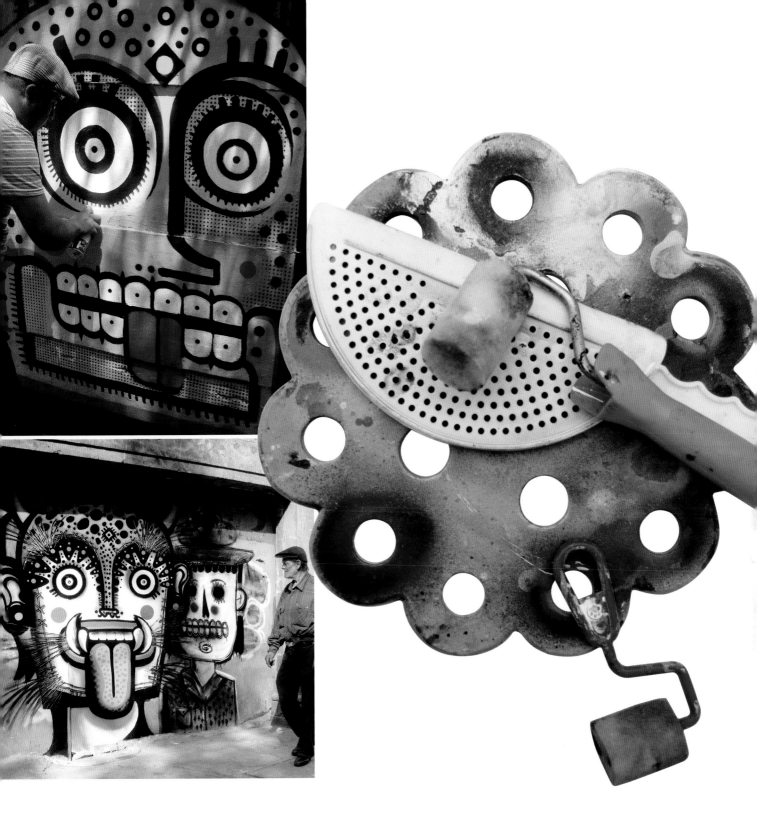

know the work of Os Gemeos, which has since become the strongest graffiti influence on me. Seeing their work made me completely reconfigure my own, and my visual perception of cities.' During his research into the worldwide scene, he discovered the website ekosystem.org, which showed him 'forms of street art that completely broke the mould of the conventional graffiti that I knew... It introduced me to the work

of Banksy, Miss Van and Flying Fortress, among others.'

Although Neuzz uses strong elements of traditional imagery and symbolism in his work, he is careful to point out that it would be wrong to simply apply the blanket term 'Mexican' to it: 'Mexico is a huge, multicultural country, and the cultures of each region vary considerably through the different ethnic groups. Therefore it seems impossible to speak

of a single Mexican identity, nor can it be summarized in a few concepts or icons.'

Traditional masks are a key feature of Neuzz's work. Initially it was their aesthetic appeal that attracted him, but he soon began to use them as a valuable communication tool. 'When I looked into masks in more detail,' he explains, 'I realized that there is much more to them than mere aesthetics and visual expression. Some people think of

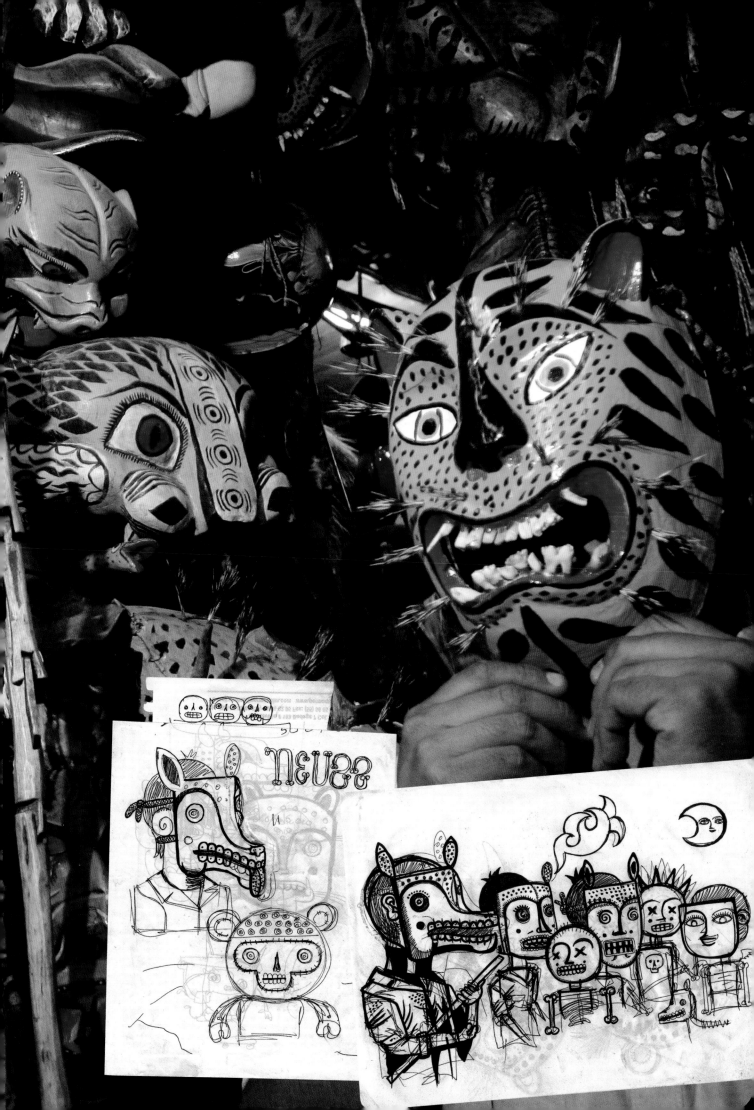

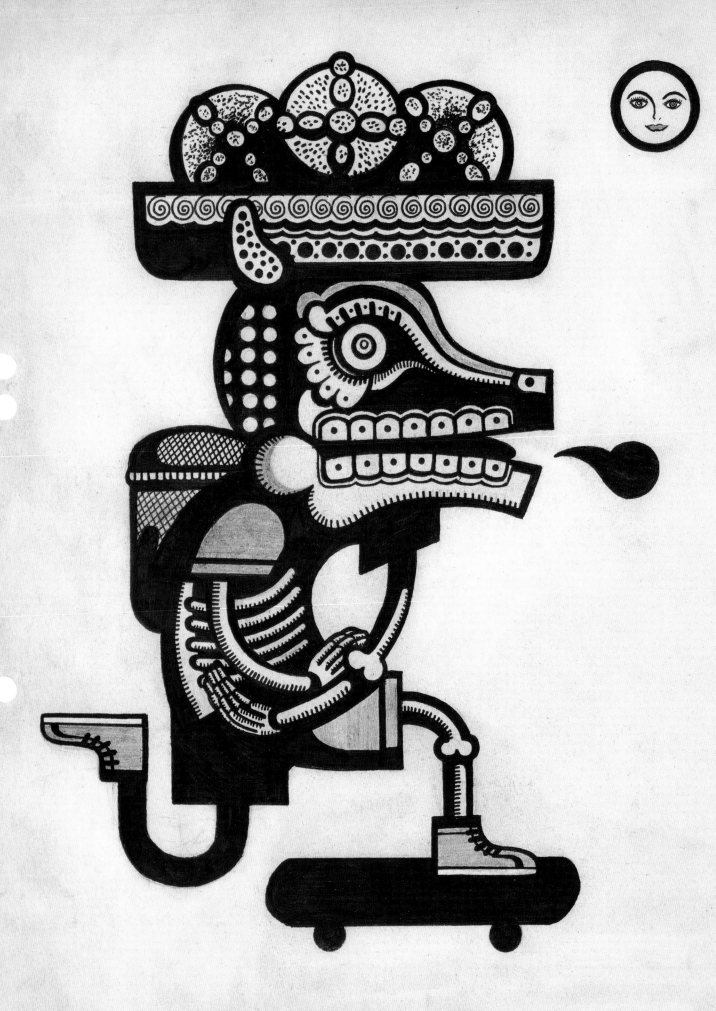

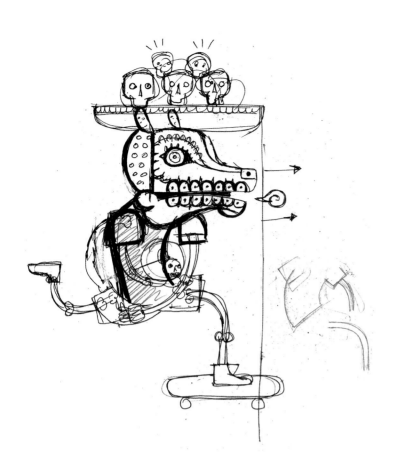

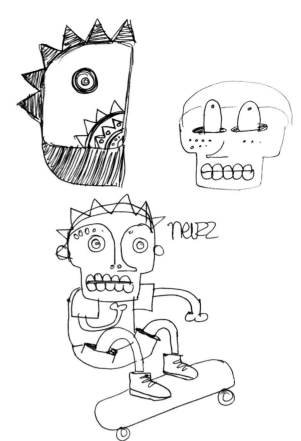

a mask simply as a decorative object whose function is to conceal the face, but Mexicans take the concept much further. Mexican masks are instruments of spiritual interaction and communication between the human-animal and the forces of nature as well as the world of magic.'

Neuzz's interpretations are always deeply personal. He selects 'ethnic cultural elements that are representative of regions of Mexico – those elements that I've come into contact with, and am attracted by... Many of my paintings are representations through which I try to maintain an emotional bond with people who have died – to thank people for all that we shared during the time we had together.' Sketches often form the basis of his ideas, which are transformed into vibrant compositions on the wall using spraypaint and stencils of various geometric shapes.

It can take Neuzz a long time to find the perfect spot for his paintings. He seeks out 'spaces where something is needed, where my paintings can evolve and become part of the environment

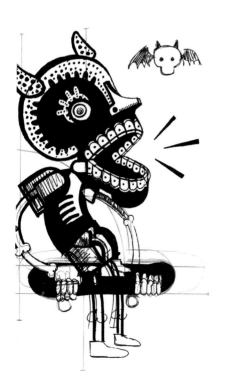

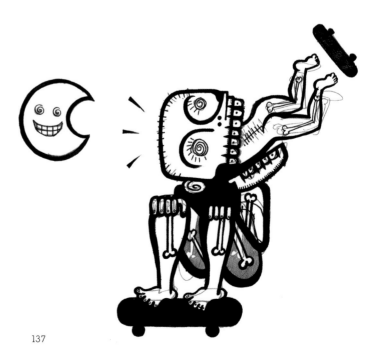

without invading it. I like to work mainly in run-down or derelict areas. I like textured surfaces. I try to preserve as much of the original texture of the walls as possible, so I don't usually do backgrounds. I use the very essence of the wall as an adjunct to my paintings.' The entire city never ceases to amaze Neuzz, and its rich fabric is an endless source of inspiration: 'The layers that make up this city – layer upon layer – bear testament to all the cities that this city has been, from the pre-Hispanic to the contemporary.'

Neuzz's unique contemporary slant on the traditional makes his vibrant paintings and drawings instantly recognizable. They radiate life and energy. There is a deeply spiritual and personal bond between the artist and his painting, the motifs influenced by his childhood and the figures inspired by people who have touched his life. He considers his work 'a gift to the city and its people', and strives to 'produce something constructive in public spaces and use graffiti as a positive means, not a visual assault'.

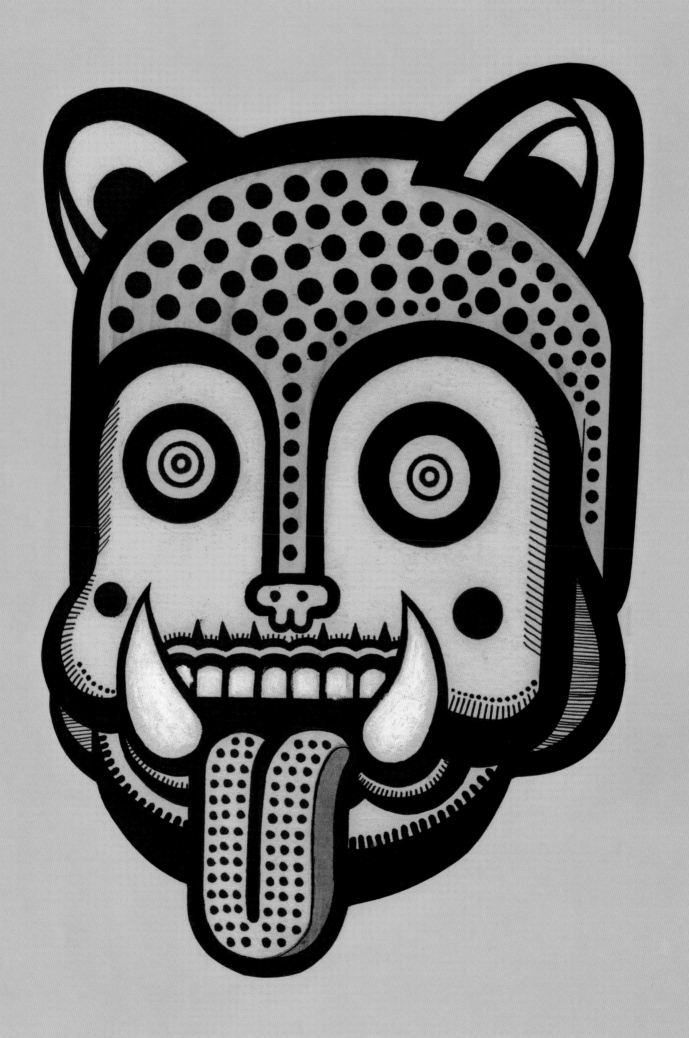

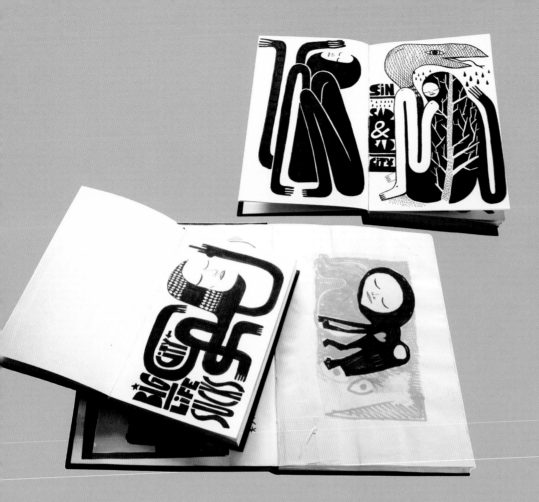

Concrete Zoo
Otecki

Otecki is a young Polish artist based in Wroclaw, whose work, although rooted in graffiti, has a folk art flavour. As a child he dreamt of becoming a comic-book artist, but graffiti also held a fascination for him. The 1990s were a golden age of graffiti in his city as local artists experimented with new and fresh styles, in great contrast to everyday life in post-Communist Poland, which seemed grey and colourless in comparison.

Although Otecki grew up painting graffiti and creating comic strips, his artistic journey really began later, in high school, when he decided to become a fine artist. Initially he painted in a realist manner, but at university he started to simplify and synthesize the form. He also found inspiration in Cubism and primitive and tribal art. 'I have always admired Picasso,' he says, 'and my journey was a bit similar to his – not so spectacular, of course, but he remains a very important artist for me. He started as a classical painter and then invented deformation; his art is a bit like graffiti – good graffiti that involves

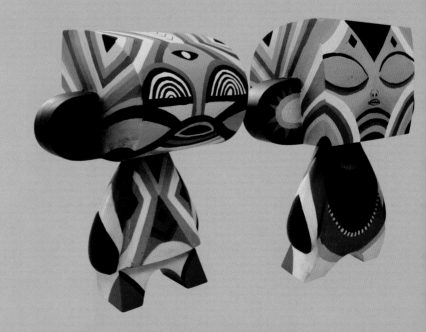

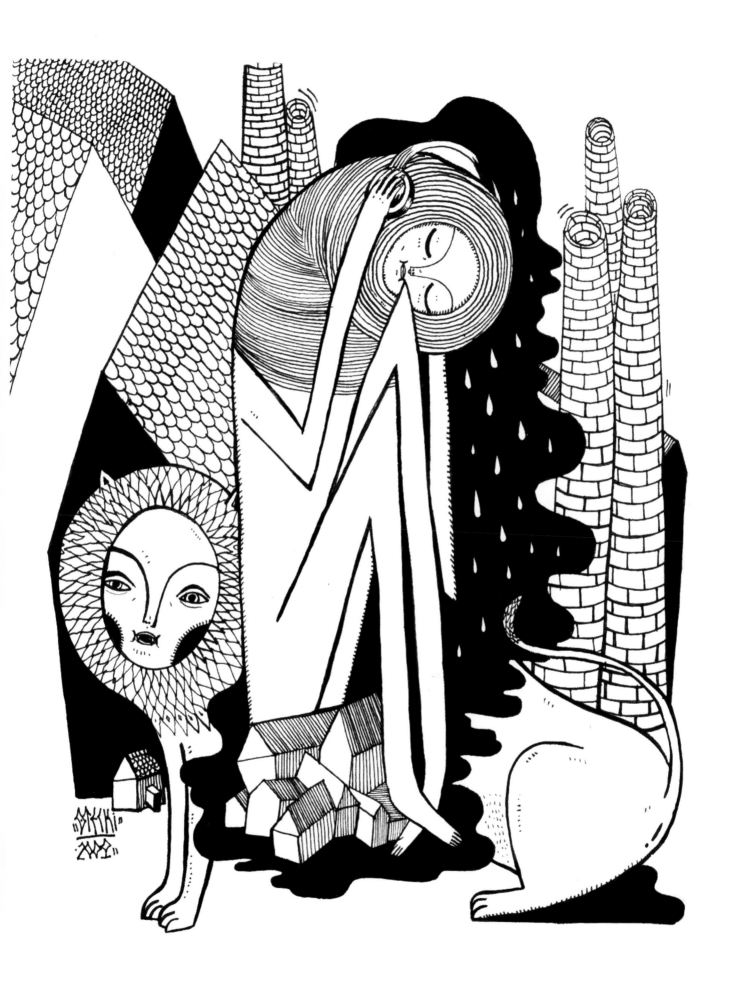

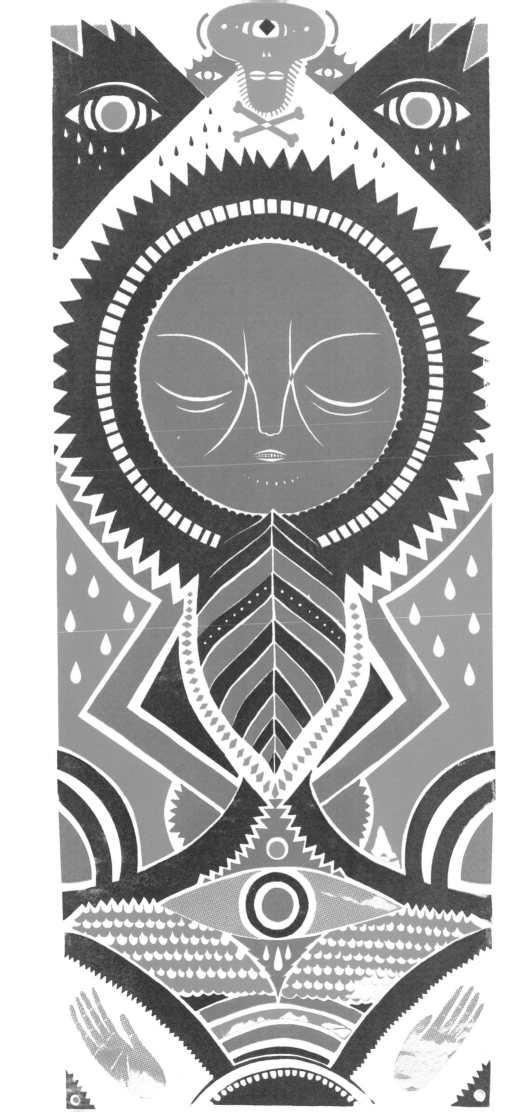

deforming simple letters. *Guernica* is one
of my favourite paintings. I believe that
if spraypaint had been invented in
Picasso's time, he would have used it.'

Otecki's art now treads a line between
graffiti, street art and illustration using
many different media such as murals,
sculpture and painting. While studying
fine art, he took a break from graffiti to
work primarily on canvas and graphic
prints; when he went back to using
spraypaint on walls, he found that he
approached it in a completely different
way. His formal training also gave him
knowledge of techniques such as
woodcut printing, which he now uses in
his street art posters and print editions.

Otecki's works draw on many
elements of Polish culture and artistic
traditions, from kitsch design to folk art,
and crafts such as paper cutting and
woodcraft. In search of inspiration he
often visits antique fairs to look for
old toys, wooden figures and masks,
sometimes to collect or photograph
as references. He also enjoys visiting
ethnographic museums to research and
study artefacts. The Poles are a Slavic
people, and he feels there is a true Slavic
spirit to his work. 'My real name is Slavic.
It means something like "he who relishes

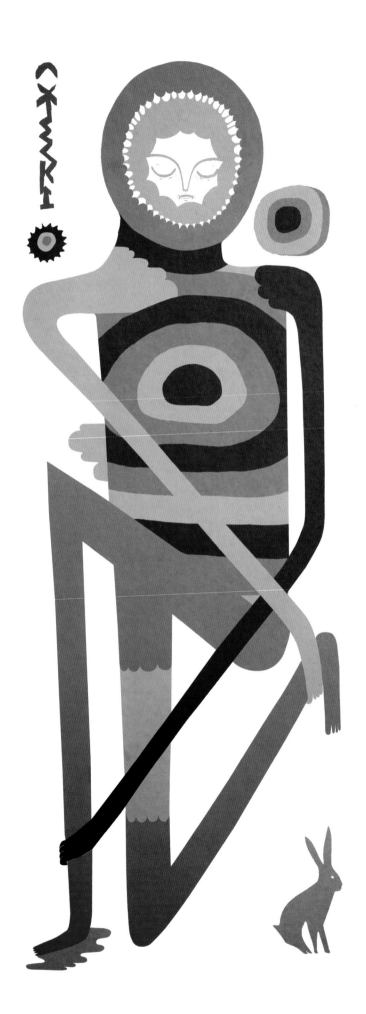

a struggle" or "he who enjoys being a warrior". My images are generally inspired by Slavic folk art. I have found my roots in Slavic culture, so I believe that what I do also has a Slavic spirit – chaotic and full of imagination.' While he is attracted to the decorative elements of Polish folk art, he likes the way it is used to illustrate and tell stories, and tries to do the same in his own work.

Nature is also a great source of inspiration, with its variety of shapes, symmetry and colours. One of Otecki's favourite media is wood, and in a recent project he created various painted wooden masks which he attached to trees around the city. 'The idea is to use the growing process as part of my work,' he explains. 'I attach my small sculptures to trees and wait for the bark to reclaim them, growing over the faces until they almost disappear. It's a very long process and I'm still waiting for the final results. Wood is a very inspiring medium. I like the way that the appearance of wood changes over time through a beautiful process of destruction. As a kid I imagined fantastical creatures living in the forests. I was afraid of them. Now this idea also inspires me.'

Imaginary creatures, animals, nature, the city and the mysteries of life are just some of the recurring themes in his imagery. His characters are often

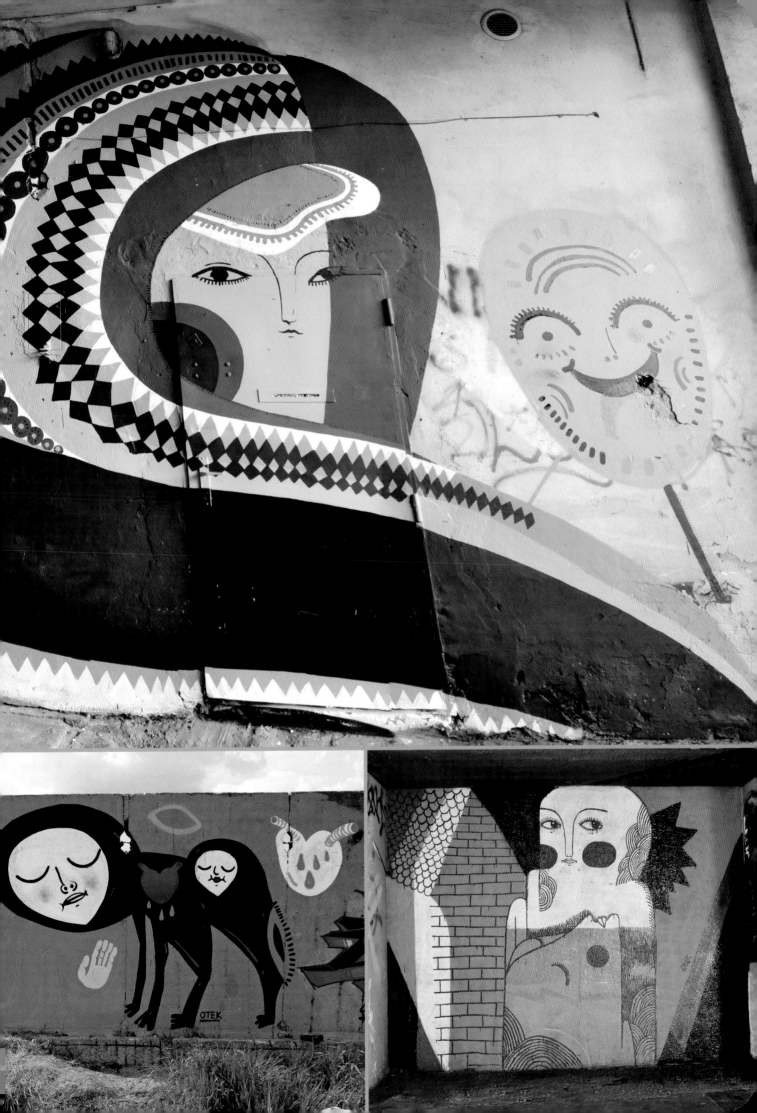

depicted with their eyes closed, as he explains: 'I like the gesture of silent contemplation. Sometimes when we close our eyes we look like we are suffering, but inside we are experiencing spiritual joy. I think that my figures raise more questions than they answer. They stand in stark contrast to urban life, which is very loud and fast. I want my work to be decorative and give people some pleasure and space for contemplation. I sometimes show that people have a dual nature, like half-man, half-animal, and we shouldn't be afraid of this beast. We should respect it and learn to live in harmony. I'm a Gemini and maybe this is why I find myself dualistic.'

Working on the street is an adventure for Otecki, an escape from his studio and an opportunity to work with other artists. As he puts it, 'To create art outside is a great way to meet people and open up a dialogue with them. It shows the beauty of human nature and is also great fun. Sometimes I detect spiritual vibes between people when they paint together. But the graffiti is also important. When I look at halls of fame, I see individual pieces but I also view them as one big piece. My concept of street art revolves around its local character, creating something specific to my culture and my city, so I'm not interested in global trends. I have found my roots and I'm now intent on exploring them.'

South Central Tour
Ripo

Ripo was raised in New York City but now lives in Barcelona. It was through comic books that he was first inspired to draw, and his creative parents encouraged him to pursue this interest. Growing up in a city that was the birthplace of modern graffiti, it was perhaps only natural that he should have started to take an interest in this art form; he was thirteen years old, and little did he know that this initial spark would eventually lead him on some fantastic journeys.

Moving to Barcelona in 2006 proved to be the catalyst. He soon settled into the local graffiti art scene and made friends with like-minded artists. Among them was Above, a fellow American who had just finished a street art tour of European cities. In June 2006 these two artists set out together on a twenty-four-country trip, relying on the hospitality and knowledge of a network of local graffiti and street artists.

The trip lasted over four months, taking them from Amsterdam to Vienna, and from Tallinn to Bucharest. They absorbed elements of each unique atmosphere, heritage and local culture and applied these to their work on the street. Although they never stayed in one place for long, they experienced everyday life in the cities they visited. It was also a time for sharing ideas and techniques with others and discovering different outlooks, like a Jack Kerouac-style road trip and

CARNICERIA TAMAU...
SERVIC...

Claro que Yes!

MERCADO DE LAS PUL...

SEBA
ARAÑA
MUEBLES ANT...
OBJETOS

SPEZIALITÄT
IN
Erdäpfelbro...

Compra Venta de Antiguedades

TRASTO'S

4899-2432

Alquileres Consignaciones

CEL 1555952213? PUESTO 95

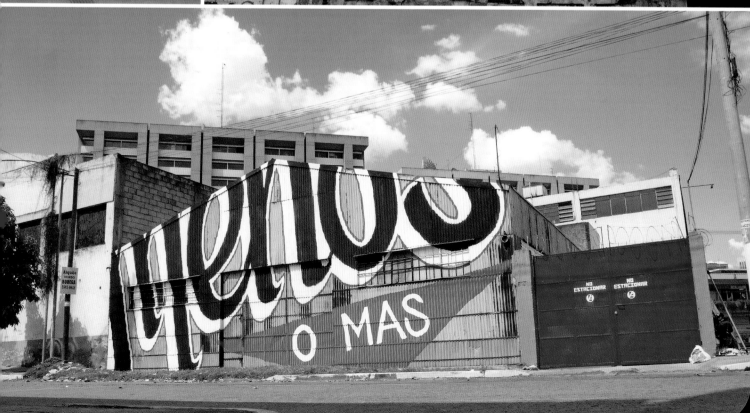

MAY 6TH 2009
trial REVERSE DRUGS ALZHEIM ERS

MAY 7TH 2009
Bustle RETURNS TO MEXICAN STREETS

Sikh POLICE OFFICERS REQUESTING BULLET PROOF TURBANS MAY 8th 2009

Pakistan FIGHTING SURVIVAL MAY 9 2009

PAKISTAN Then Changes Mind May 10th 2009

MAY 11th 2009
US SOLDIER KILLS COMRADES IN IRAQ

HUGE BOLIVIAN glacier DISAPPEARS

LA POLICEMAN KICKS MAN IN HEAD MAY 13th 2009

Human NOSES Too Old 4 Bird Flu May 14th 2009

MAY 15TH 2009
Australia HALTS Cull of Kangaroos

At home in Barcelona Ripo returned to working on a smaller scale, creating street installations with paintings on found mirrors – something he had originally experimented with during his European Tour. This seemed perfectly suited to Barcelona's back streets. He says: 'The reflection in a mirror is our exact world but backwards. I love working with mirrors because of how the whole world and all the viewers reflect on the artwork and messages both literally and figuratively. Also, just visually, the mirrors are a lot of fun to photograph in the streets.'

Type and text continue to be central themes in his work both on the street and in gallery installations. For a recent project in Vienna, he used news headlines to 'comment on the absurdity and shocking nature of how the media feeds us information'. Every day over a ten-day period he chose one headline from the BBC website and hand-painted

it on a 1.7 × 2.4 metre panel. 'In the final work,' he explains, 'I masked off a strip of each layer so that the final piece was a combination of all the layers and featured a segment of each day's headline. This totally abstracted the headlines and lost their true meaning, in much the same way that the amount of information with which we're bombarded reduces our attention spans and makes it difficult to remember the major events from only a few days ago.'

In this last project digital information is reverted to something handmade, which is a central theme in Ripo's work. Hand-painted type brings a human touch to a world that is increasingly going digital, and Ripo strives to restore originality through his use of scale, locations, languages, and his own particular voice and messages. 'I once read a quote from Jim Jarmusch quoting Jean-Luc Godard,' says Ripo. 'It said: "It's not where you take things from – it's where you take them to."'

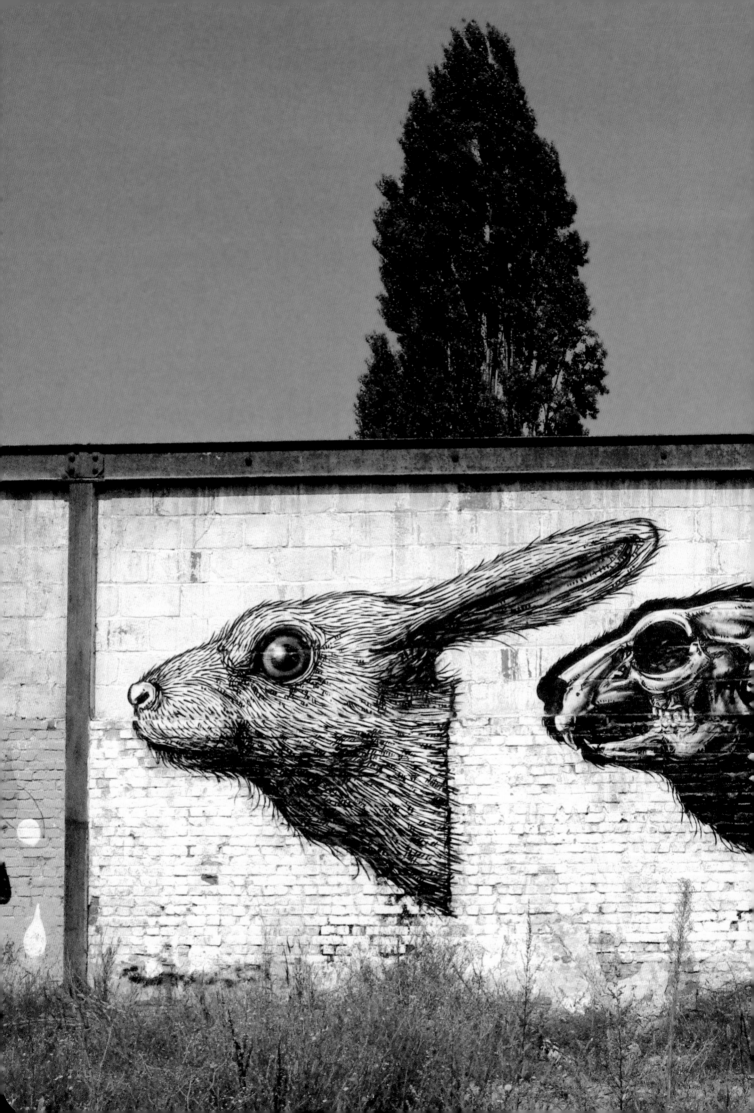

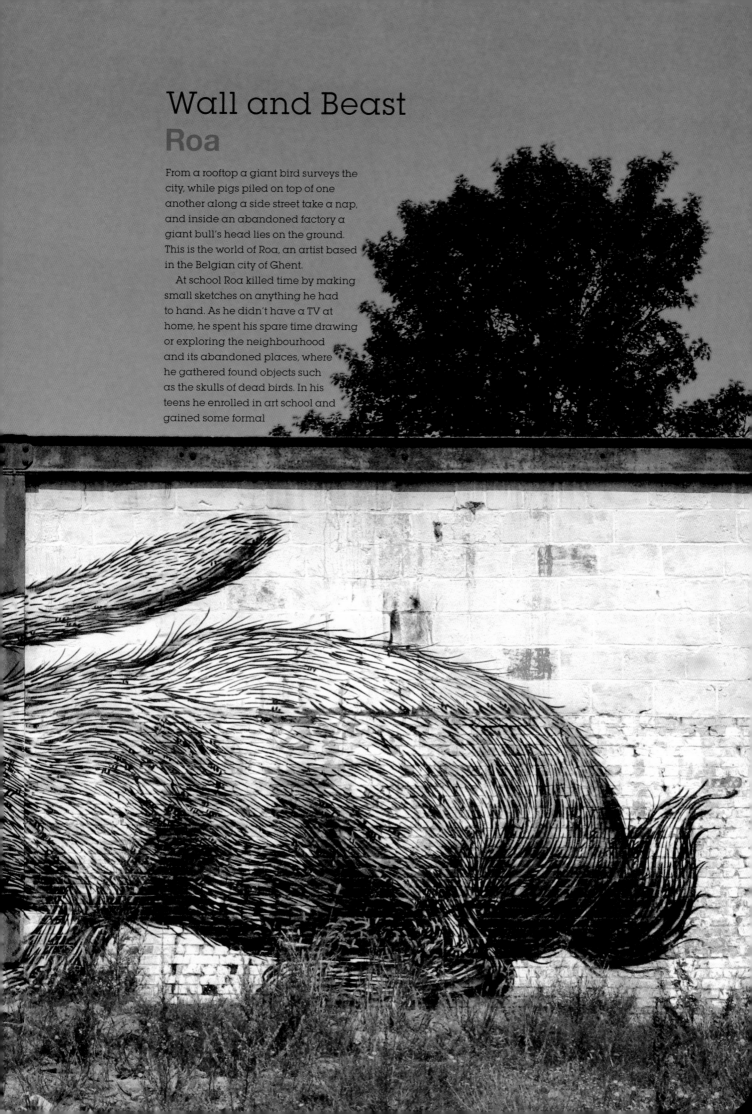

Wall and Beast
Roa

From a rooftop a giant bird surveys the
city, while pigs piled on top of one
another along a side street take a nap,
and inside an abandoned factory a
giant bull's head lies on the ground.
This is the world of Roa, an artist based
in the Belgian city of Ghent.

At school Roa killed time by making
small sketches on anything he had
to hand. As he didn't have a TV at
home, he spent his spare time drawing
or exploring the neighbourhood
and its abandoned places, where
he gathered found objects such
as the skulls of dead birds. In his
teens he enrolled in art school and
gained some formal

training, despite being something of a rebel. Out of class he began to paint graffiti, starting out in the classic way with lettering and moving on to characters as he learnt techniques. After a few years, however, painting began to lose its appeal; he no longer felt inspired by the subjects he painted, so he returned to sketching animals. Only then did it occur to him that he should be painting animals on walls, just as our ancestors did on cave walls many millennia ago.

For Roa animals represent so many things; some are considered beautiful, or are honoured in certain cultures; others are deemed verminous pests. 'It's an open theme,' he explains. 'You can create your own story with animals.

I was more interested in the everyday animals that live among us; rodents, domesticated rabbits, farmed pigs and cows. They are integrated in our western culture in many ways, and yet they seem out of place when you see them painted on the street. To depict them totally out of proportion gives them a surreal quality. I really like the ambiguity of images and of implicit meanings. I am fascinated by the circle of life, sometimes in a sombre, morbid way.'

While the rich abundance and diversity of life in the animal kingdom are to be celebrated, this theme has also become a very obvious metaphor for the pressing environmental problems of global warming, and the threats of extinction that some species are facing.

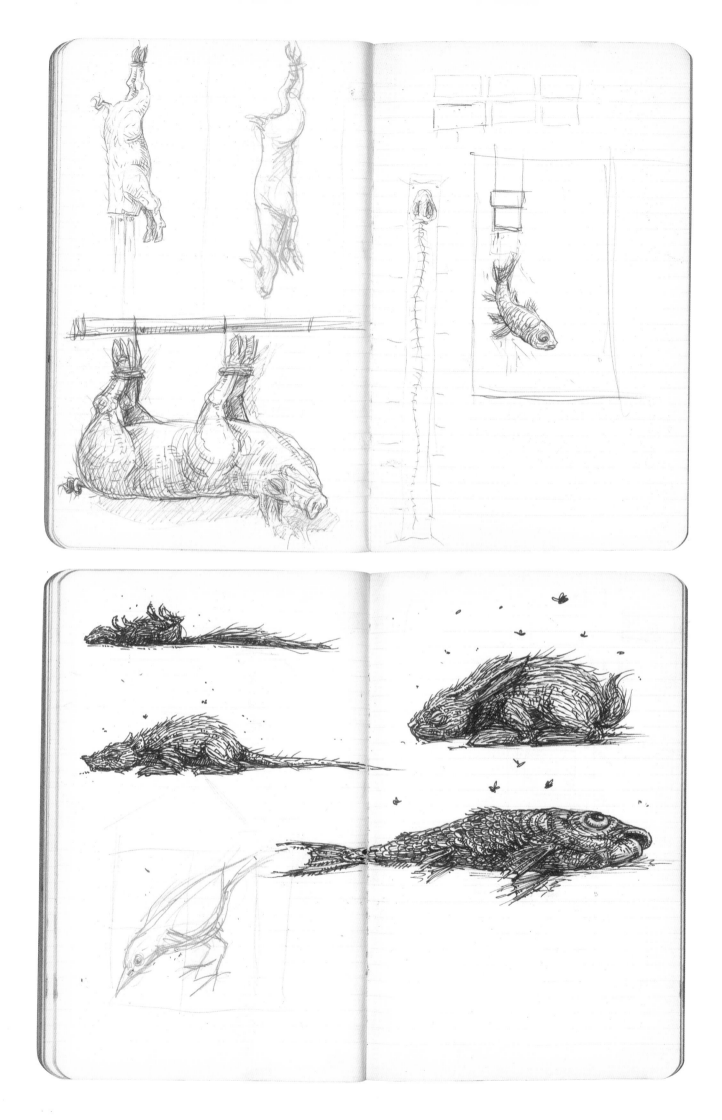

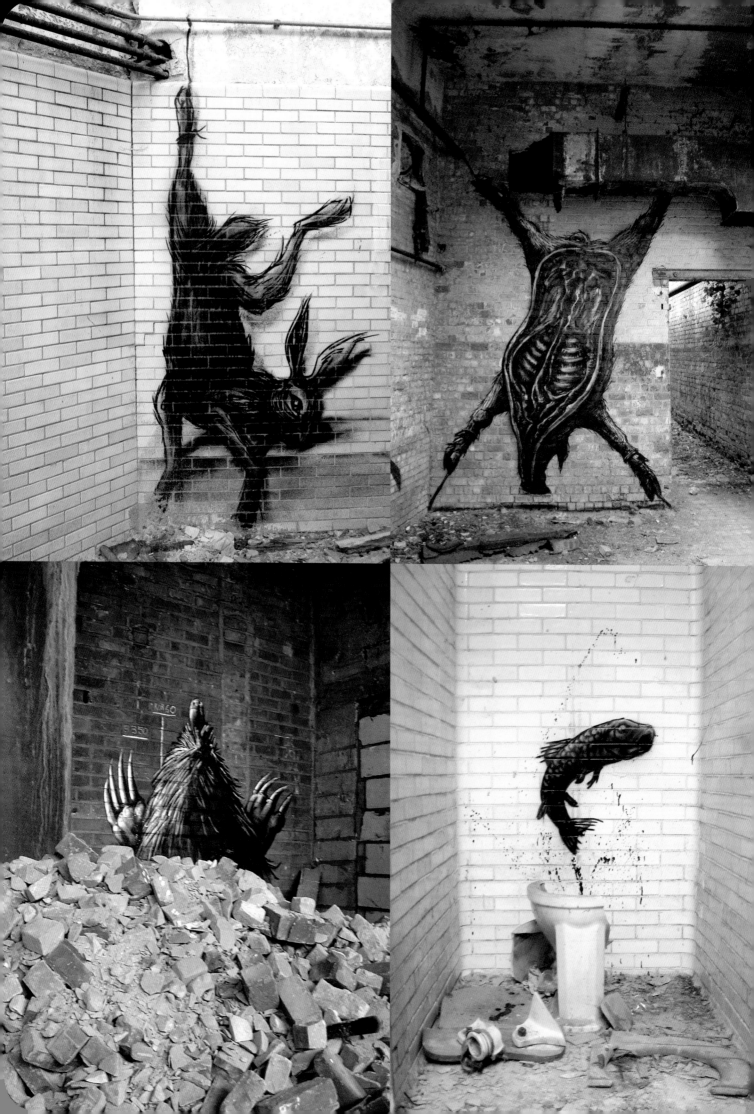

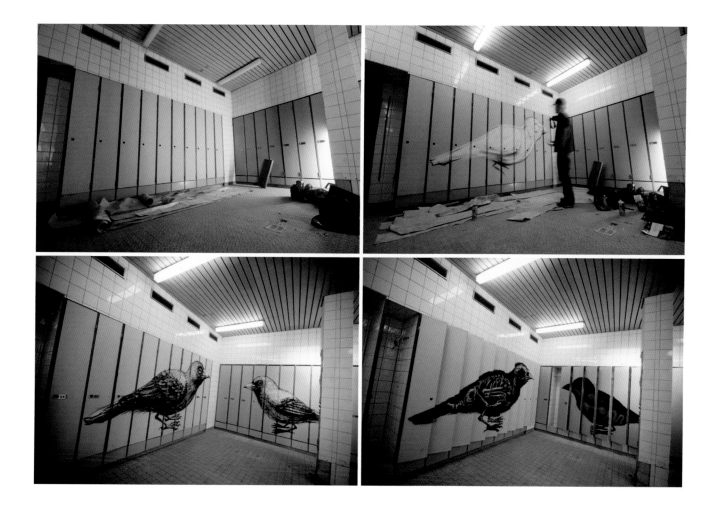

'I think it is clear that humanity has decimated several animal species over the past few decades. It is also clear that people are estranged from nature and their roots. But I want to convey something positive too. I don't want it all to be doom and gloom. I really like it when someone sees a giant rabbit in the street and is so surprised that he or she starts to laugh! These over-enlarged animals are a celebration of the animal world. I put my image out there and people can decide how to interpret it for themselves.'

In this book Roa has given us a rare glimpse of some of his working sketches, which he would not normally show to anyone. He views them not as finished drawings but as notes and ideas for his graffiti. While the excitement of painting graffiti is totally different from drawing at a desk, Roa does apply some pen and pencil techniques to his paintings, such as hatching. He particularly enjoys the physical nature of painting a wall, as he explains: 'I prefer painting on walls, working with their texture and in an environment that allows me to

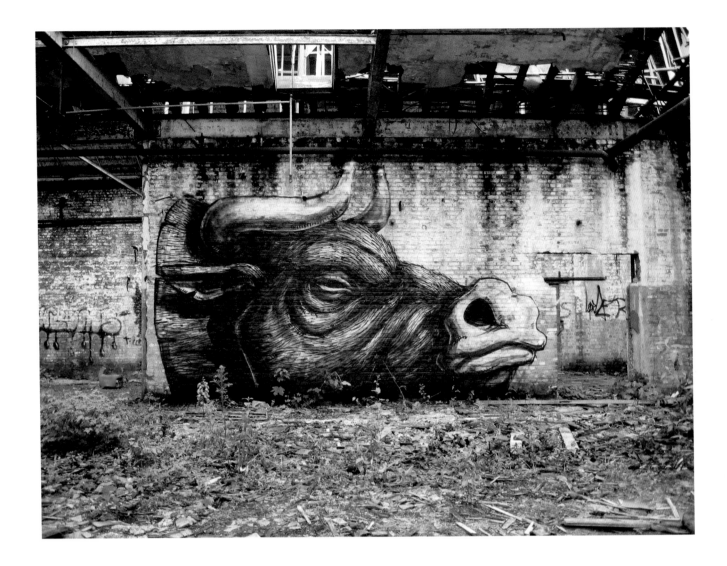

integrate the painting. You don't have that with drawing. You can try to find used or old paper to work on, but going out to paint is a bit of an adventure – you hope you'll stumble upon the ideal spot.'

While in some of Roa's paintings the animals take on a narrative role, in others they remain still and silent inhabitants of the city. The actions and situations he creates for his animals depend in part on the locations of the works. 'When I work in abandoned factories, the audience is relatively small, so I don't expect anything from them. But these buildings offer me a perfect oasis in the city to tell a lost story of that city. It is a playground where I am free to experiment, like a 3D sketchbook. A lot of my paintings work best in these environments because they reinforce

the feeling that these animals generate. A dead cow in a vacant building or a rodent in search of food are just as they appear. But when I paint in public areas I am more aware of the audience and I generally try to be more suggestive. I try to insinuate ideas – not too obviously like mass media posters, but rather with a subtler, quieter and integrated image.'

Painting in derelict places where passers-by rarely venture is also partly therapeutic, allowing Roa to explore empty spaces in the city without the usual noise or pressures. When a factory is abandoned, nature reclaims the building; plants and weeds take over, and birds and rodents move in. In this way, there is a natural relationship between the urban wastelands and the 'lost' animals that Roa paints.

One of the places Roa has frequently painted is Doel, an abandoned village in the shadow of a nuclear power plant near Antwerp. 'A ghost town like Doel is amazing, with so many possibilities and textures,' Roa says. 'The texture of the wall and the environment complete my idea or inspiration. Normally I don't know what I am going to paint until I am standing in front of the wall, and the texture is the basis of my paintings. Last year they finally demolished one of the factories I visited almost daily. It was practically in my backyard and I painted there a lot – kind of like my studio. One day I was painting there and the bulldozers came and demolished the piece I had just done! Graffiti is so ephemeral, and that's such a great feature – at any point you can start again from scratch.'

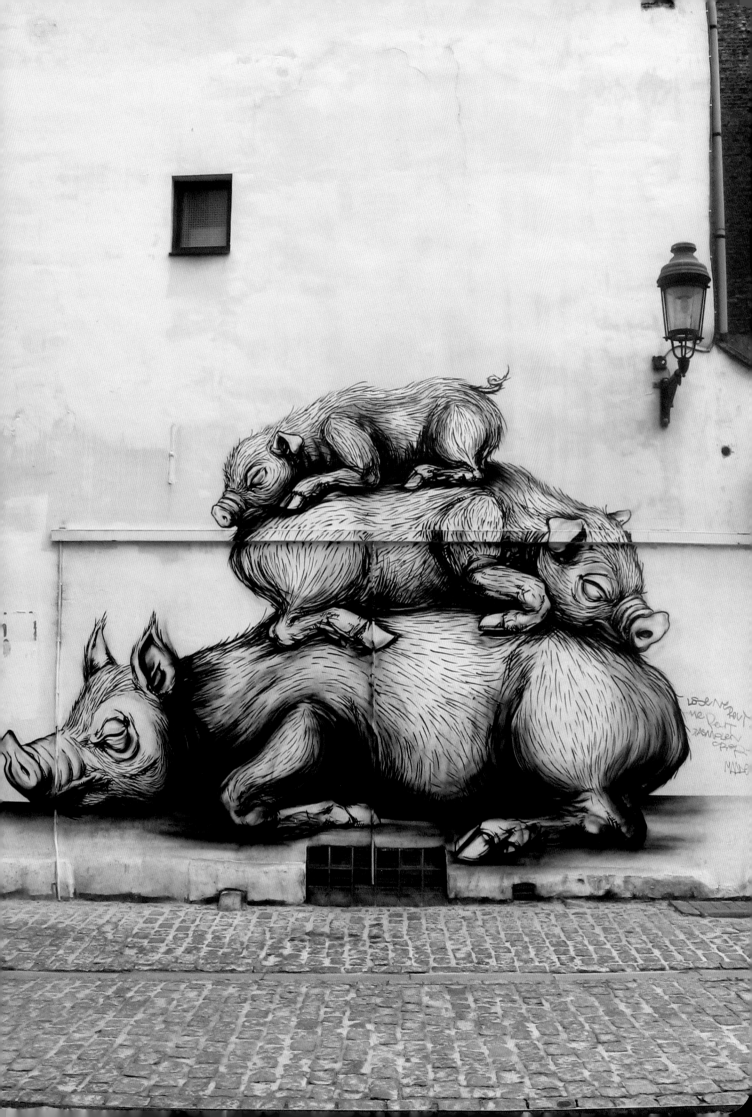

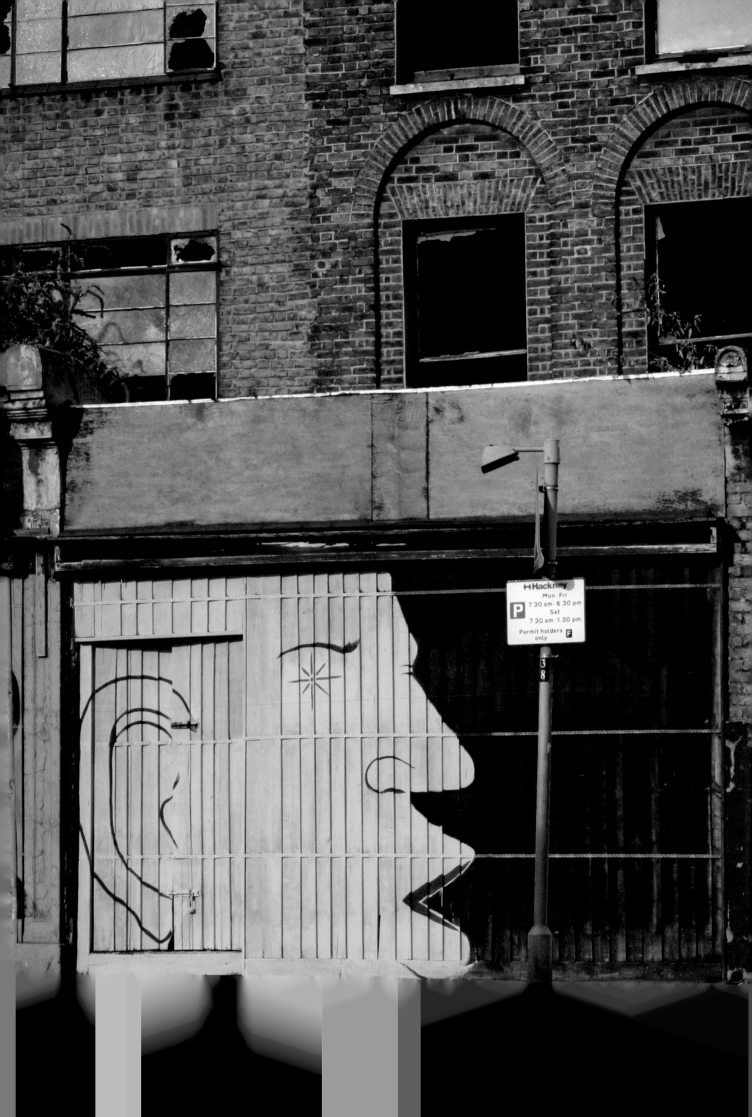

Hackney
Mon-Fri
7.30 am-6.30 pm
Sat
7.30 am-1.30 pm
Permit holders
only

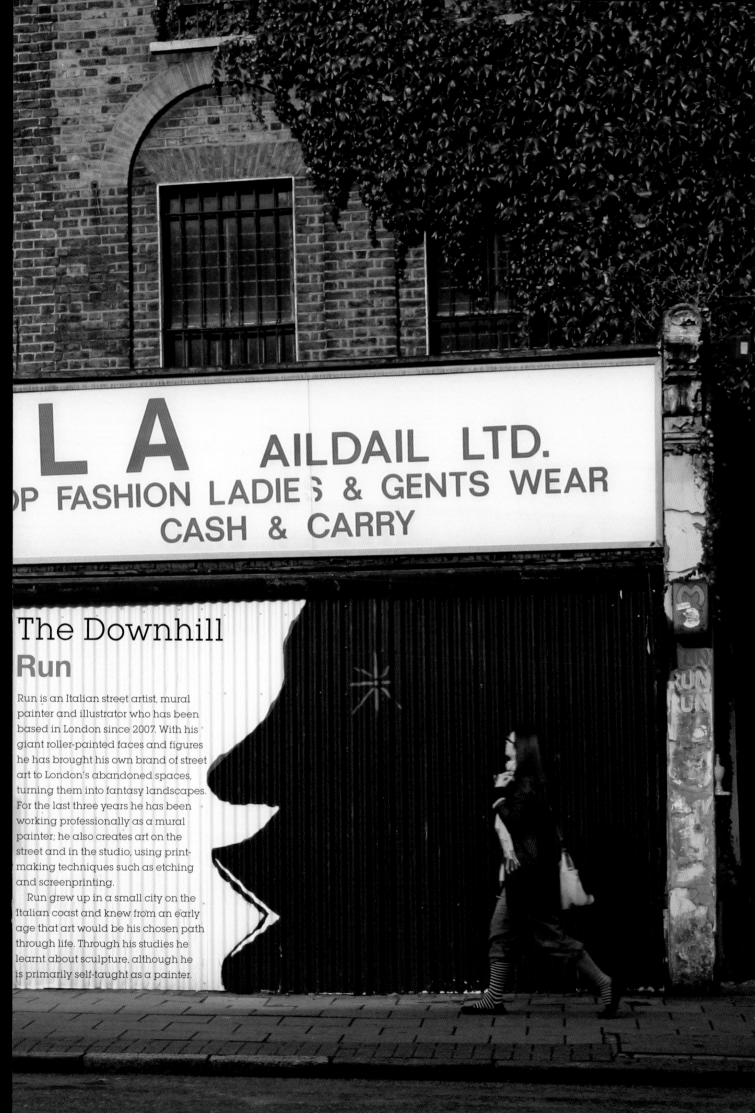

LA AILDAIL LTD.
OP FASHION LADIES & GENTS WEAR
CASH & CARRY

The Downhill
Run

Run is an Italian street artist, mural painter and illustrator who has been based in London since 2007. With his giant roller-painted faces and figures he has brought his own brand of street art to London's abandoned spaces, turning them into fantasy landscapes. For the last three years he has been working professionally as a mural painter; he also creates art on the street and in the studio, using print-making techniques such as etching and screenprinting.

Run grew up in a small city on the Italian coast and knew from an early age that art would be his chosen path through life. Through his studies he learnt about sculpture, although he is primarily self-taught as a painter.

He began to paint graffiti in the street around 1996, at first following the classic hip-hop style that was massive in his home town. Later, having left home, he travelled around Italy and changed his way of painting walls. Artist friends such as Dem, Blu, Moneyless and Ericailcane were also working in a similar way, and so naturally they began to collaborate on projects. They all painted 'freestyle', creating images purely from their imaginations, usually in flat colour. This new style subsequently came to be known by the term 'street art' rather than graffiti.

Italy's economic boom of the 1960s and eventual decline left large numbers of derelict factories and neglected warehouses in many city suburbs, which became perfect work spaces for Run and other new street artists. He and his friends experimented with painting on an architectural scale using paint rollers and brushes instead of spraypaint. By painting with rollers and using limited colours, Run found he could take whole buildings as his canvas rather than limiting himself to one small corner. Ruined structures became three-dimensional visual playgrounds in which he could create images at any

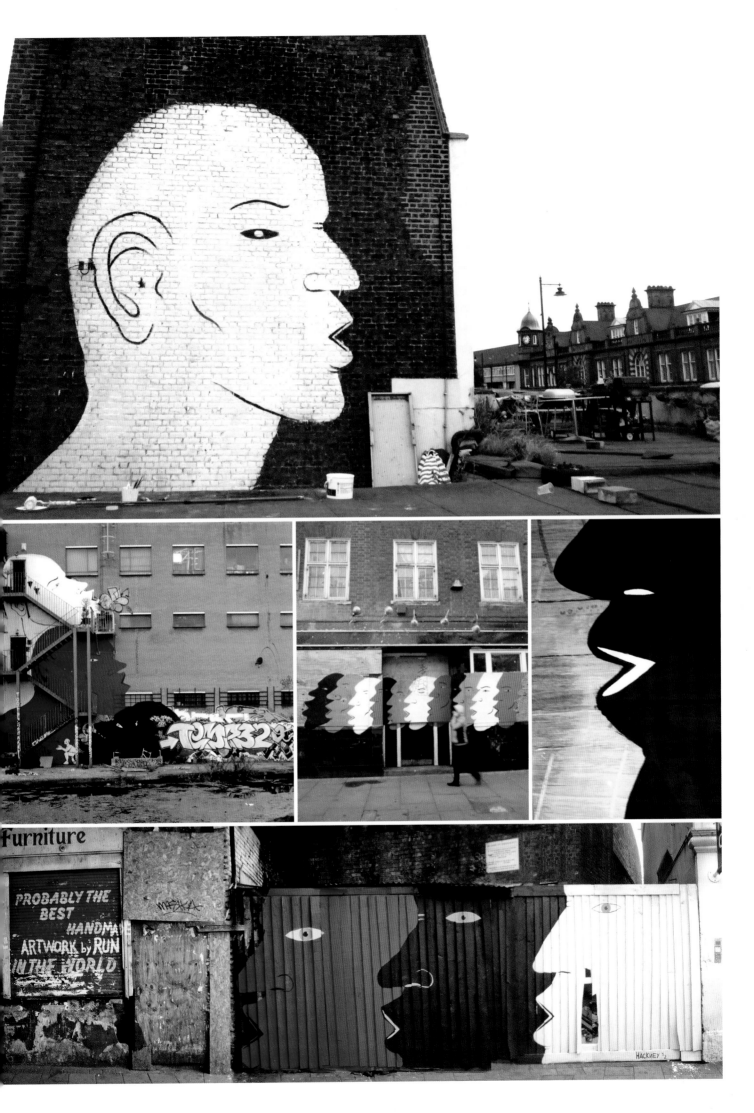

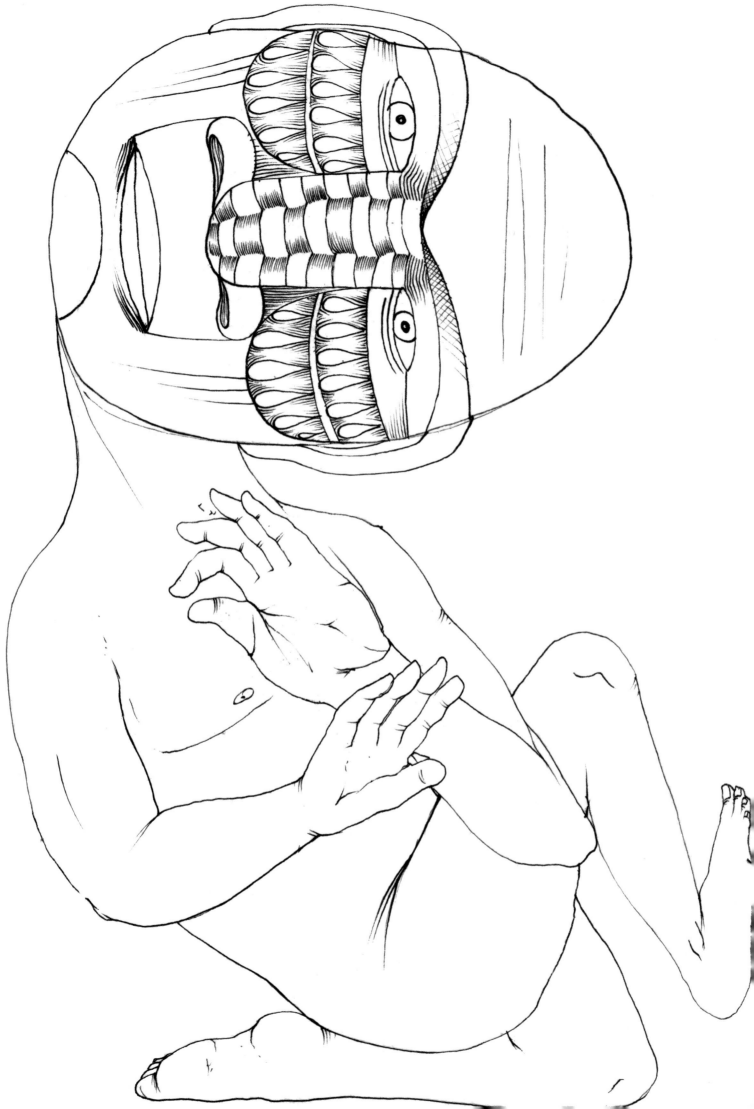

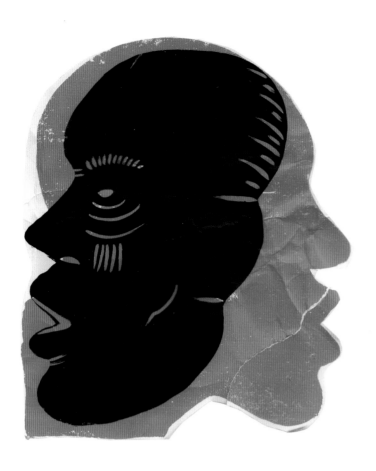

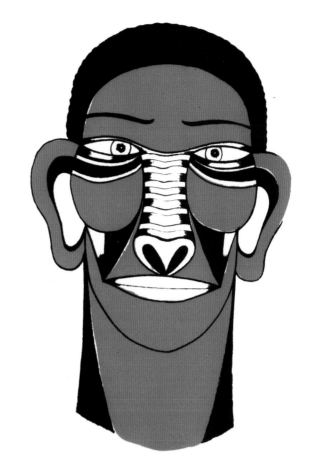

angle, fill entire façades and incorporate architectural details such as windows into a piece. For Run, rollers and brushes began as a novelty but soon became essential tools; they enabled him to produce more primitive marks and focus on simple and yet strong visual ideas, in contrast to the complicated colour fades and styles of classic graffiti.

Although he has become known as a street artist, he is uncomfortable with the term. As he explains, 'I would like to see this game of street art end one day soon, and go back to being an artist without any labels. What makes me a street artist is just the fact that my stuff is on the street right now, but I don't feel I belong to one particular art scene.'

Run's style, he says, is 'always changing in continuous mutation and revolution, like the people that change all around me now. We are constantly in transition so it's better to be flexible in life and let yourself adapt to change. In my work I like to communicate that dynamism and movement.' Over the years he has become drawn to different topics, but he tends to 'try to communicate what I see in my daily life.

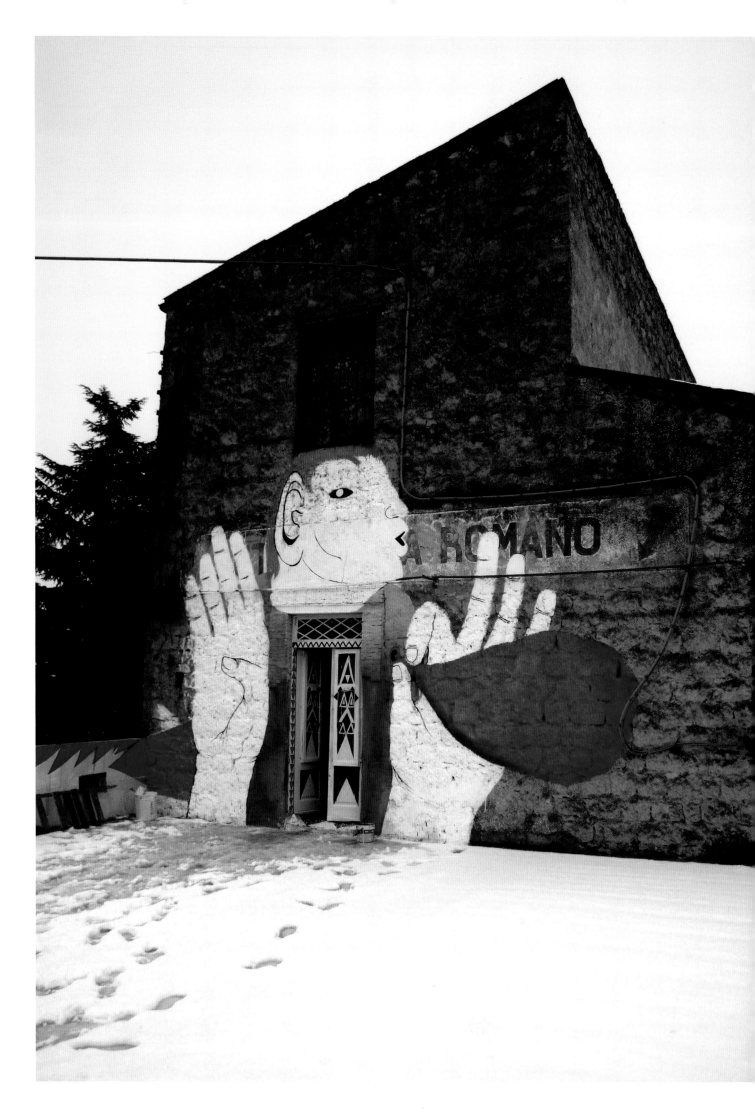

I can't talk of anything outside of my own experience.' His subject matter often concerns modern society and he is fascinated by human beings, observing their diverse features, ethnicities, expressions and forms of behaviour. Another theme that inspires him is dance and body movement: 'I am enchanted when I see deaf people speaking in sign language.' He also has a love of tribal art, partly because it relates to our roots but also because it reflects human behaviour and the way we express our feelings through depictions of human forms.

In the UK, the opportunities to paint outside are relatively rare in comparison to Italy, although it is still possible. Given these difficulties, he has recently become more fascinated by printmaking, but in a very handmade way. He enjoys all the processes of print production, preferring each one to be slightly different and relishing his 'mistakes'. Drawing is the starting point for all his work, both outside and indoors. His sketchbooks are always full, not only of drawings but words and phrases which he sometimes combines with images.

Living in cosmopolitan London has made him feel like an anthropological explorer, speaking in a foreign tongue and learning about local habits and slang, which he writes down in his notebooks to learn and decipher. Immersing himself in this new culture has been a weird and interesting experience and has made him all the more curious to learn about traditions, culture and language, the themes that are echoed in his art.

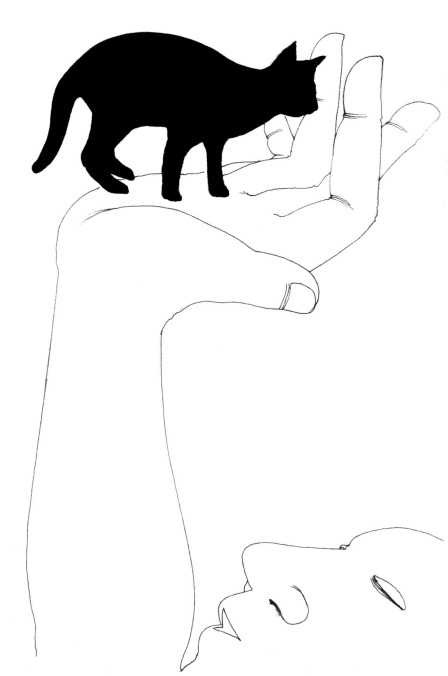

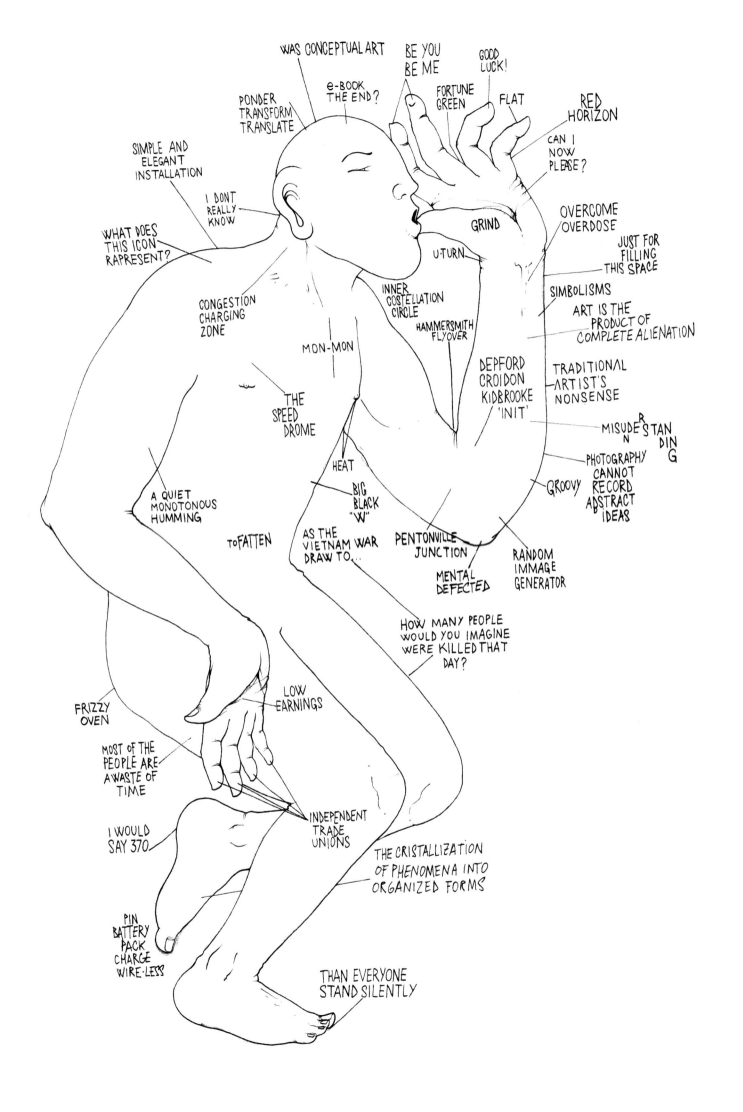

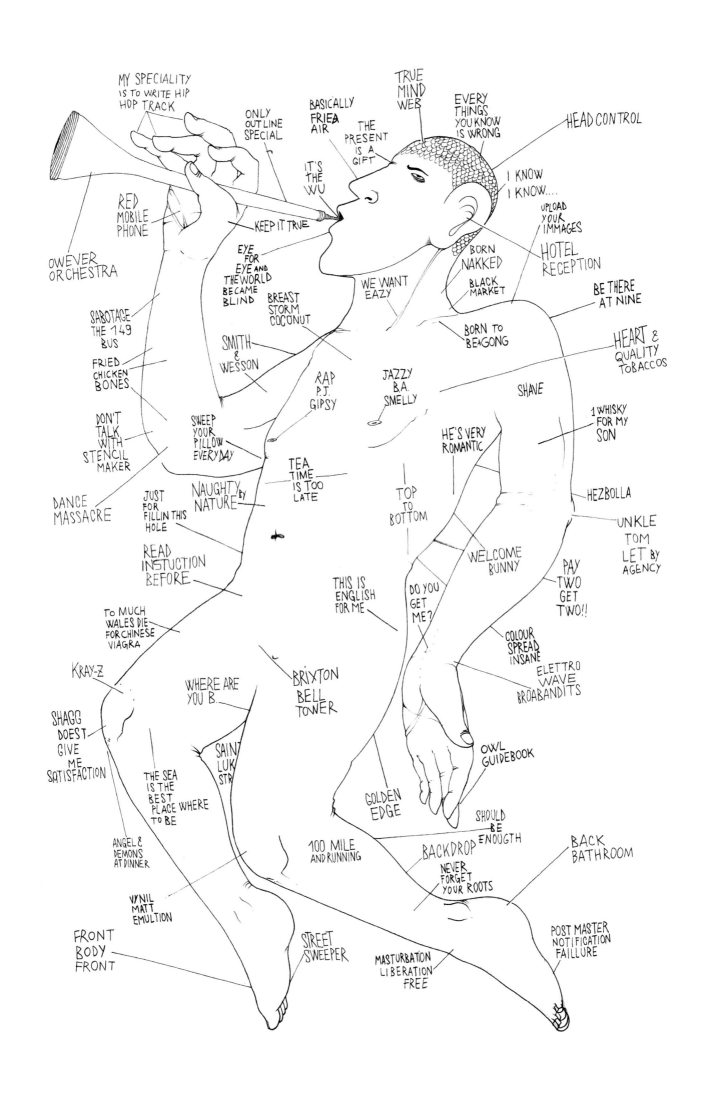

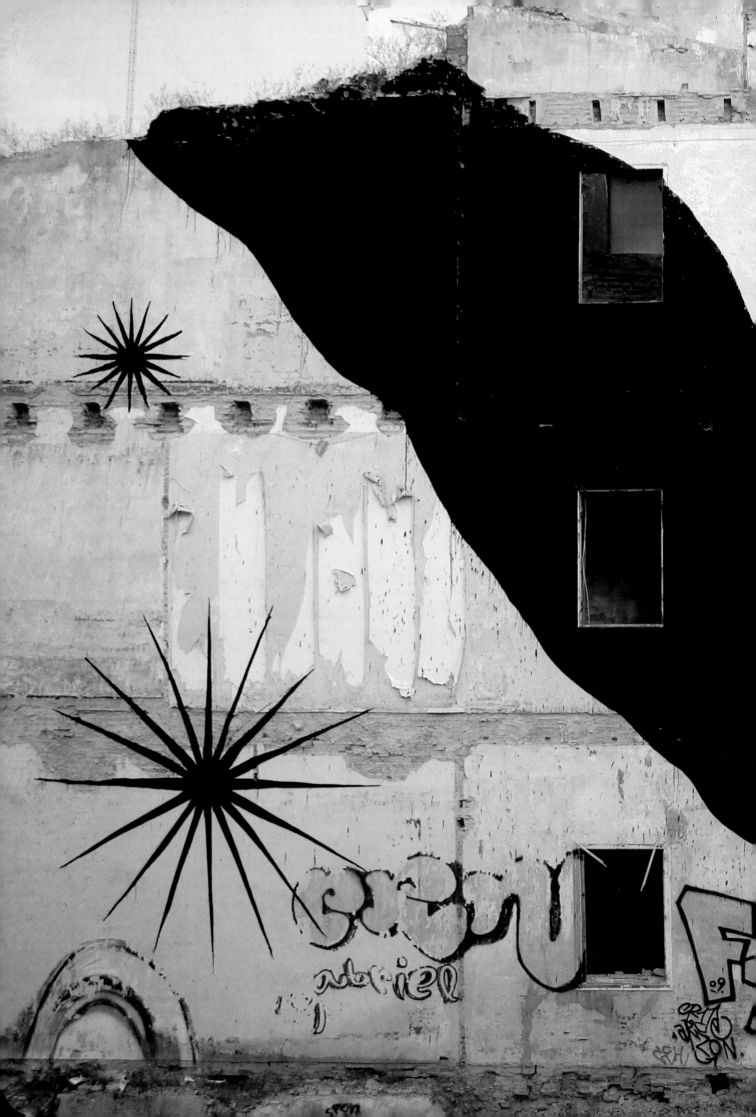

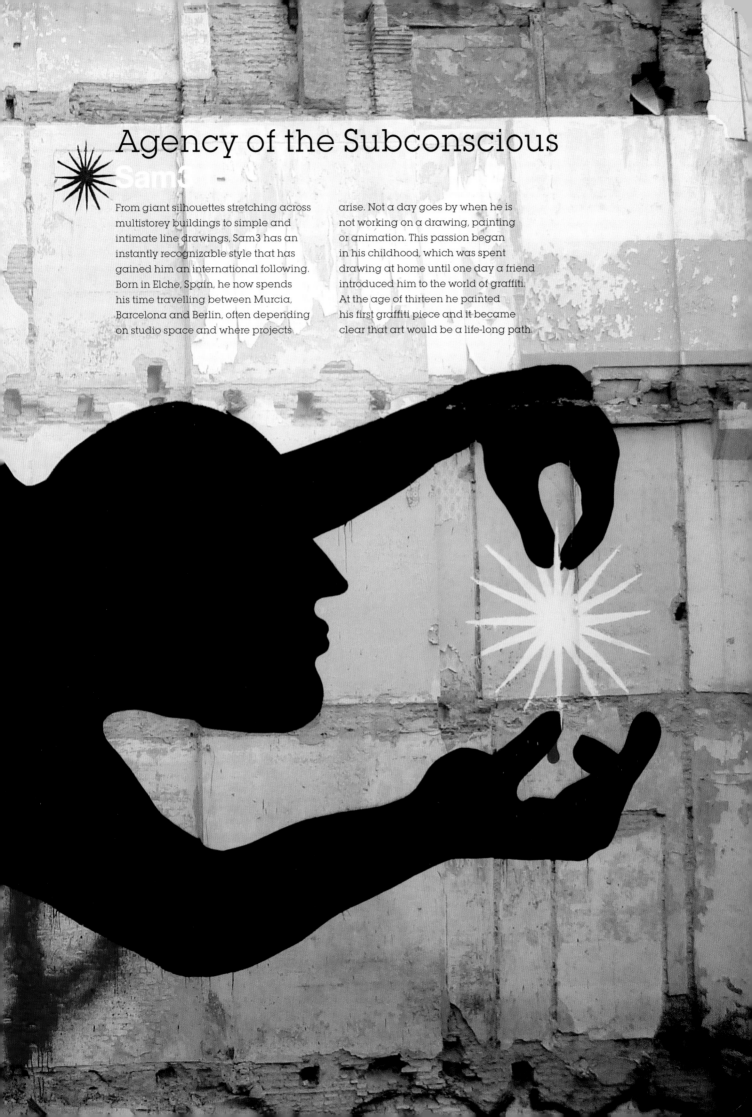

Agency of the Subconscious
Sam3

From giant silhouettes stretching across multistorey buildings to simple and intimate line drawings, Sam3 has an instantly recognizable style that has gained him an international following. Born in Elche, Spain, he now spends his time travelling between Murcia, Barcelona and Berlin, often depending on studio space and where projects arise. Not a day goes by when he is not working on a drawing, painting or animation. This passion began in his childhood, which was spent drawing at home until one day a friend introduced him to the world of graffiti. At the age of thirteen he painted his first graffiti piece and it became clear that art would be a life-long path.

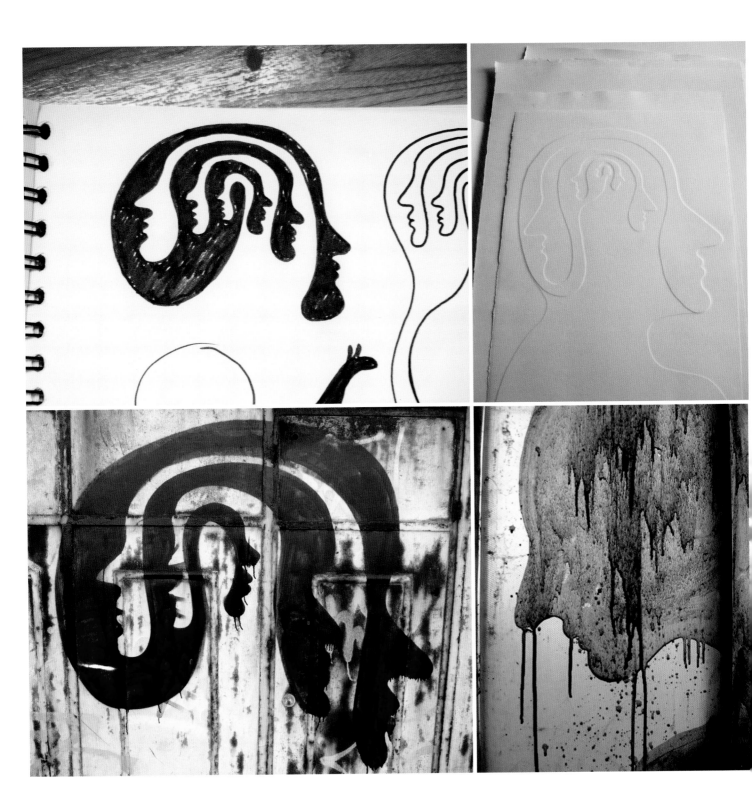

This love of art has always been combined with a desire to learn. While studying fine arts at the University of Granada, he spent four years experimenting with materials and ideas. In postgraduate courses and personal work, he continues to develop new techniques in areas such as printmaking and stop-motion animation. He also devours books, studying the Old Masters such as Bosch and Goya, and looking at the origins of classical and Renaissance art.

First and foremost Sam3 is a painter, but when an idea needs another medium he'll use whatever is necessary; animations, installations, even his own voice and body.

This willingness to try anything underlies all of his work. One day he may paint a giant mural, the next he might film water evaporating in the sun. In his first forays into graffiti he remained open to different styles, from stencil to freehand. Highly skilled with the spraycan, he created fluid figurative designs using dazzling colours, but then came a turning point when he began to paint with black alone, mostly in silhouette, which soon became his trademark.

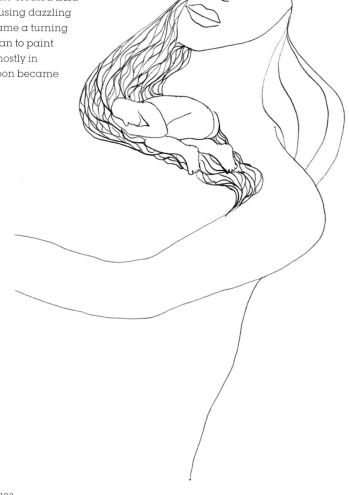

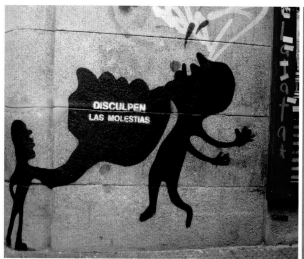

DISCULPEN
LAS MOLESTIAS

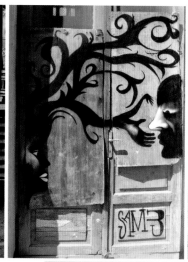

ITALIAN
CATS

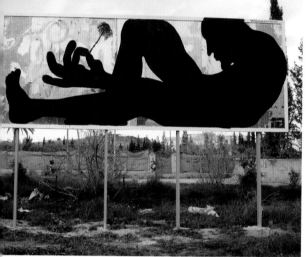

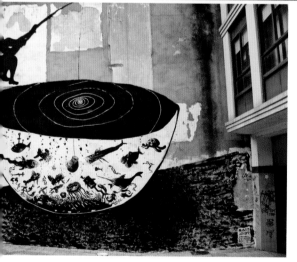

He began his first 'shadow series' around 2006, painting small silhouette figures in black spraypaint on the streets of Madrid. It was only later that year, after meeting Italian painters such as Dem, Blu and Ericailcane at the Arte Bastardo Festival in Bologna, that he began to think about painting on a larger scale. These artists inspired him to abandon the spraycan and take up the paintbrush and paint roller. Soon afterwards he travelled to Barcelona and painted his first *pertiga* or

'roller piece', a giant mural using paint rollers on the end of long poles. Later at an arts festival in Murcia he had the chance to paint twelve giant shadows on the sides of abandoned buildings in the city centre. He threw himself into this new technique, and the results were local fame and the beginnings of international attention.

Entire buildings become stage sets for his shadow puppets; a seated man becomes the branches of a tree, giraffes tower into the sky as their legs become rooted into the ground. For Sam3 the attraction for painting in only black was the 'naked idea, without the sweet deceit of colour, without tricks. Shadows are

185

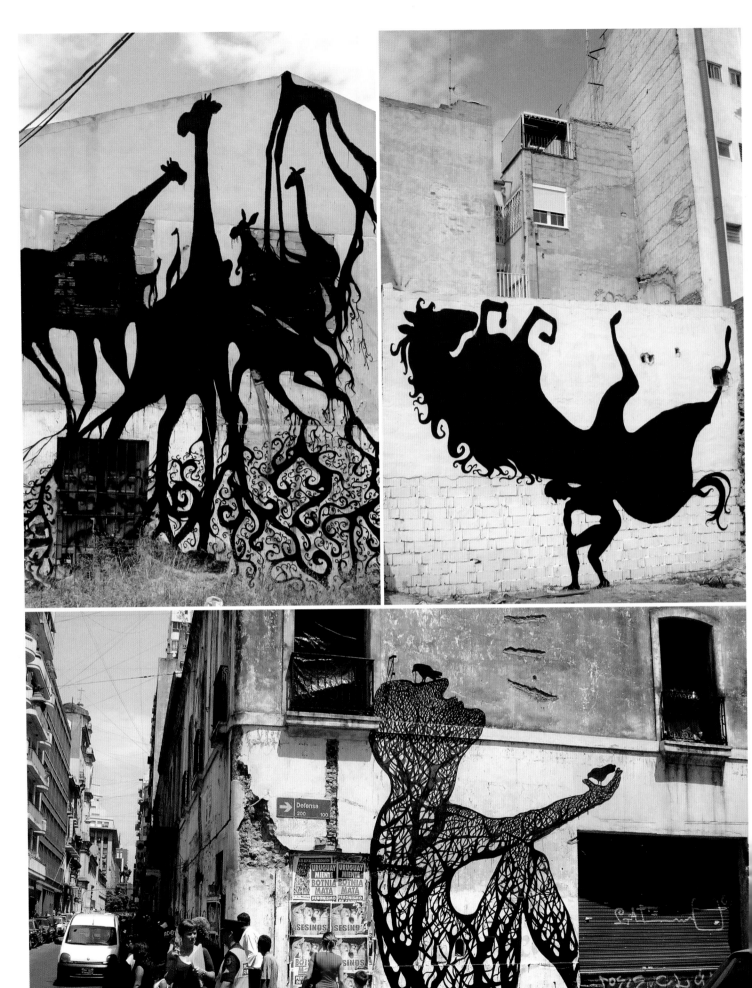

ambiguous; you don't know if they're watching you or turning their back on you.'

His drawings tend to be made with simple lines that outline shapes and capture the essence of an idea. Like his shadow paintings, his sketches are also playful, breaking the rules of anatomy and scale to create results that can be surreal, graceful and often poignant. These simple lines can say things which words alone might not be able to express.

A theme he often explores is relationships between men and women, depicting poetic moments such as a man nestling in the comfort of a woman's hair, or a man and a woman connected through their gaze by a precarious tightrope. These images can often be very personal

and he describes his own work as 'capricious and demanding at the same time. I am looking for complicity with the enemy, to scream some secrets, disinfect some wounds and spill alcohol on the injuries.'

Much of Sam3's work is allegorical; his human and animal figures symbolize and comment on society, human behaviour, our desires and failings. Sometimes these allegories relate to classical stories, but often they illustrate more modern fables.

One modern-day reality to which he responded using symbolic imagery was Bethlehem. In December 2007 Sam3 was invited to work in the troubled holy city. Positioned in the West Bank, on land taken by Israel during the Six Day War

of 1967, this Palestinian city is surrounded by a separation barrier, an 8-metre-high wall built by the Israeli military. The city has one exit to Jerusalem through the wall, but permission for ordinary Palestinians to pass through is rarely given. Sam3 spent time listening to local people's feelings about the wall and began to sketch ideas which expressed those stories, and over a number of days was able to paint them directly onto the wall. The impact of this project, which also included work by Banksy, Blu and Swoon, attracted huge media coverage, and highlighted the daily struggle of Bethlehem's citizens.

Sam3 continues to work in a variety of media as his opportunities grow along with his desire to experiment.

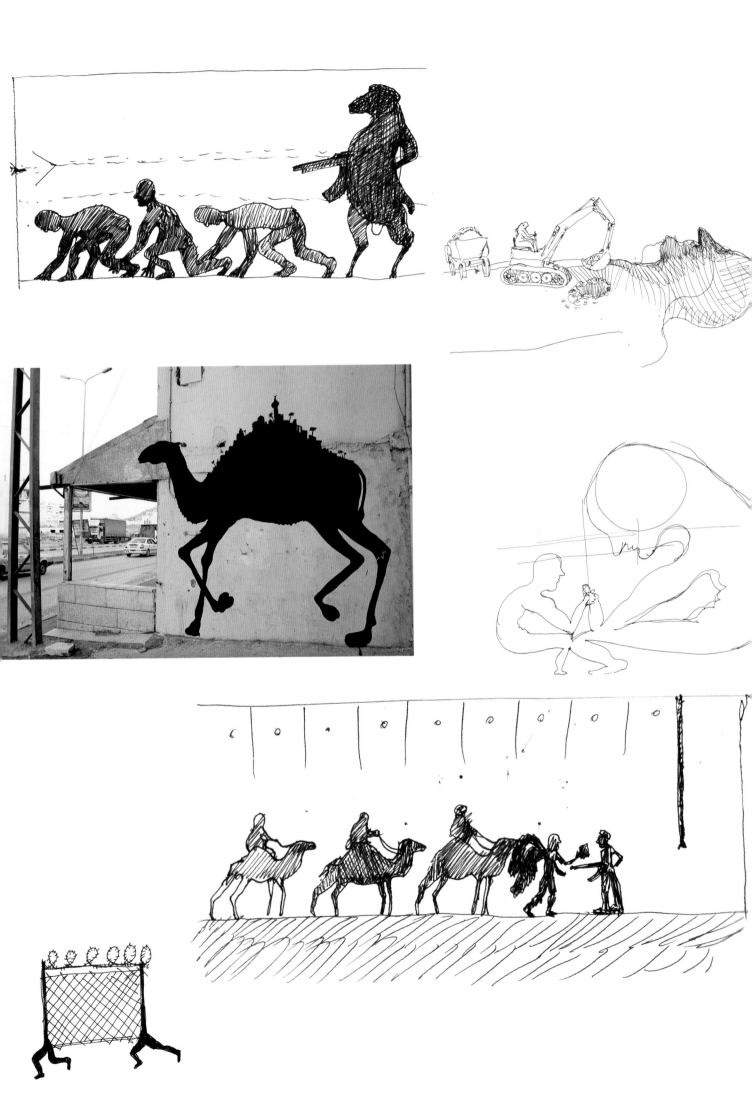

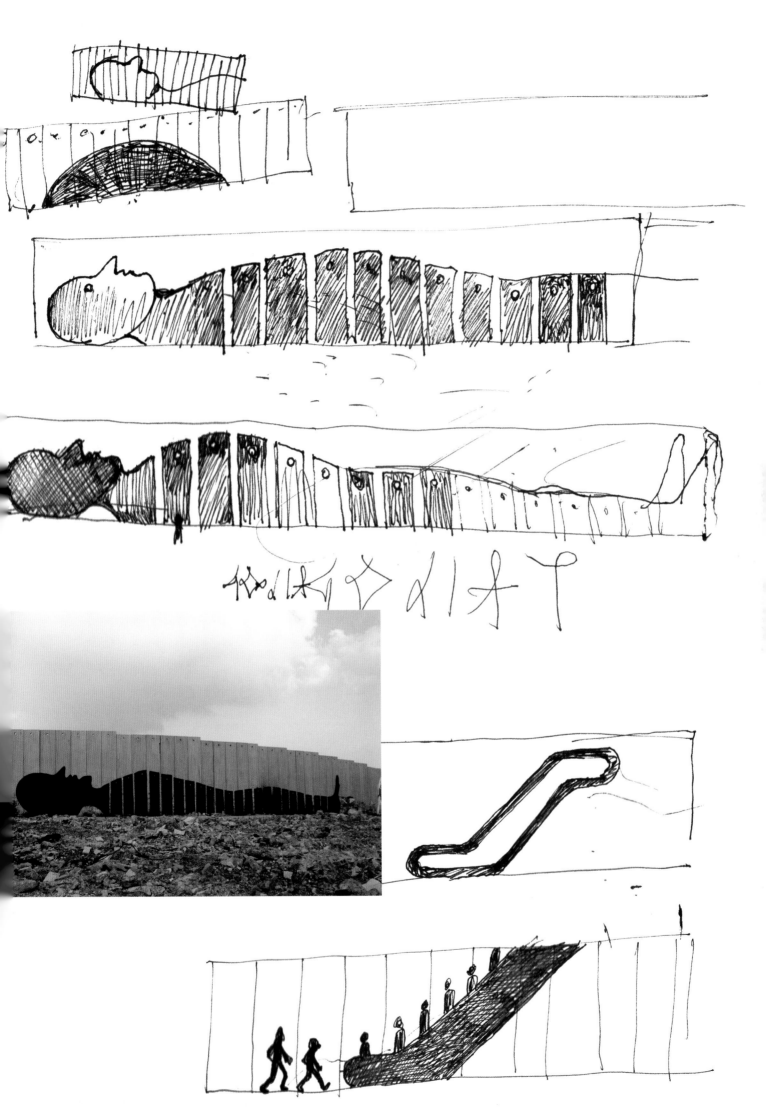

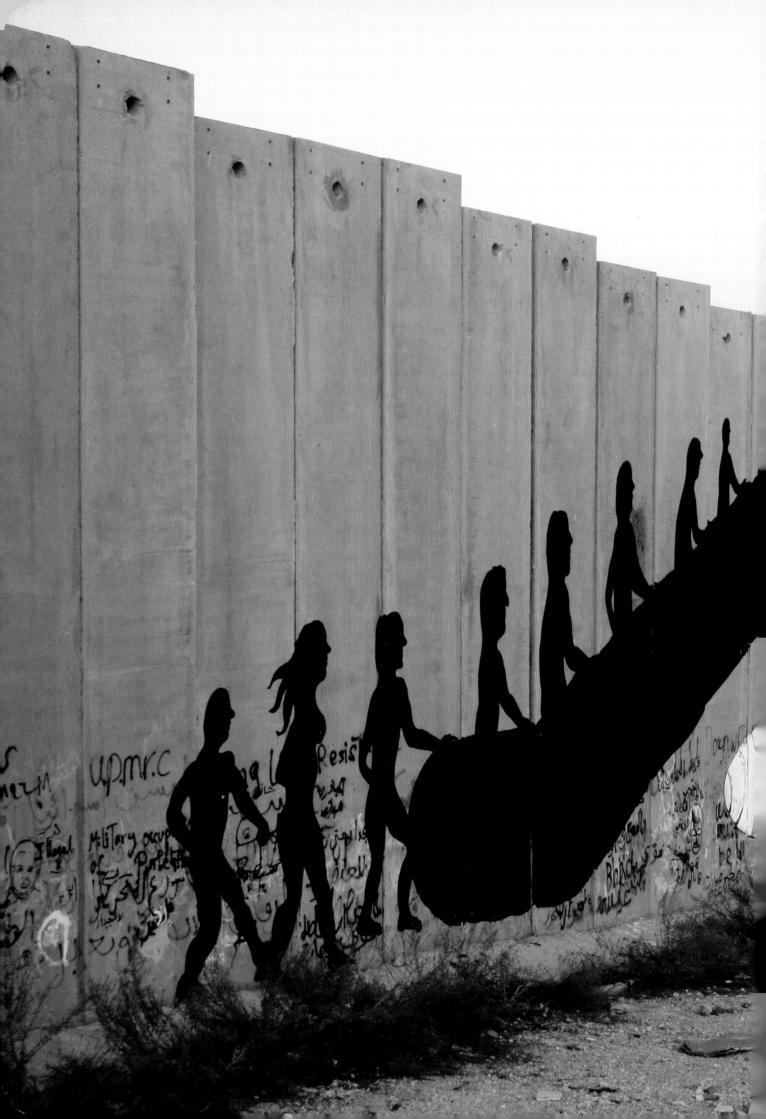

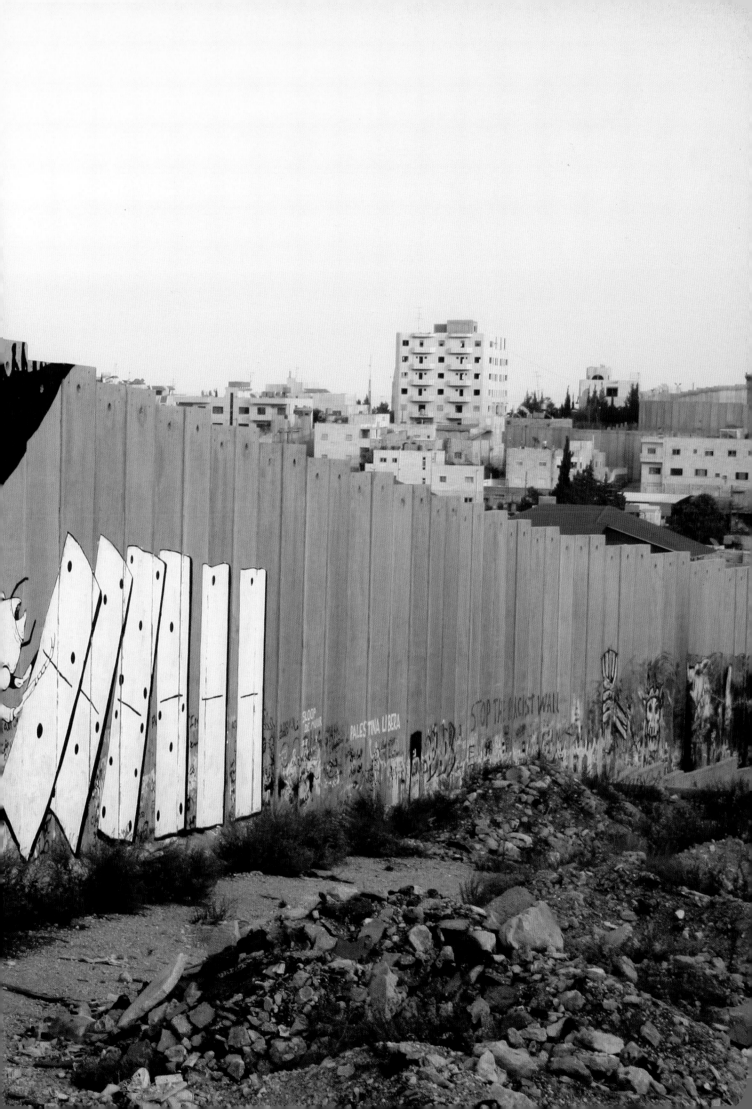

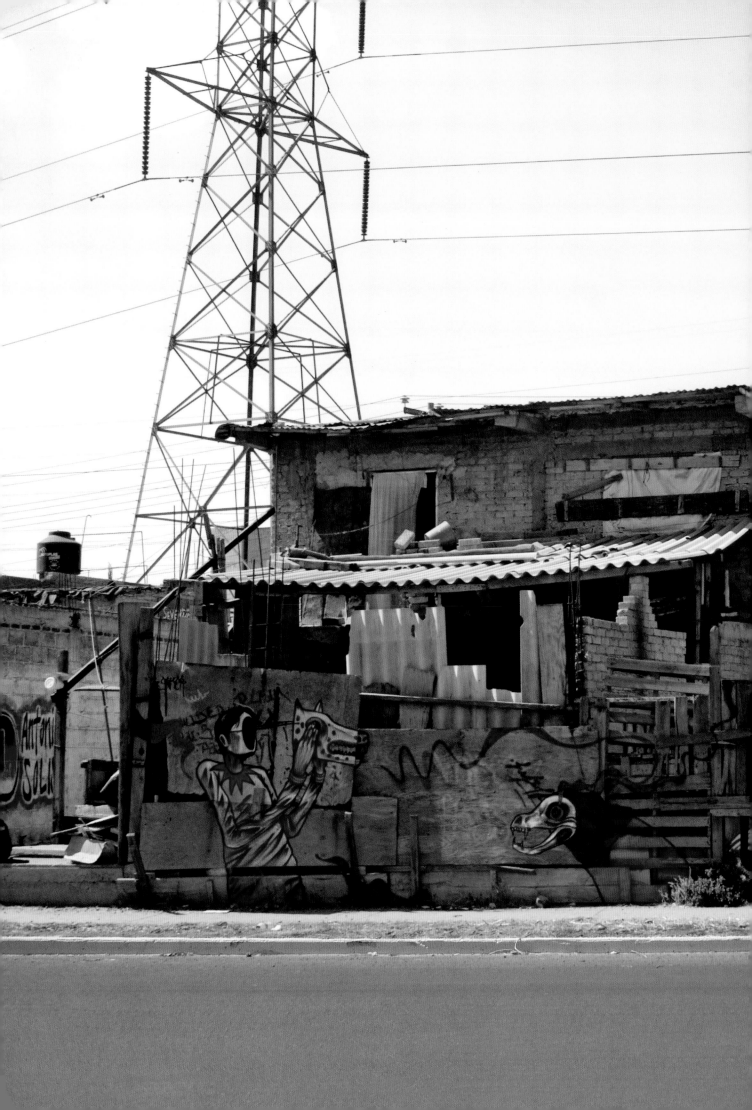

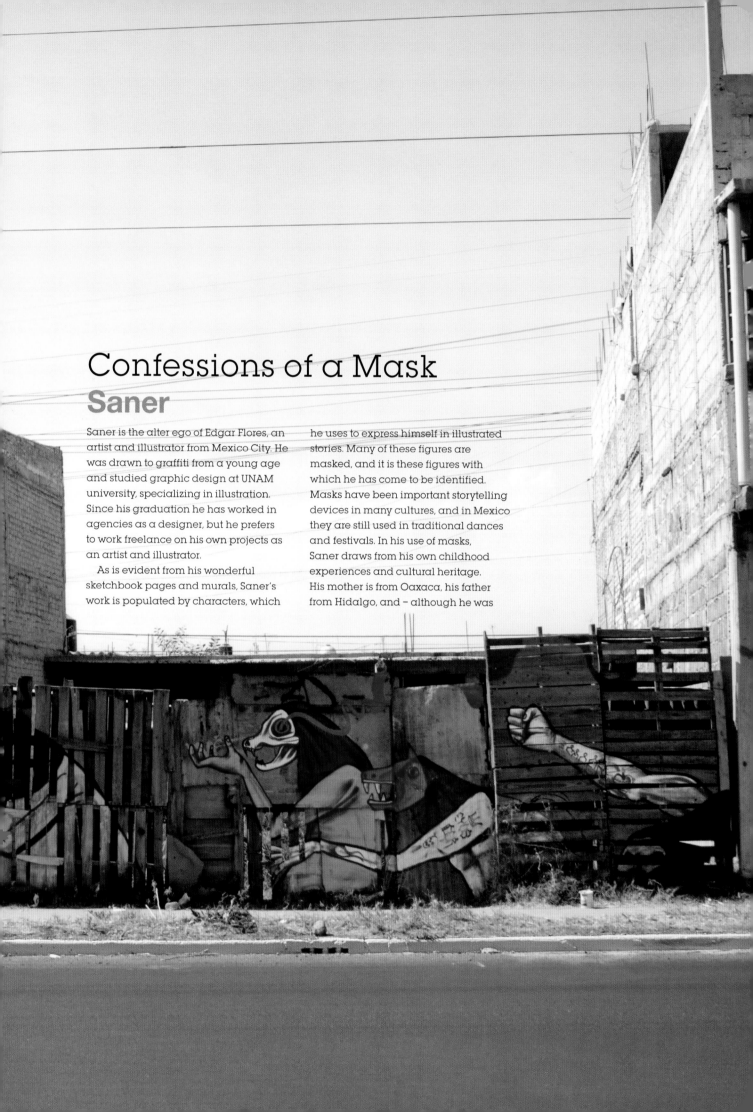

Confessions of a Mask
Saner

Saner is the alter ego of Edgar Flores, an
artist and illustrator from Mexico City. He
was drawn to graffiti from a young age
and studied graphic design at UNAM
university, specializing in illustration.
Since his graduation he has worked in
agencies as a designer, but he prefers
to work freelance on his own projects as
an artist and illustrator.

As is evident from his wonderful
sketchbook pages and murals, Saner's
work is populated by characters, which

he uses to express himself in illustrated
stories. Many of these figures are
masked, and it is these figures with
which he has come to be identified.
Masks have been important storytelling
devices in many cultures, and in Mexico
they are still used in traditional dances
and festivals. In his use of masks,
Saner draws from his own childhood
experiences and cultural heritage.
His mother is from Oaxaca, his father
from Hidalgo, and – although he was

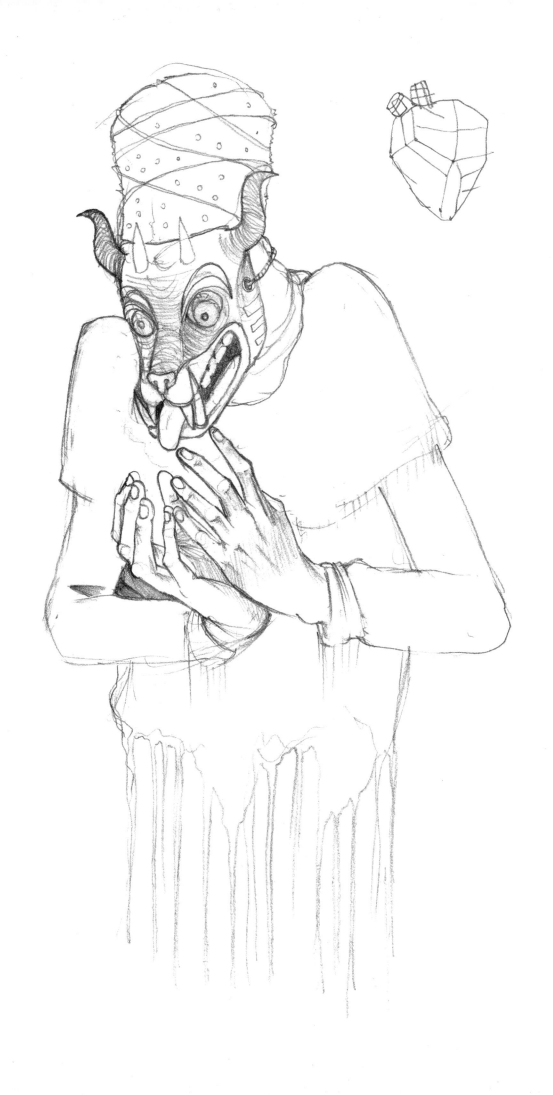

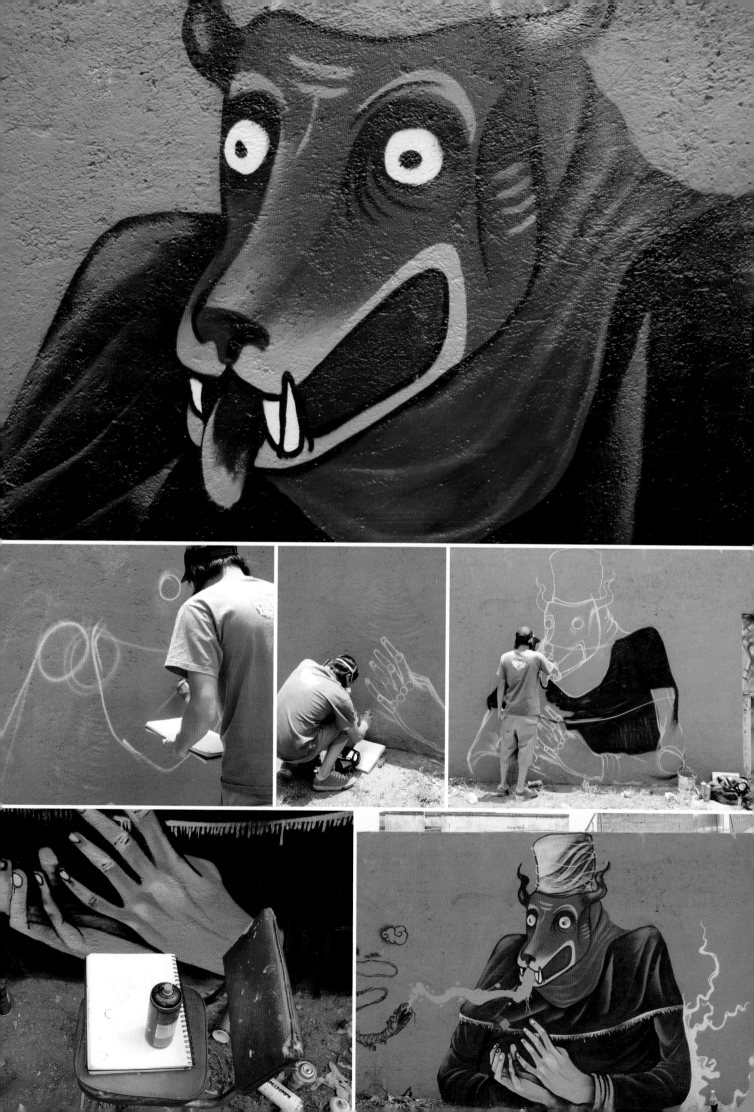

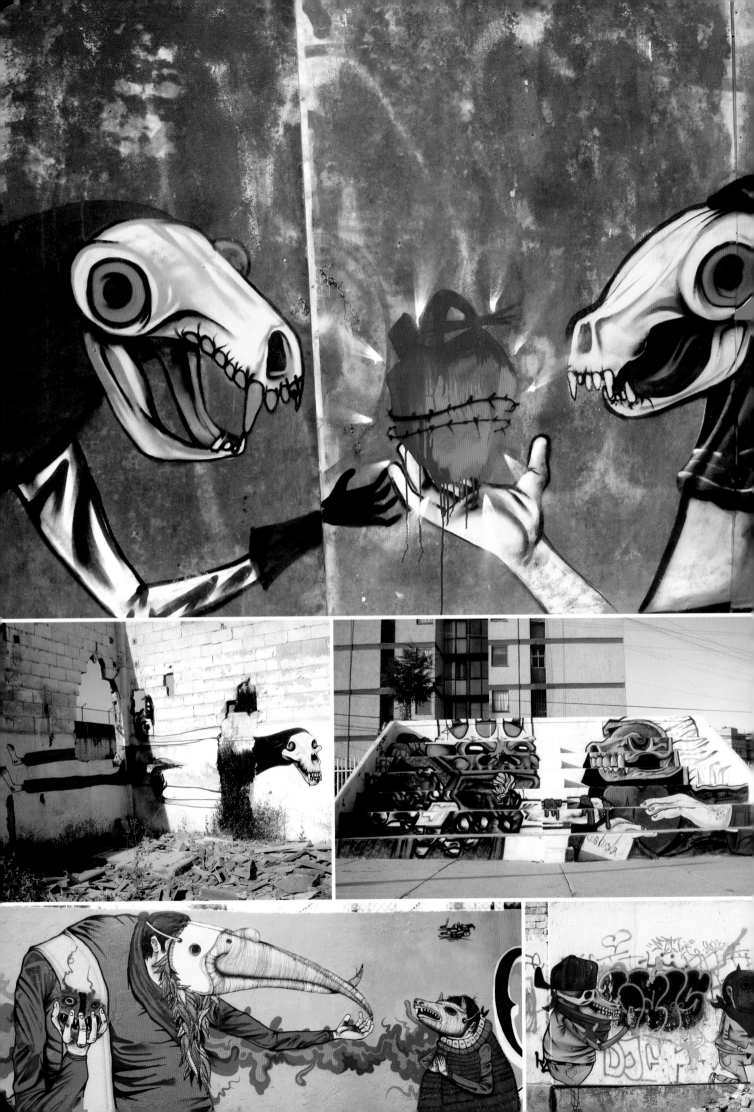

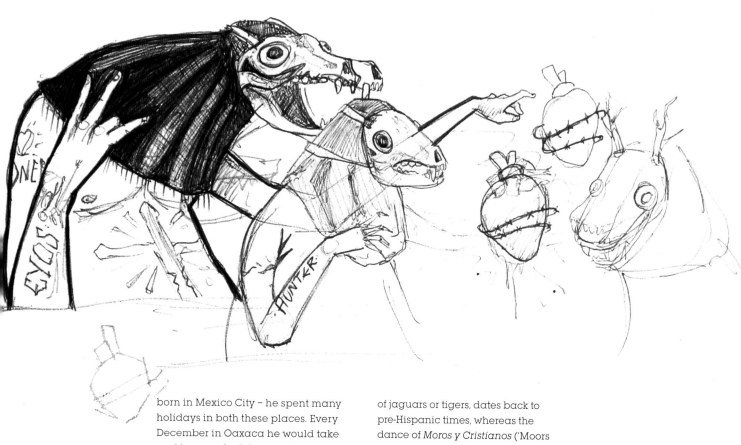

born in Mexico City – he spent many holidays in both these places. Every December in Oaxaca he would take part in a masked dance where the boys dressed up as girls, and vice versa. These experiences have stayed with him, particularly the colours and energy of the celebrations.

Masks in Mexico are linked to ancient rituals, religious traditions and carnivals. There is no such thing as a standard mask, they can be made from all sorts of materials depending on the local culture, history and context. The dance of the *tecuani* ('wild beasts'), for example, in which the performers wear masks of jaguars or tigers, dates back to pre-Hispanic times, whereas the dance of *Moros y Cristianos* ('Moors and Christians') was introduced by the Spanish after the Conquest and tells the story of the Catholic Church's triumph over the pagan Moors. 'In some indigenous villages, the wearers of the masks are chosen,' says Saner. 'The masks in these cultures represent the true self. To the Yaquis, for example, the deer dancer is born with the power of the deer. He has to have a state of purity.' Deer dancers are believed to come from a flower-filled spiritual world of natural beauty.

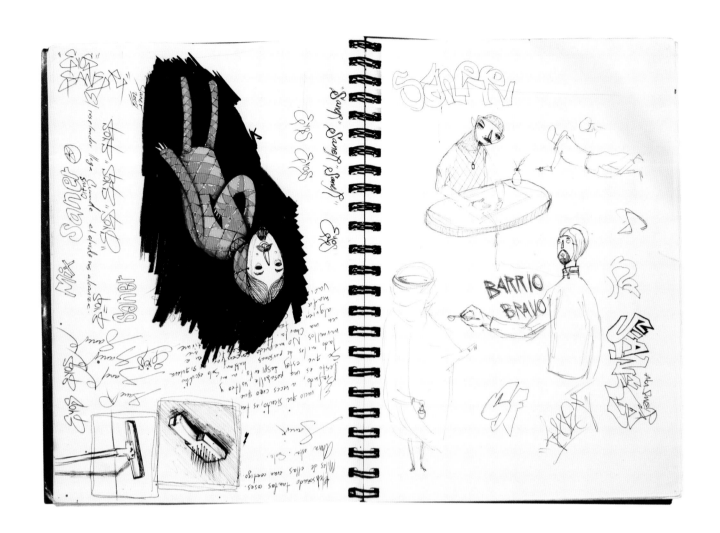
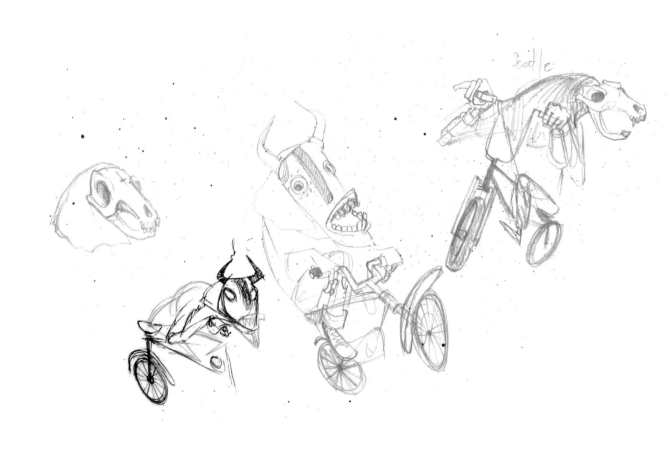

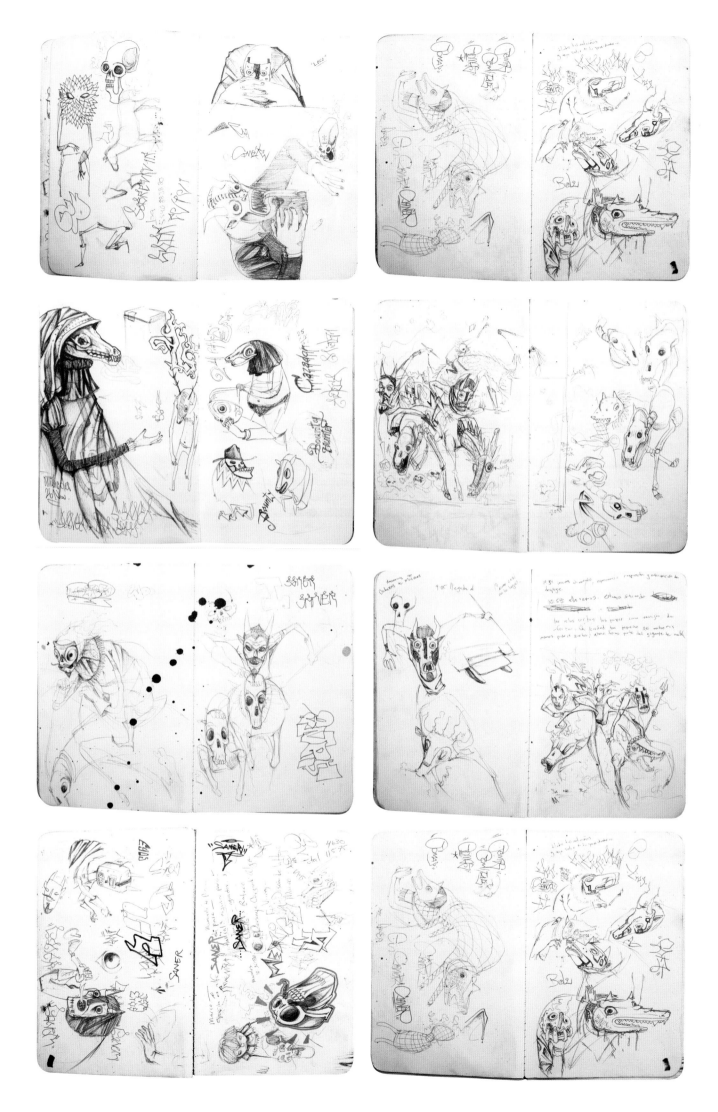

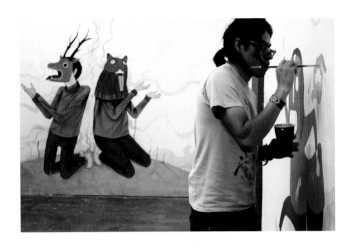

'We wear a mask most of the time,' Saner says, 'or at least that's how I see it. I think there are some sides we prefer to hide, or sometimes we just walk around without knowing who we are.' Masks are used in many different ways. 'I use masks not as an element that is intended to hide the true self but as something that reveals a parallel side of it. The mask draws a line between the state of mind of the person hiding behind it and the outside world. Sometimes my masks allow me to liberate my inner world.'

Saner's work is full of folkloric references such as masks, skulls, textures and *quetzalcoatls* (feathered serpent gods), which he uses to create his own stories. Every wall, painting and sketch tells a different story that can range from something symbolic and sacred to a personal or social protest. He tries to embrace everything that surrounds him, and to echo his own experiences in his work.

As he explains, 'The characters that I paint acquire their own personality through their expression and colours.

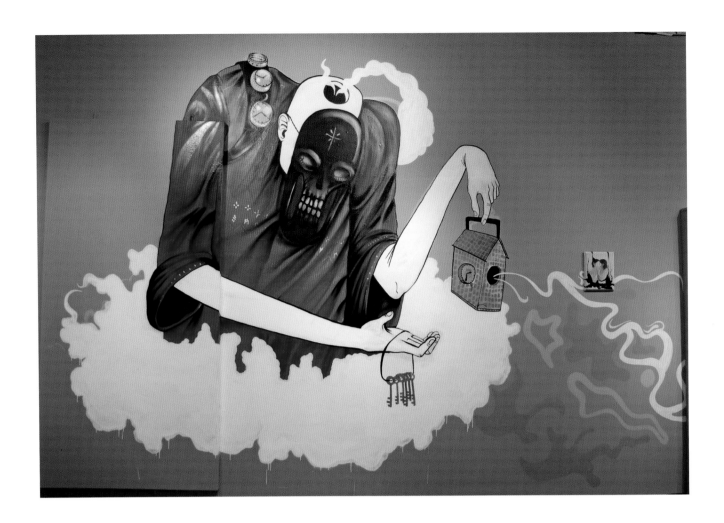

That's why location, perspective, movement and strength are important. I don't want to paint static beings, but characters capable of telling a story. Each one of them is unique, as are we.'

To give an example of one of his narratives, Saner recently began working on a series of paintings called *Bounty Hunters*. These murals feature characters who have coyote or dog skulls for heads. The whole concept is based on a story by Saner, a gruesome tale of lost innocence, in which these creatures steal people's souls.

Above all, Saner wants people to notice his work and to be intrigued by it, whether they are passers-by in the street or viewing it in a gallery. They may not know the stories behind his works, but ultimately they can make up their own.

For each project, Saner spends hours creating an initial sketch. All of his work, he says, has been born from simple sketches, but he always wants the sketches to have their own life. Finally he goes through all his sketches and chooses the best one. At any one time he may be working on a number of projects, all of which require study and preparation, but only he knows when something is ready to be painted as a final piece, which is a magical moment. Others will see the finished result, but only he can trace the journey of the piece – the beginning (a simple sketch), the personal experiences, and the decisions that the final piece required. His aim is that people take something from his art, use it, and identify their inner selves within it.

Guardians of Dreams
Sego

Sego is a young graffiti artist who creates extraordinary creatures and brings them to life on the walls of his native Mexico City. His artist's name, Sego, derives from his surname Segovia, and he chose it partly for its brevity and partly for its sound. It also has a family history since his professional footballer grandfather was known as Sego. The artist's father

was also a footballer, but while Sego enjoys sports, his passion has always been art. As an artist he is self-taught, developing through practice rather than academic teaching, and he feels strongly that this approach has kept his work honest.

Growing up in Mexico City, he became aware of graffiti and was inspired to try it for himself. He had no idea of what was happening in other parts of the world, and this allowed him to develop his own style without much outside influence. At first he started working with graffiti letters but this soon turned into abstraction, a style for which he used

the tag 'Ovbal'. (He still paints in this style and plans to create larger, more architectural pieces under this alter ego in the future.) His work as Ovbal resembled organic forms in an abstract way. Over time, these shapes grew more concrete and began to suggest animals, insects, fish and creatures that only existed in his imagination. As this new style developed, he decided to sign it with a new name – 'Sego'.

He calls these colourful life forms his 'Dream Guardians' and has given them all a shared history, imagining them existing in another dimension and manifesting themselves through

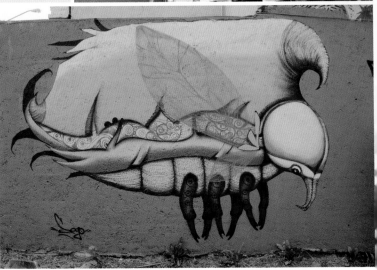

people's dreams and nightmares. In Sego's own words: 'These beings have a sinister side at first glance, but if you lose your fears they turn out to be your friends, helping you achieve your dreams.' The Dream Guardians are now in their third year, and their shapes, details and designs are still evolving.

The Dream Guardians owe much to the time Sego spent living on the Oaxaca coast when his father was transferred there for work. In this tropical region, he experienced an incredible diversity of plant and animal life, including reptiles, insects, birds and fish. This nurtured in him a passion for nature, one that

remained in his subconscious. Now when he draws organic shapes, he often extracts from those memories, as well as seeking new references to the natural world in parks, natural history museums and books.

Sego sketches out his ideas for a piece in blue biro, a technique that he finds works well for drawing in detail. Drawing and painting put him in an almost trance-like meditative state: 'I am inside a cocoon with my ideas in a way, putting them down on paper.' While his drawings are used as a base to plan a mural, he also improvises with colour and forms as he builds up the image

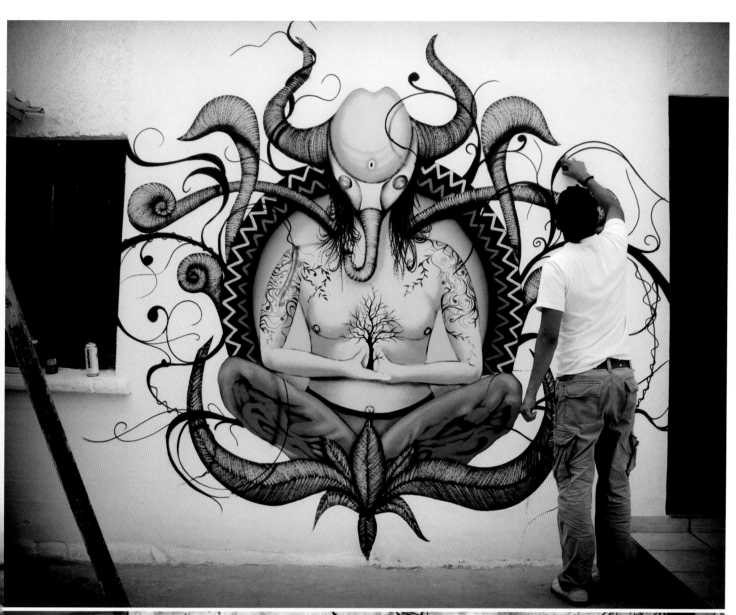

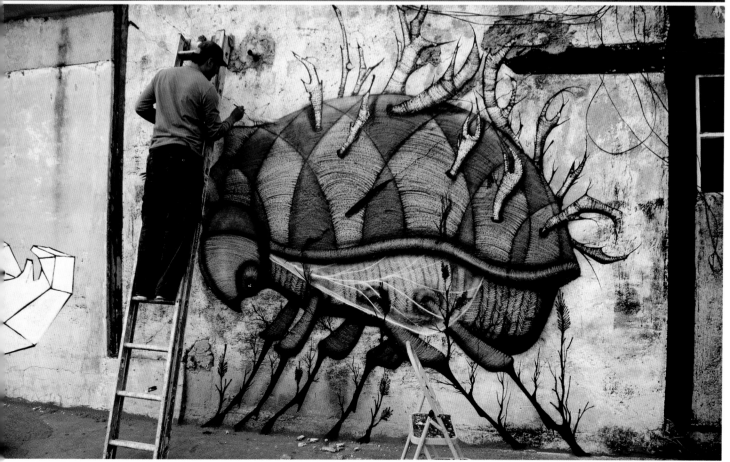

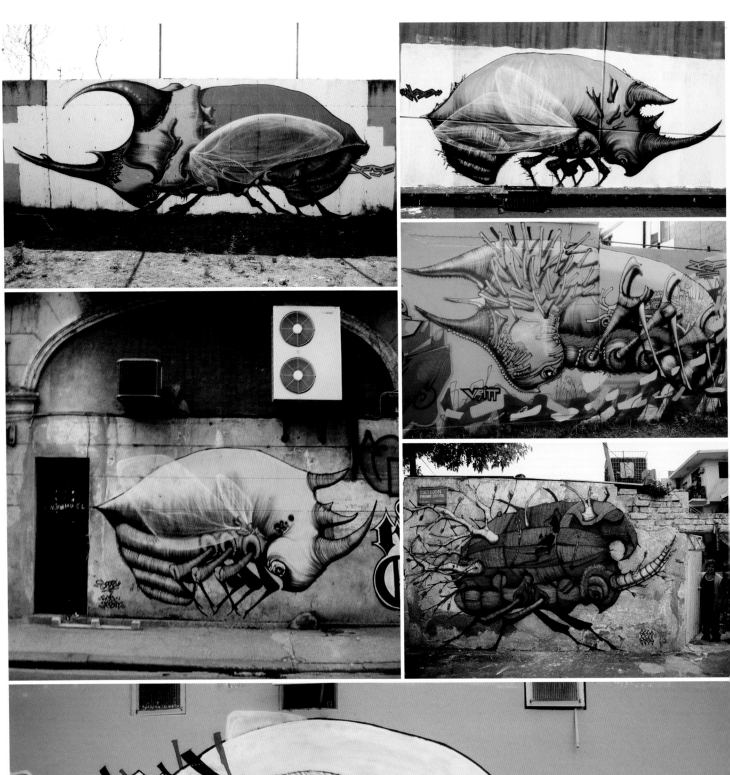

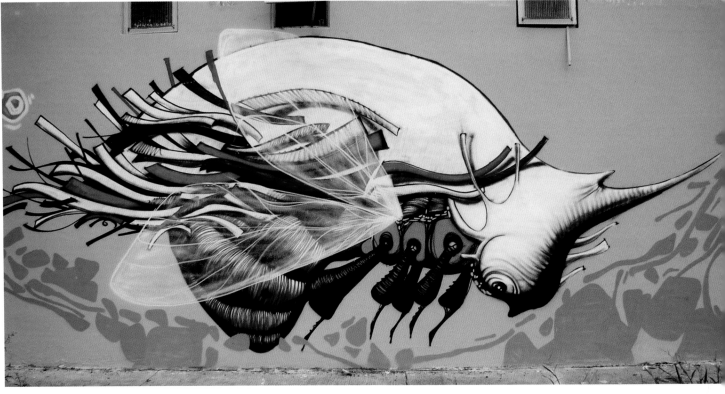

with spraypaint. 'Using the sketch as a base I let things flow, depending on the wall I choose to paint. Ultimately I try to select a wall that is pleasant to work on. It's better if it is in view and on the street, although I also paint in abandoned and closed places too. Before, I used to improvise a lot and I've had many opportunities to experiment, but I always have a very clear objective.'

Sego's paintings tend to be brilliantly coloured, although he is apt to change his palette depending on the mood of the piece or the materials available. He describes his treatment of colour as very instinctive and visceral, based on a pure love of colour but also influenced by the lively shades of nature. Through experimentation he has learned to create blends of colours, textures and transparent effects, giving his work more depth. His techniques take time and hard work; a piece can sometimes take him between six to twelve hours to produce, while others still have taken him three consecutive working days to complete.

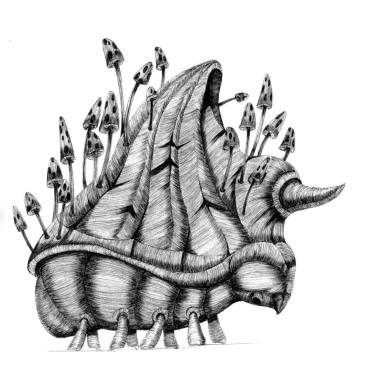

In addition to his time in Oaxaca, Sego has also been lucky enough to travel outside of Mexico. A trip to Havana in Cuba opened his eyes to the social realities there and made him appreciate the opportunities he currently has to express his ideas freely on the walls of his city. He also travelled to Paris, where on a visit to the Louvre he came across the work of Arcimboldo, an Italian painter of the 16th century, whose work left a lasting impression on him.

His home country of Mexico is an important part of his work's identity. Although he does not necessarily include obvious Mexican references,

Mexico City is the place that created him as a graffiti artist. 'I love this city: she has given me everything, and it's partly thanks to her that I am who I am,' he acknowledges. 'Currently there are graffiti artists here who are very good and authentic, but there are also some who have very orthodox ideas of how to do graffiti and they paint in a very traditional manner. This is true of all places where graffiti is made. I think Mexico has an important place in the future of graffiti worldwide, as the work of its artists is now maturing and being appreciated internationally.'

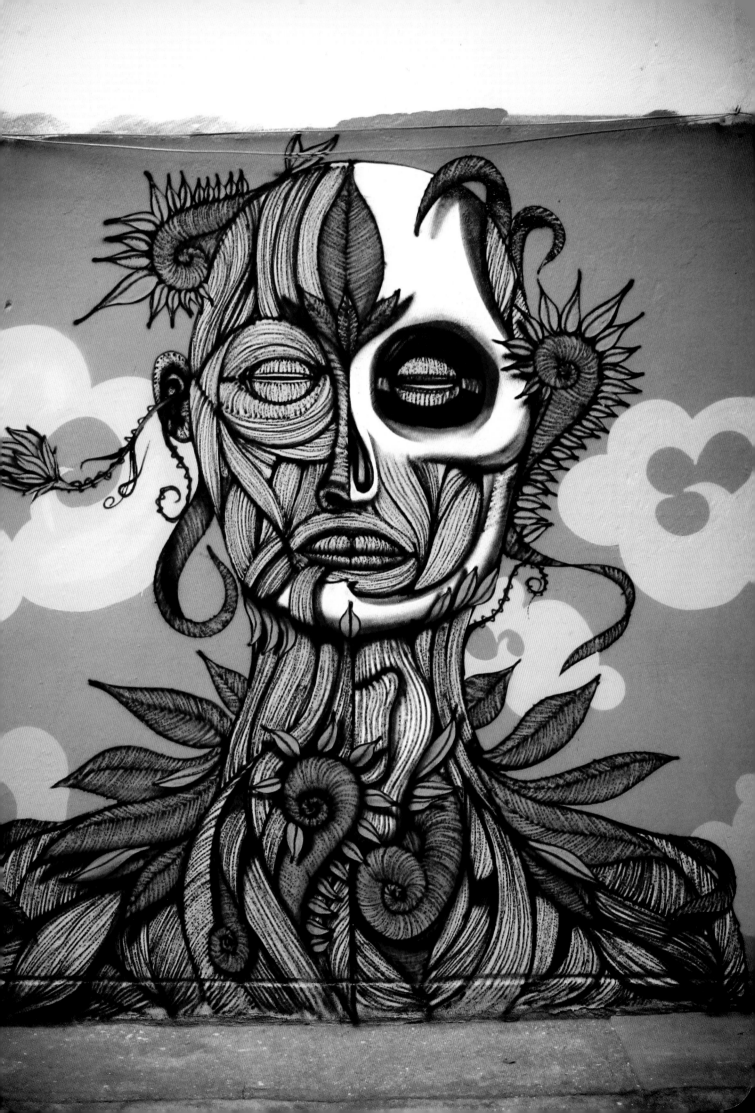

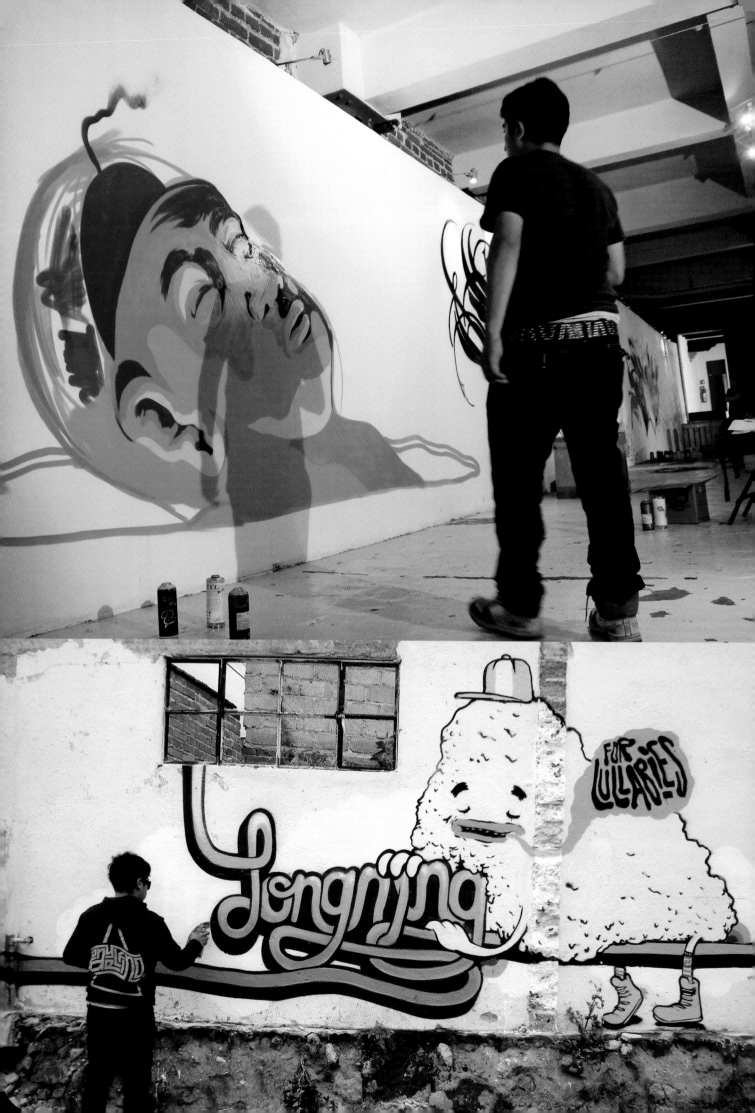

Mexican Milkshake
Smithe

Smithe was born in Mexico City and lives with his family in Iztapalapa, one of the most heavily populated and controversial boroughs in the city with a reputation for robberies and kidnappings. It is also a very religious place, famous for its re-enactments of the Passion of Christ.

Of all the artists featured in this book Smithe is one of the most varied in his creative outlets, working with both typographic and character designs in his graffiti writing and illustration, as well as producing electro music under the name Poligono. But it is on walls that he really lets himself go, mixing weird and wonderful figures with retro-tinged font concoctions, all painted in vivid and quirky colours.

Now in his early twenties, Smithe has been drawing and painting graffiti for several years, although artistically he feels that he has barely started on what he hopes will be a long road of discovery. He has changed his style many times, experimenting with colour, graphics and typographic elements to express his thoughts and new ideas. 'I use different kinds of media and situations when I make art,' he says. 'I put it all together into a machine inside my mind and it comes out like a milkshake.' The result is like a 'big graphic diary', he adds.

In both art and music Smithe's projects are normally self-initiated and self-produced. He absorbs himself completely

215

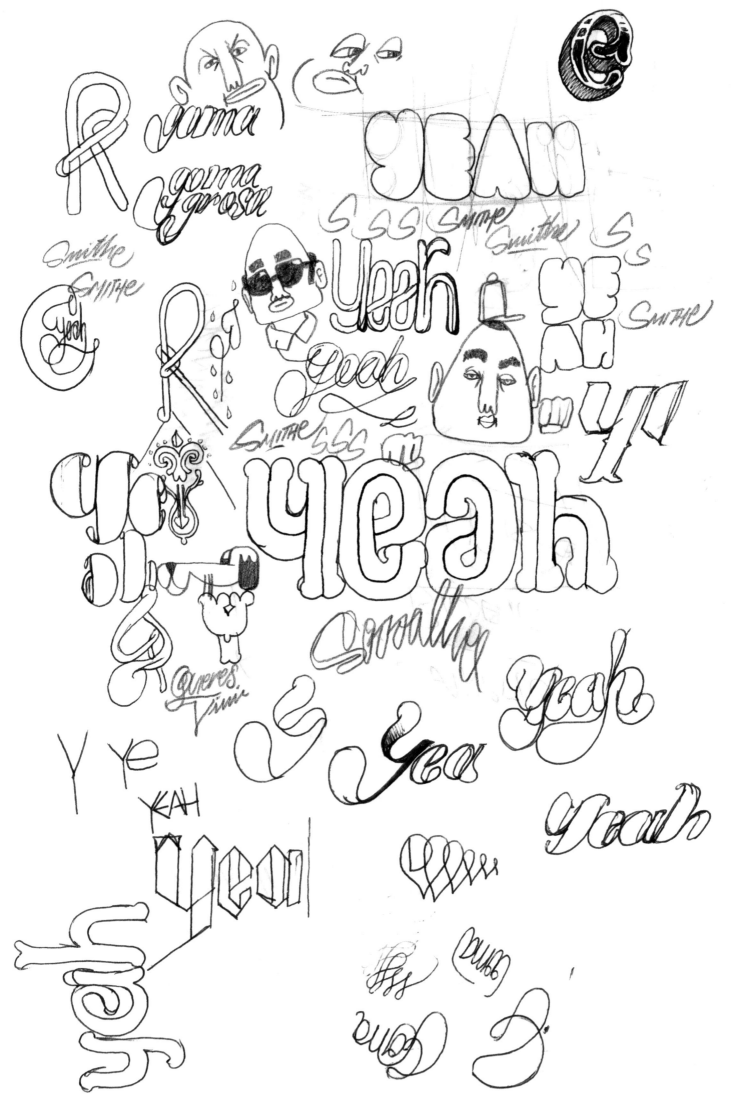

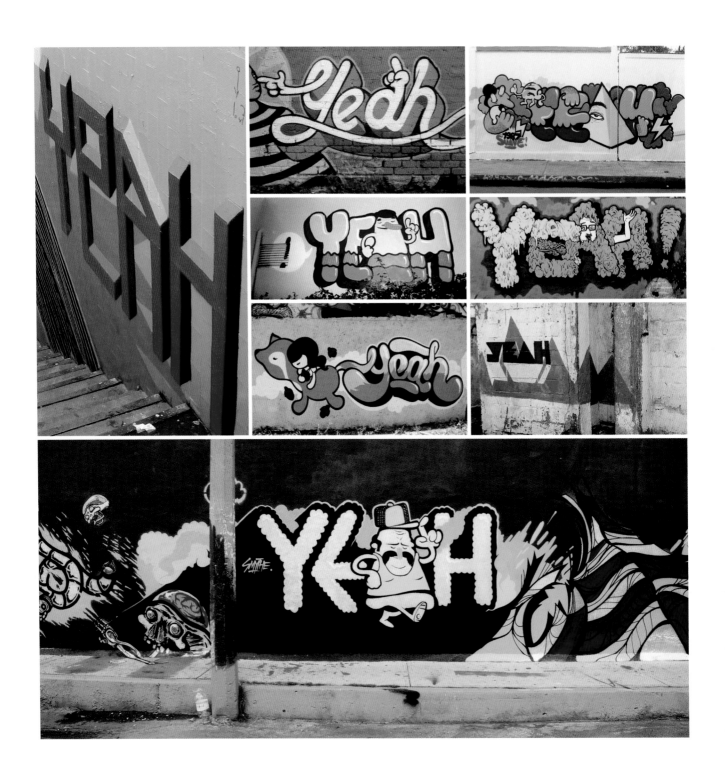

in each new venture and learns on the job. For example, his musical alter ego Poligono started out as a bit of fun with friends, but through this experience he learnt the basics of music production, by which time he was hooked. Within a year he was signed to a British music label and released three EPs; he also produced a lot of the promotional material. With friends he has also launched a T-shirt label called Goma Grosa, using freaky sci-fi and gross-out images. As far as Smithe is concerned, music and art are inextricably linked.

His characters usually fall into one of two categories: gruesome images or zany cartoons. On the horror side, he often depicts human guts and brains, which he finds therapeutic: 'I'm not a psycho, but I like to channel those dark thoughts onto the walls or into my illustrations, and try to keep them there.' There are no hidden messages in his characters; they are simply flights of imagination.

The lighter side of his work is uplifting and fun, featuring bright colours and funky fonts. One example is his 'Yeah'

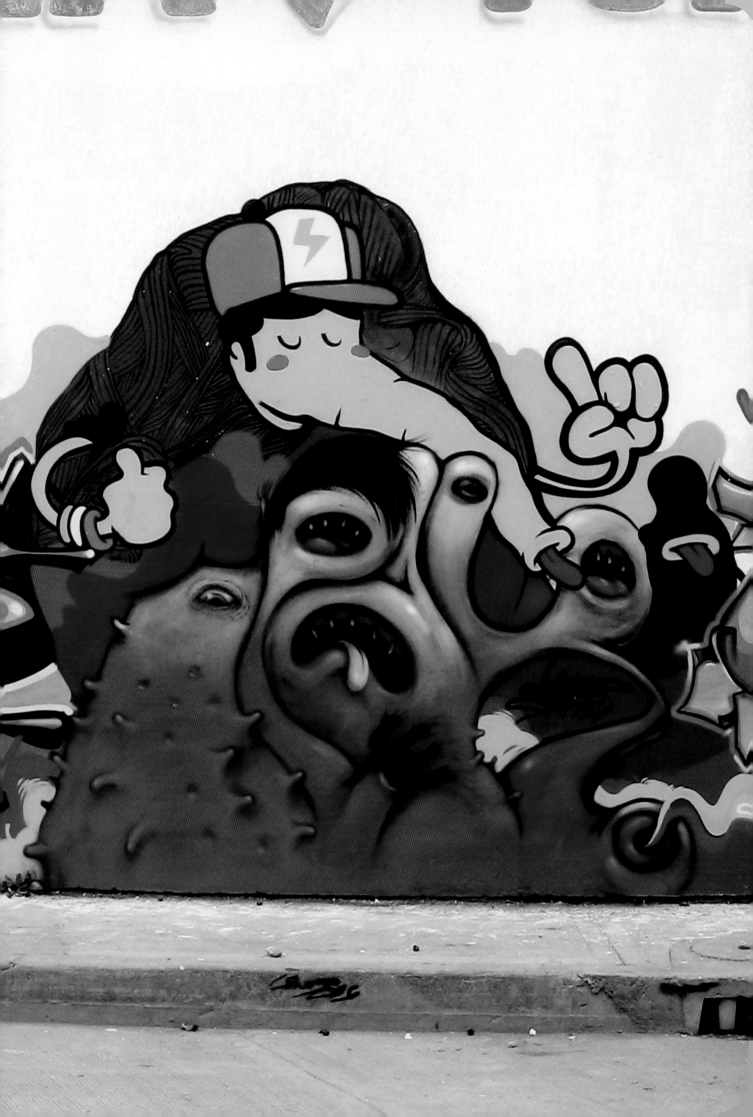

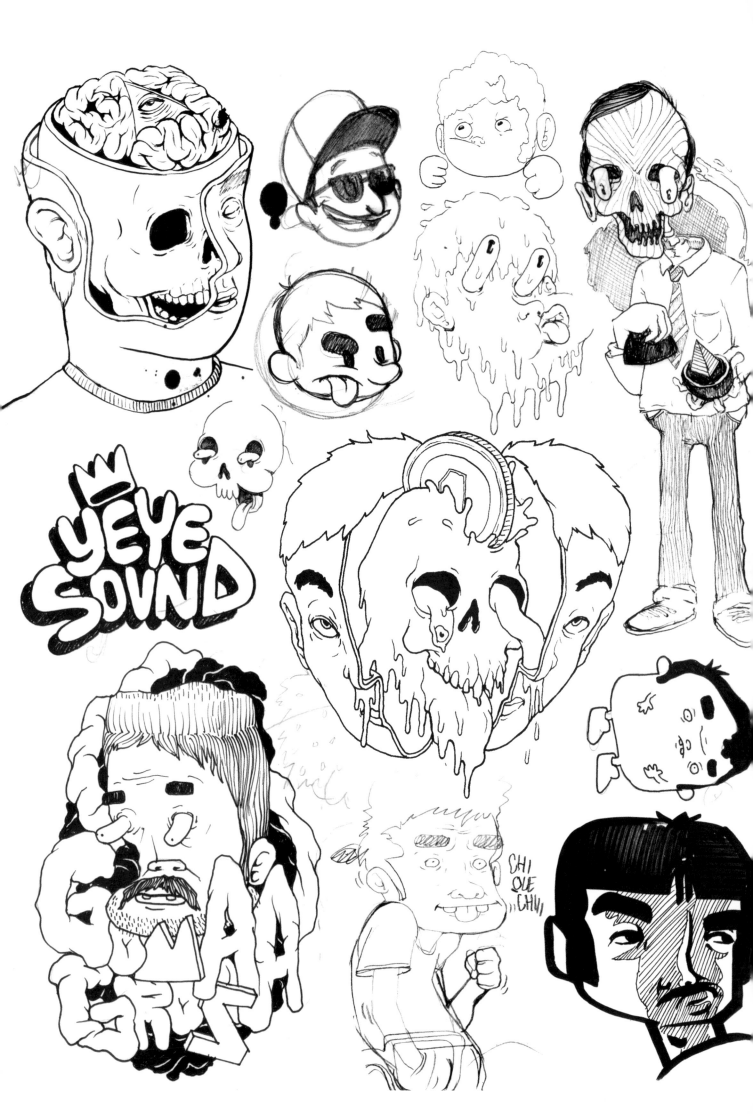

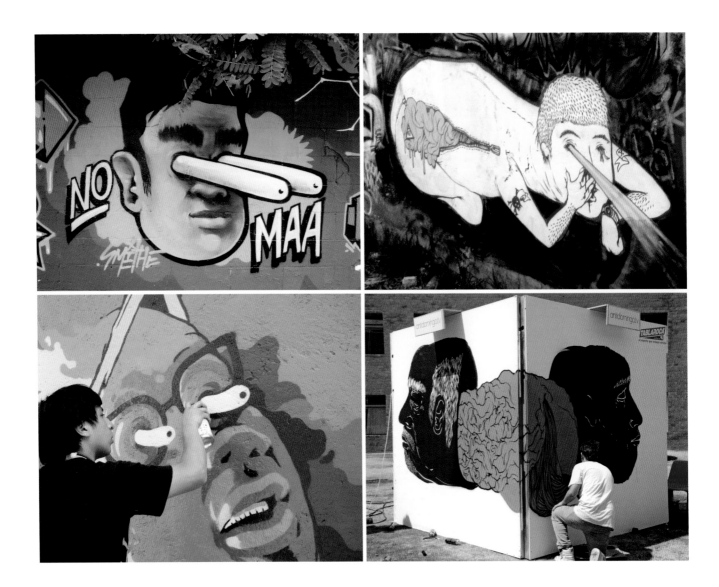

series, in which he tried to find as many different typographic ways as possible to write this exclamation. To reflect the energy of the word, he used simple palettes and solid colours. 'Every colour', he says, 'has its own personality, which we have to take advantage of.'

Smithe has a love-hate relationship with Mexico City, which has had a particular influence on his art. On the one hand, it was not an easy place to grow up, and had he lived somewhere else, perhaps he'd have taken a different path. But the city itself was a factor in him becoming a graffiti writer, and he loves the environment that encouraged him. 'Mexico is a country of friendship,' he says. 'Friends are so important. Without them, I wouldn't have grown up so fast.' Most of his pieces are painted

on the city's walls, which are like a giant gallery where everyone is invited, and he is always grateful for support and feedback from other artists.

In his eclectic fusion of different styles, Smithe takes inspiration from several sources such as the Spanish typeface designer Alex Trochut, American cartoonist and animator Mark 'Thurop' Van Orman, illustrator You Byun and artist Jen Stark. He sketches continually and notes down his ideas. Often he sketches the same thing several times so that it becomes etched in his mind and he doesn't need to refer to his drawings. As simple as it sounds, he loves creating from scratch, whether it be music or art, so that in the process there is always an element of surprise and of living in and preserving the moment.

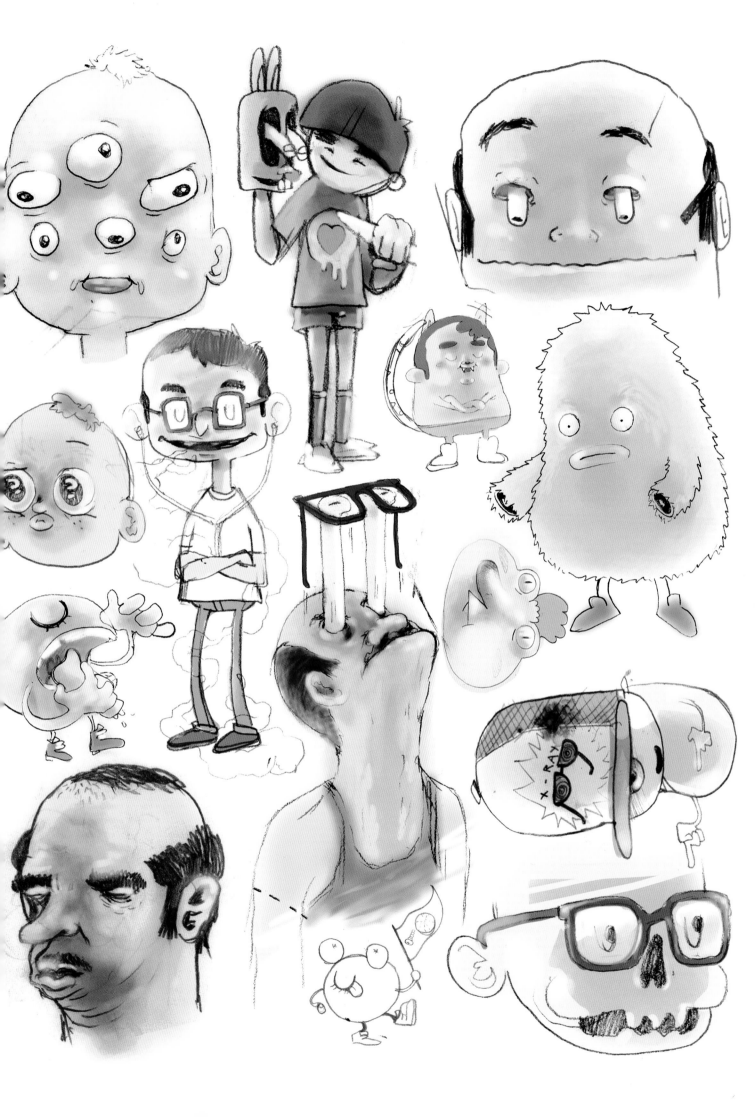

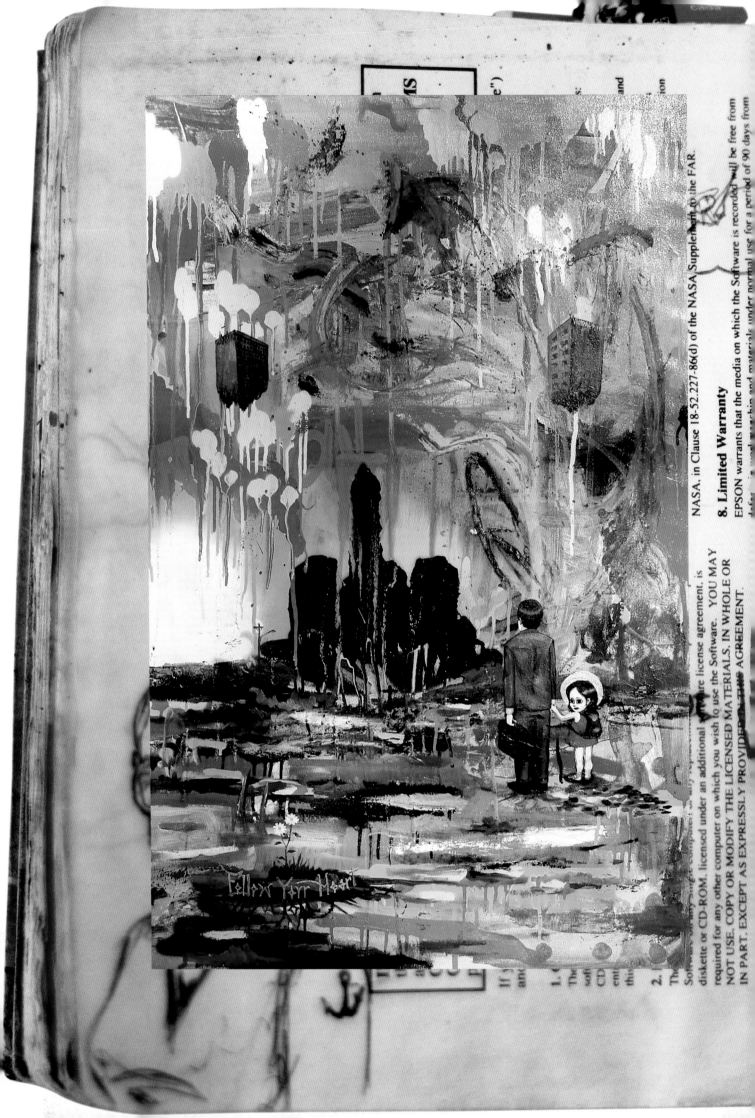

FUNCHAL

FUNCHAL

FUNCHAL

14,40

São Paulo Periphery
Tinho

São Paulo is a sprawling city where over 20 million citizens, rich and poor alike, live side by side. From the skyscrapered skylines of its central districts to the shantytowns at its edges, this massive urban landscape is the playground, inspiration and home of Tinho, one of the most talented and pioneering artists of the Brazilian graffiti scene.

These streets have been Tinho's training ground, and being surrounded by such social and economic distortions is a constant reminder that life can be hard. Although he explores many different themes, the city is ingrained in his work: how people live their lives and social and economic problems are subjects that he tackles head on.

People are drawn to the city looking for a better life – Tinho's own family originally came from Japan and faced the additional struggle of adapting to a new culture and language. He initially studied computer science, but later switched to fine art; in class he learnt about art history and practice, which

he then selectively applied to his street work. By the time he came into contact with the world of graffiti, he was already a punk and a skateboarder; this subculture had enabled him to explore the city on four wheels, but graffiti gave him the opportunity to express himself on the street. For Tinho, the city space and the act of making art have gone hand in hand ever since he first started painting outside in 1986 – initially tagging in the angular *pichação* style native to São Paulo, then later in the New York style of graffiti, inspired by the influential movie *Beat Street* (1984).

By the end of the 1980s, the energy that was radiating from the New York scene was having a deep impact on Brazilian graffiti. Tinho and other graffiti pioneers in São Paulo such as Binho, Os Gemeos and Vitché were young kids at the time, absorbing what they could from the limited graffiti videos and books, trying things out for themselves, sharing ideas and having fun painting.

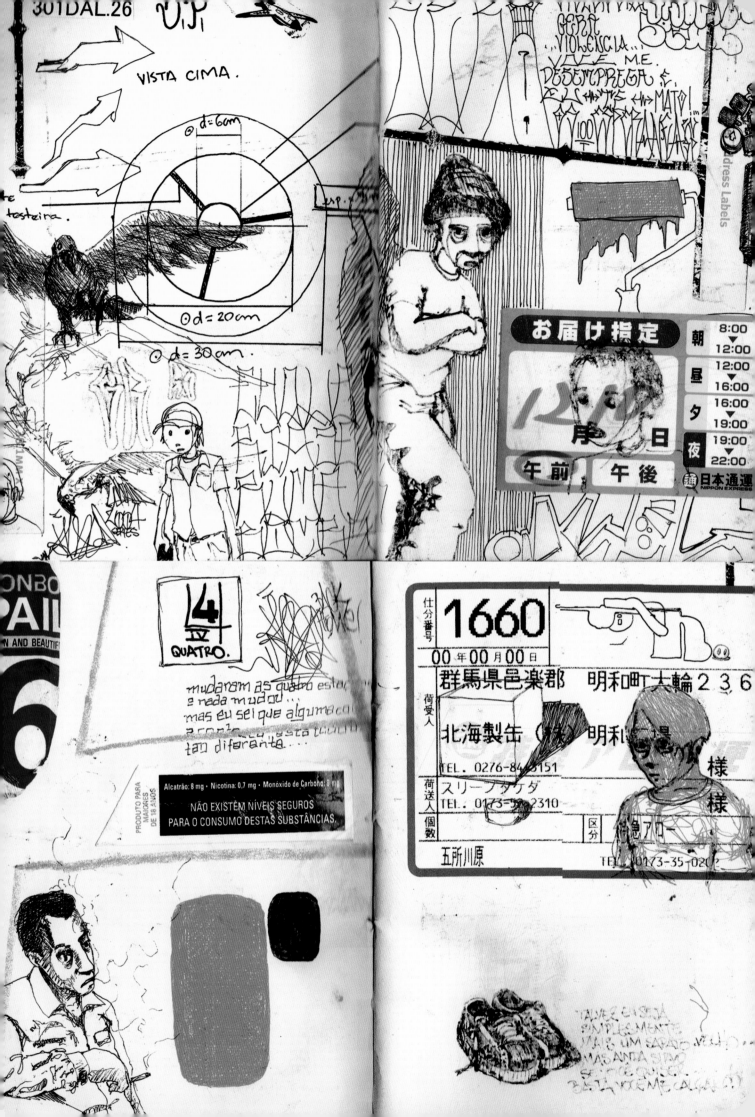

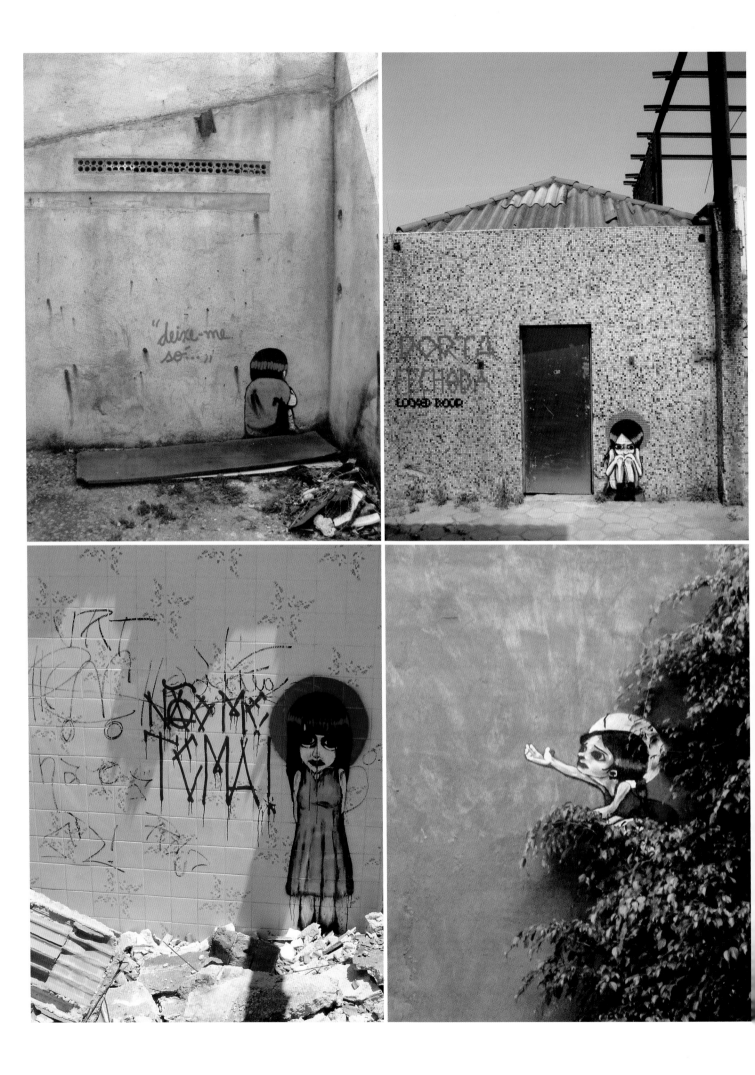

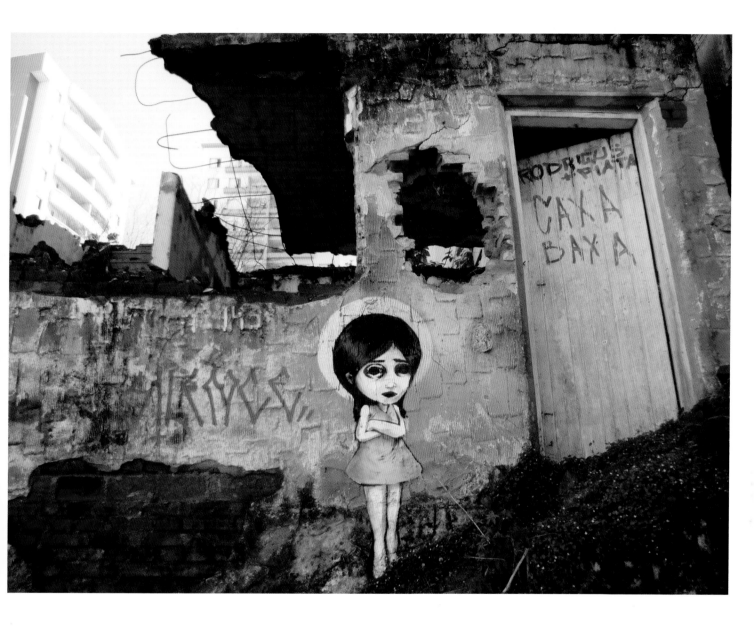

In the 1990s Tinho and his friends began to find their own voice, experimenting with new approaches beyond wild style to create what became known as freestyle. Tinho's particular freestyle involved layers of household paint overlaid with spraypaint, in a collage approach to composition that echoed the work of American Pop artist Robert Rauschenberg and punk fanzines. Punk and Pop art were influences, but Tinho's style also had its roots in the Paris old school, American West Coast and German new schools of graffiti. His pieces were a riot of colour and shapes that had

evolved from graffiti lettering to become something new. Absorbing the colour and attitude of graffiti, mixing it with the hues and flavour of the Brazilian landscape, it was a style that was completely unique to the Brazilian graffiti scene and continues to evolve in his art to this day.

After graduation he began to teach and show his art in schools, but gradually art institutions such as galleries and museums became interested in his work and started to exhibit it. This pattern of teaching and exhibiting gave him time to grow as an artist both in the context of

creative institutions and in the free spaces of the city. In the institutions he enjoyed the critical discussions with curators, other artists and his own pupils, while on the street he found direct contact with the public invaluable.

Tinho's work invites a reaction, often dealing with raw issues of social injustice and emotional and psychological subjects. While his images may have an underlying theme, such as messages against violence or exploitation, they are often layered with personal and human experiences, for example an encounter or a memory that plays a pivotal role in the

ARTE PUBLICA – P/ SER OBSERVADO EM PUBLICO
EQUILIBRISTAS

bebado?

vivendo dentro do armário

ME LIKE YOU

painting. For Tinho and the viewer, it is these emotional and personal feelings that are important to explore and that give soul to his work – the general sense of an innocence lost in his paintings, tackling both the beauty and the sadness of life.

Symbols are important in Tinho's visual language; without them, he says, 'we could not be where or who we are'. Children are often used as central figures, symbolizing hope in otherwise tragic scenes; they stand for us, as there is an inner child in us all. Another recurring symbol is tower blocks, which Tinho uses to signify authority in our society, figures such as politicians, judges and rich businessmen. Sometimes he paints these buildings with their bases destroyed to convey the idea that these powerful people are untouchable, have no concern for other people, and have lost touch with reality.

As interest in Tinho's work has grown, he has been invited to exhibit around the world. 'Each journey has been important in my life,' he says. 'To get to know different people, different cultures, different landscapes, architectures and sounds... even the similarities are very important to me. Looking at the similarities between different people in different places is very interesting. All these things help me to understand human nature.' Even in his own city he sometimes just walks around looking for areas to paint and studying the behaviour of the people around him. Whether listening to friends and family or watching passers-by, Tinho is a great and compassionate observer of life who brings empathy and real emotion to his art. His overall message is that we should strive for a better world where we have a deep sense of compassion and respect.

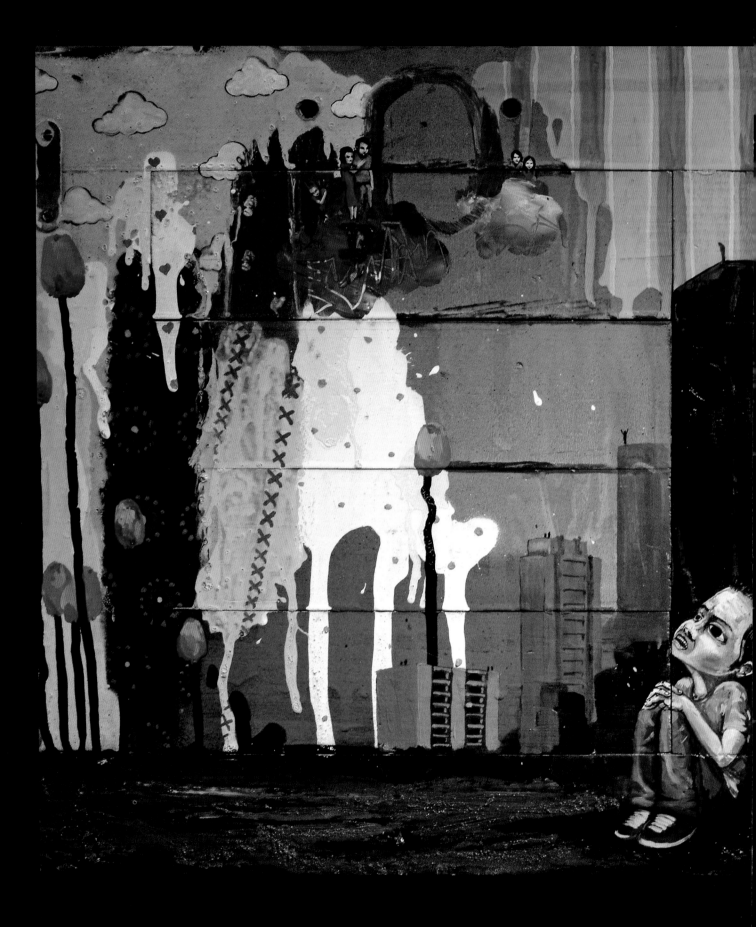

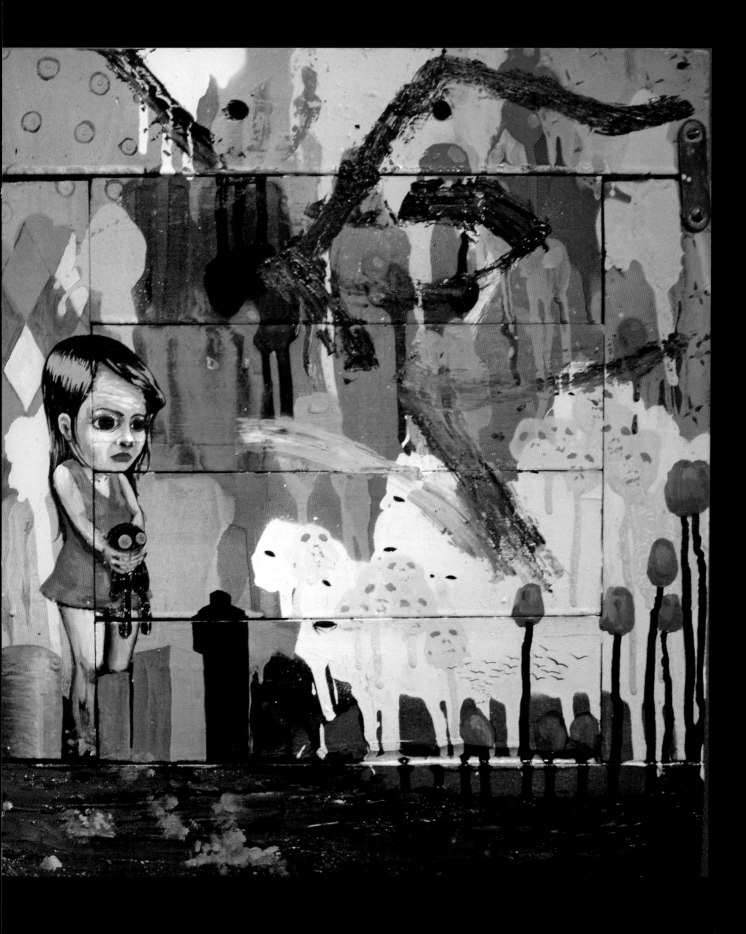

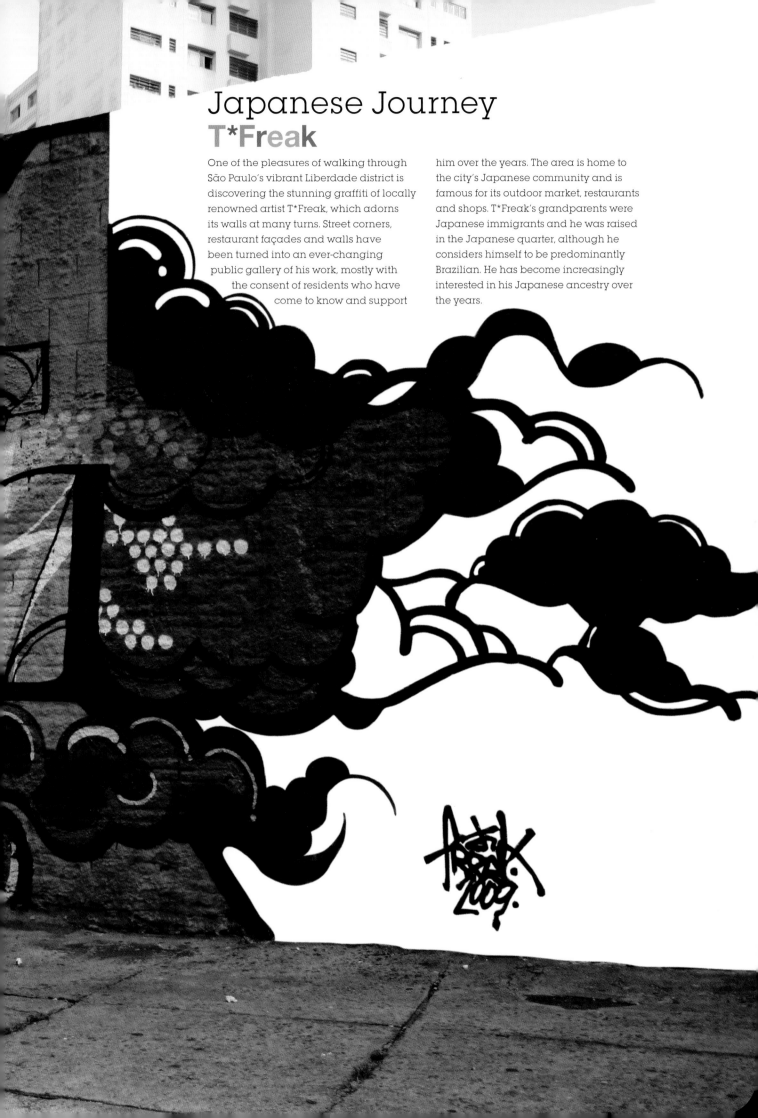

Japanese Journey
T*Freak

One of the pleasures of walking through São Paulo's vibrant Liberdade district is discovering the stunning graffiti of locally renowned artist T*Freak, which adorns its walls at many turns. Street corners, restaurant façades and walls have been turned into an ever-changing public gallery of his work, mostly with the consent of residents who have come to know and support him over the years. The area is home to the city's Japanese community and is famous for its outdoor market, restaurants and shops. T*Freak's grandparents were Japanese immigrants and he was raised in the Japanese quarter, although he considers himself to be predominantly Brazilian. He has become increasingly interested in his Japanese ancestry over the years.

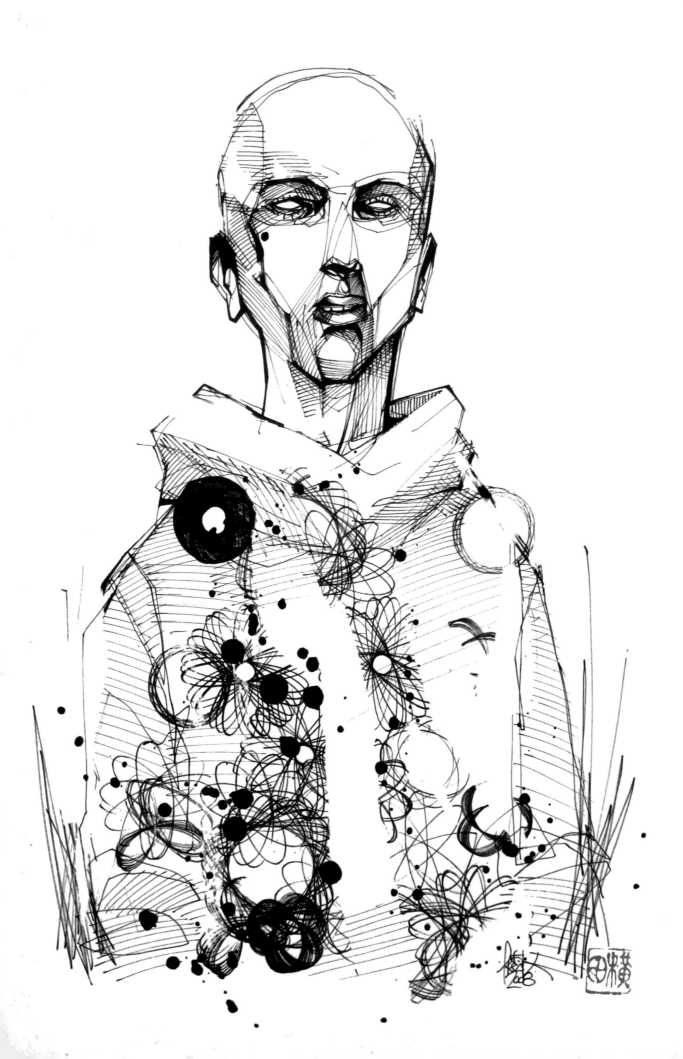

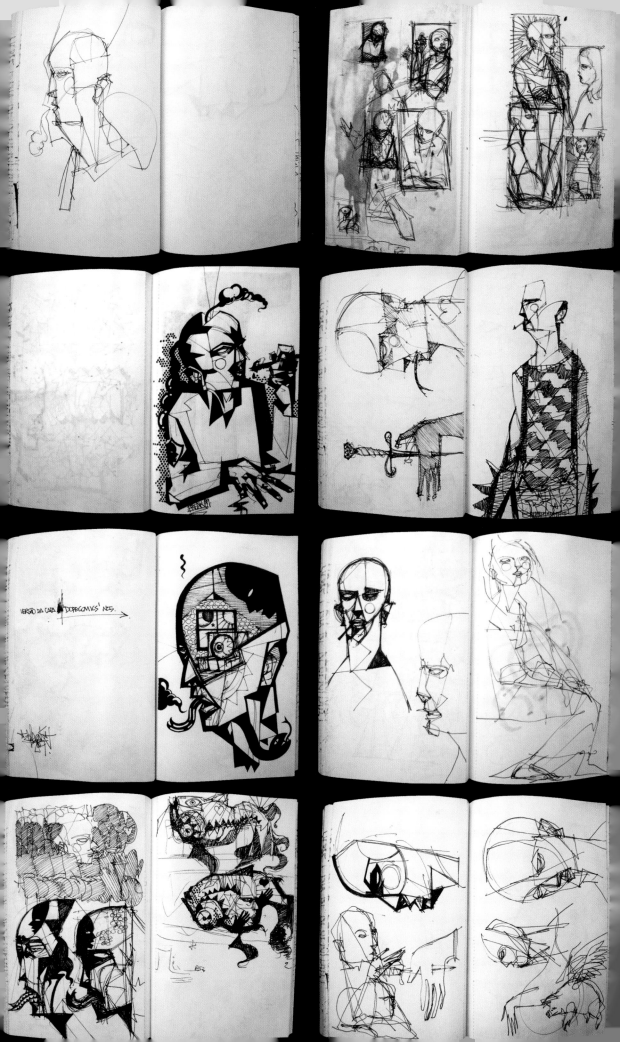

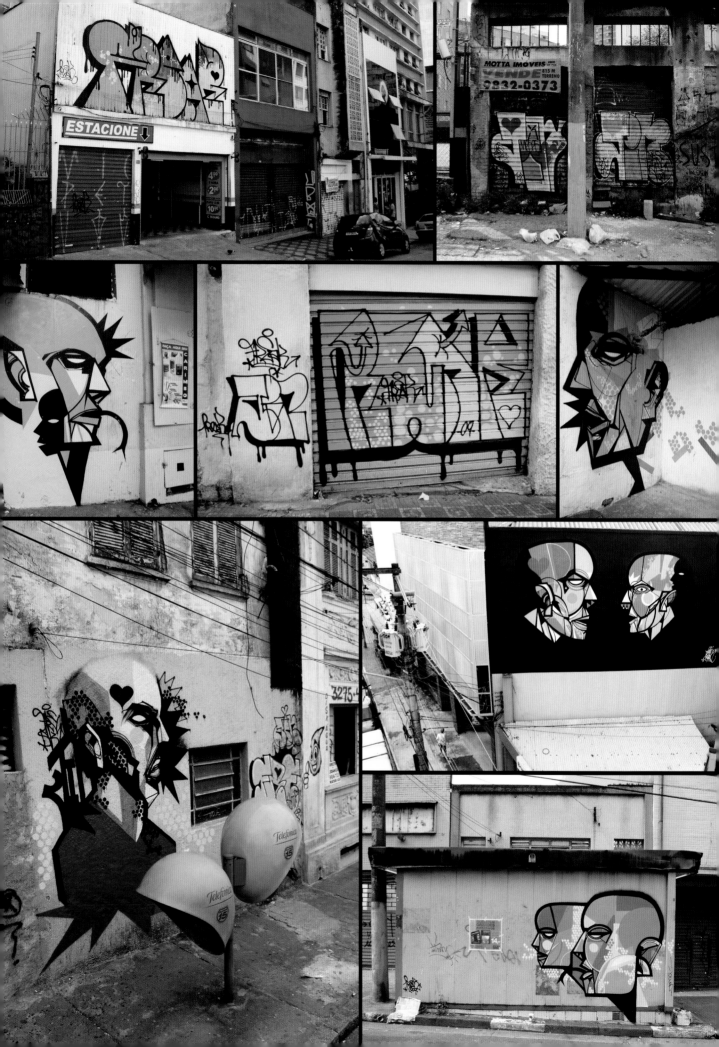

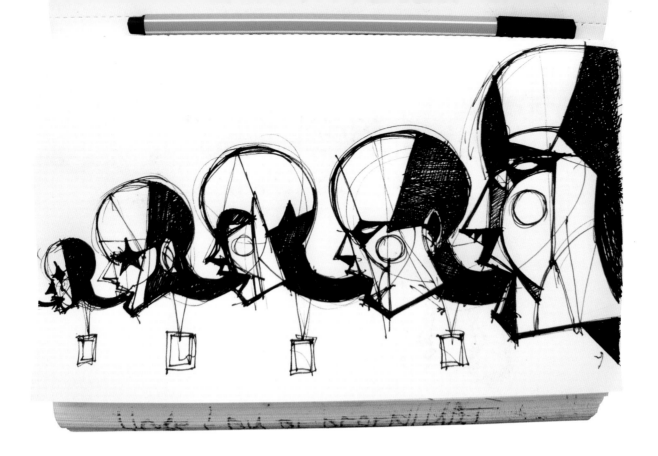

Brought up on comics, T*Freak (short for Titifreak) began drawing at a very young age. His talent was soon recognized, and he was offered work at Mauricio de Sousa Studio, one of the most successful comic-book companies in Brazil. He was only thirteen and, as the youngest employee, was affectionately given the nickname 'Titi' after one of the studio's famous cartoon characters. 'Freak' was added later, around 1995, when he started to get involved in graffiti.

At the comic-book company there was little opportunity for his unique style to flourish. Graffiti offered a new-found freedom and excitement; it enabled him to be entirely spontaneous and personal in his creative expression. Today his references have moved beyond comic art to include all kinds of influences, but the joy of creating something personal and free remains at the heart of his work.

Between 1995 and 2005 T*Freak built up a reputation as an artist

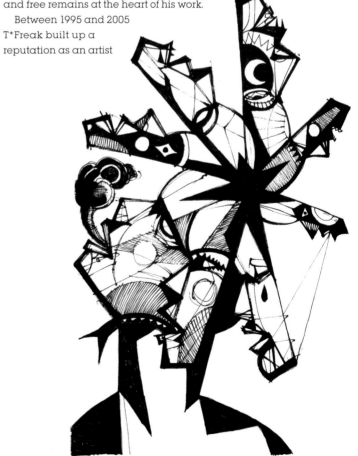

and illustrator, creating designs for T-shirts, magazines and animation, as well as painting and developing his graffiti. After more than ten years of applying his skills on the walls of São Paulo, in 2006 he was given his first solo exhibition at the city's Choque Cultural gallery.

The success of this show led to increasing international interest in his work, and in 2007 he began to receive offers to participate in shows in New York, St Tropez and the British seaside town of Brighton. It was also an important year

in his personal life as he met his wife, a Japanese artist. Following a whirlwind romance, he made his first trip to Japan and staged a solo show in Osaka, which was a landmark moment for him. He found it hugely inspiring to experience the culture of his grandparents, and quickly became immersed in a culture that was both familiar and yet at the same time new to him.

In Japan graffiti is not widely appreciated and is far less common than on the streets of Brazil. It is also far

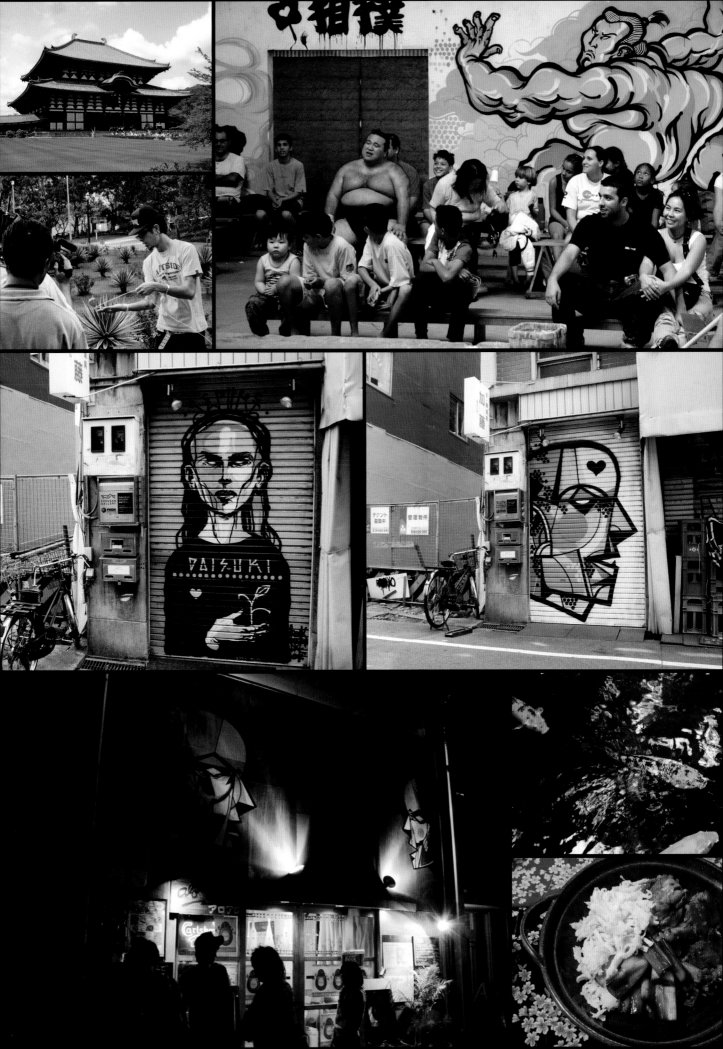

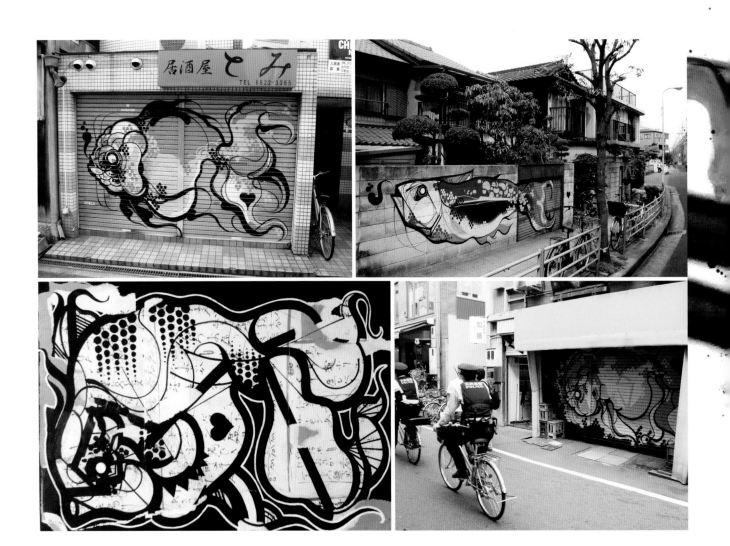

more difficult to evade the authorities, although this gave T*Freak even more of an incentive to show the people of Japan his Brazilian painting style. Painting in broad daylight, he asked the locals for permission, while the public enthusiastically watched him in action and talked to him as he worked. In 2009 he made a second trip, and many of his pieces still adorn old neighbourhood bars, the sidewalls of private houses, and steel shutters in the centre of the city where his ancestors once lived. Different places require different solutions and ideas, and the change of routine made him look at his life and approach in a new light.

Another turning point for T*Freak was the birth of his son, which changed his outlook not only on life but also his art.

His paintings began to feature images of family life and the bonds between parent and child, and he spent more time at home sketching and formulating new ideas. At the same time he took a break from his more established figurative style, with which he had become synonymous, and instead began to bomb 'Freak' and also his son's name on the streets in strong and funky styles. It was a way for him to empty his mind. When he started to draw faces again, he found that the bombing had influenced his painting style, which became more flexible – looser, more angular, bolder and more graphic.

The experiences of the last couple of years have opened a new door for T*Freak's work. The time at home sketching, the bombing, his travels and family life

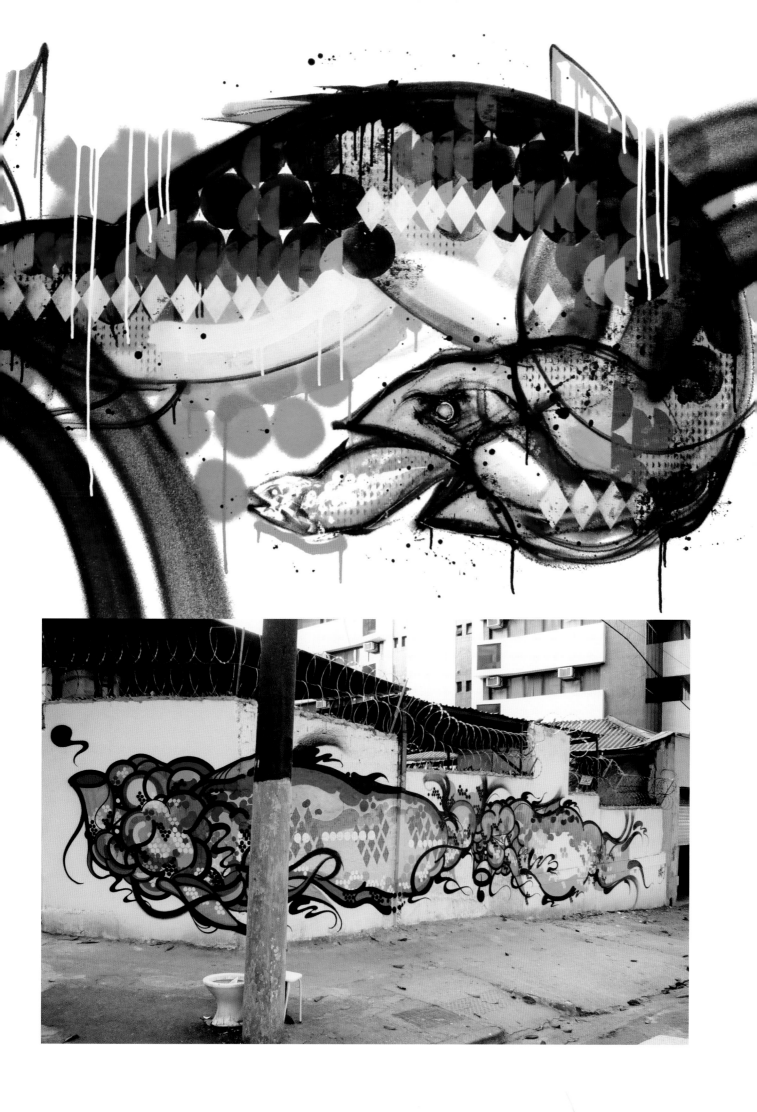

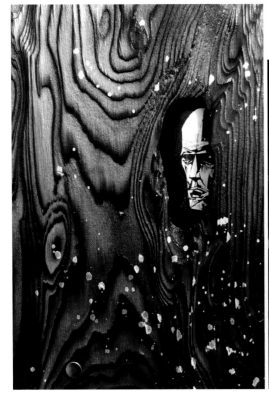

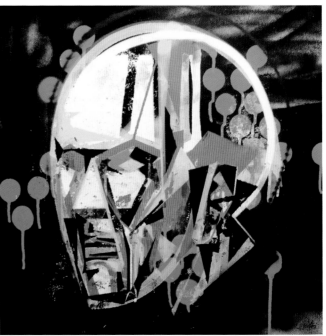

have all had a major influence on his work. By literally drawing from all his experiences, he now feels that he has a better understanding of himself and his artistic approach, and is more flexible and open to new ways of expression. A good example of this is his celebrated series of 'fish' murals and paintings, which he began in São Paulo and continued in Osaka. With bold blocks of beautiful colour and pattern and layers of delicate details, they combine all he has learnt from his career in illustration with his years of painting graffiti, and their fluid style is infused with the emotions of his personal experiences.

There is one word that T*Freak often uses in his artwork: 'sempre', meaning 'always'. This word 'represents the desire to maintain myself as I am now, always working and going after my dreams, always with my heart light and open, always with love, always preserving my character in order to continue growing. It is a way of saying that we will always be learning.'

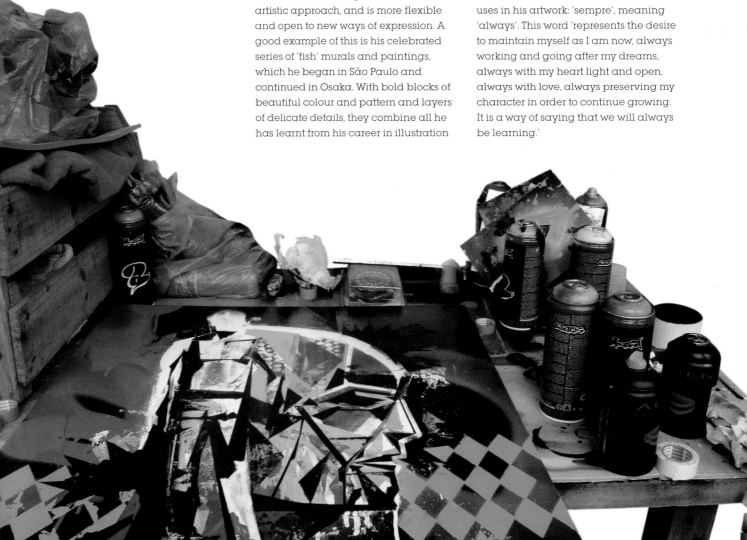

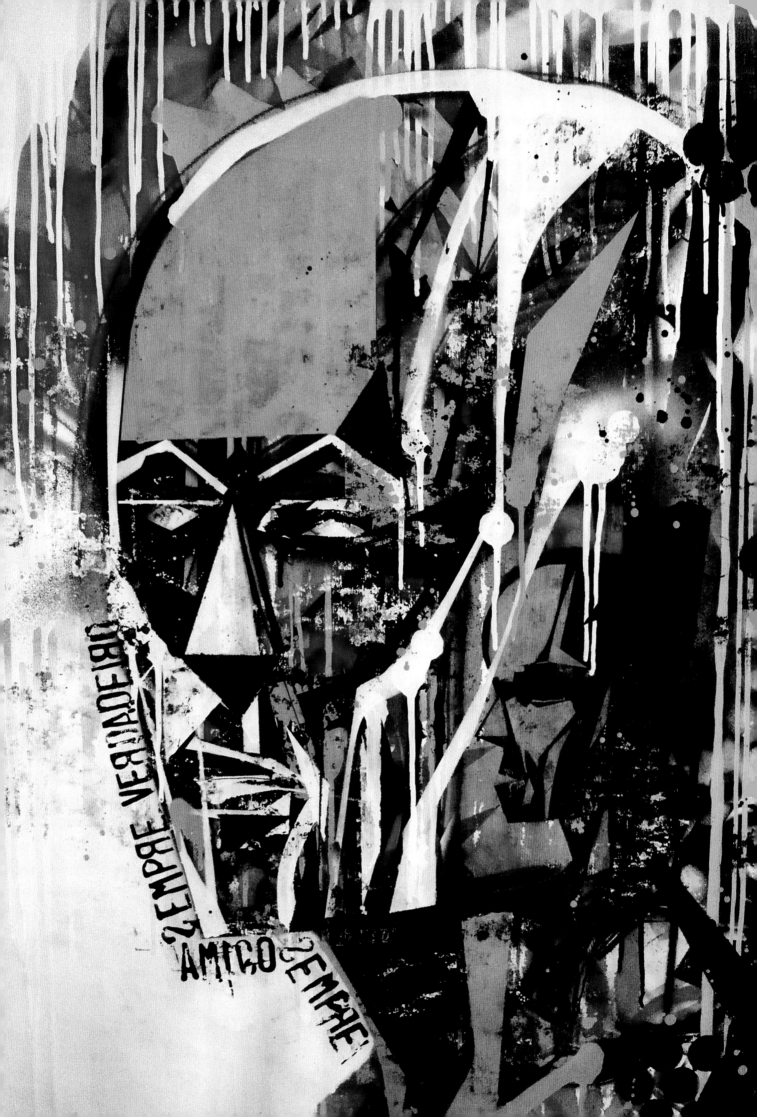

The Decameron of Giovanni Boccaccio
Basco Vazko

For ten years, Chilean artist Basco Vazko has been religiously illuminating the pages of one book. Wherever he has lived and travelled, this ongoing sketchbook has been his companion, and he paints and draws in it whenever he can. Each page represents a new day, a visual diary of thoughts, dreams and experiments. The book in question is a Korean edition of *The Decameron* by the 14th-century Italian author Giovanni Boccaccio. Basco found the book in the street, in the Asian neighbourhood

of Santiago. Something about it inspired him to recycle it and give it new life by painting over its pages. The book has more than 800 pages and so far he has painted up to page 657...

The Decameron, which was completed in 1353, is a medieval allegorical tale. It opens with a description of the bubonic plague and follows a group of men and women who have fled Florence to hide in the country. To while away the time, they tell each other stories of love and fortune, which make up the content of

the book. The tales are full of symbolism and, though the connection is purely accidental, are a perfect base for Basco's own work, owing to the artist's fascination with arcane symbols, his love of history and his particular liking for printed ephemera.

Finding the book that was to become his sketchbook was a significant moment, as it was around the same time that he began painting in the street. It was the end of the 1990s, and artists in Chile and around the world were

developing their own distinctive styles rather than imitating the mainstream spraycan art of New York's heyday. This was certainly true of Basco, who in relative isolation began to produce work in a completely uninhibited way. Although still inspired by the original energy of hip-hop graffiti, his imagery and approach were detached from the old graffiti styles. Instead he began to paint in a bolder and more direct manner, using flat colour, raw primitive lines, and decorative details that were more in keeping with fine art and illustration than graffiti.

On the streets of Santiago he let his imagination run riot, painting strange images such as colonels in old military uniforms and anthropomorphic creatures that seemed to have escaped from storybooks. In the spirit of Surrealism he wanted to surprise himself and his friends continually with new subjects, techniques and materials. He never painted the same thing twice; nor did he follow any particular compositional rules. His characters playfully interacted with the city's walls, sometimes with angular calligraphic messages or symbols. It is often said that

graffiti artists use the street as a canvas, but Basco's work goes one step further. He seems to view the weathered streets and faded façades not as an accidental background for his work but as an integral part of the whole picture.

Basco sees himself as a painter rather than an artist or street artist. As a kid his father, who was also a painter, encouraged him by buying works that Basco had done on paper. He was fifteen when he sold his first painting to a collector. He has no qualms about parting with paintings on canvas, saying it is 'almost like they were asking

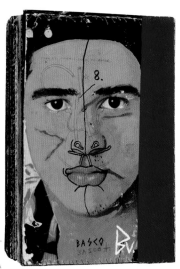

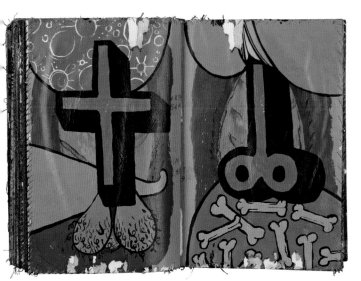

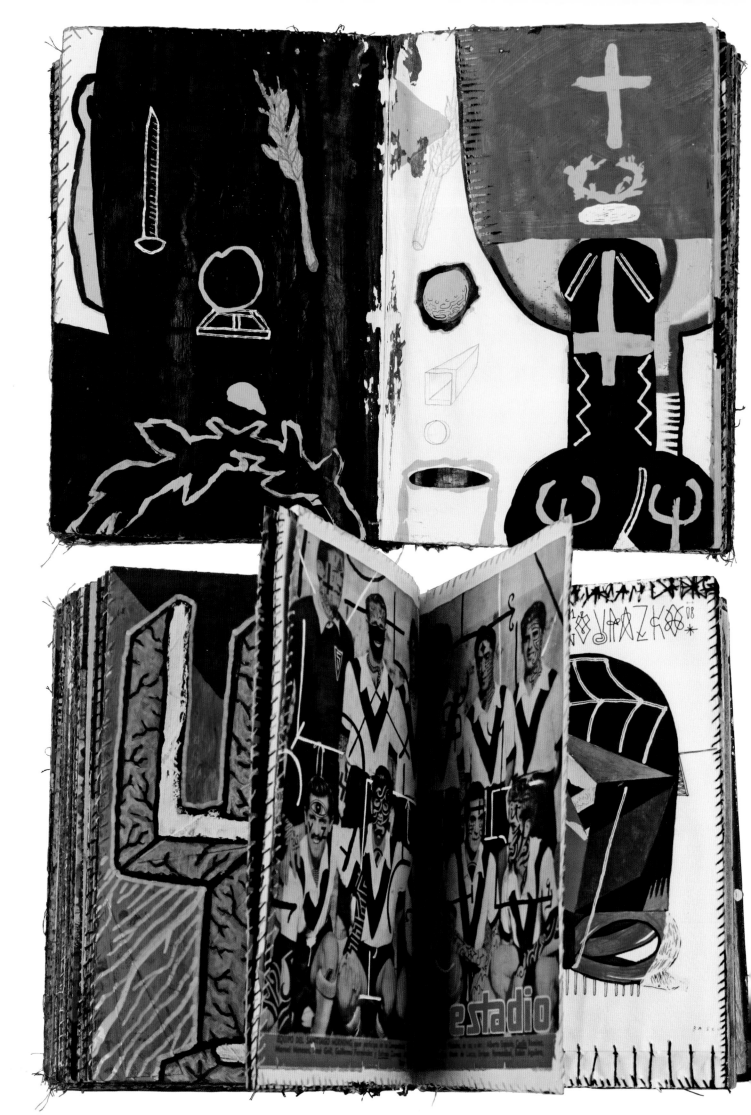

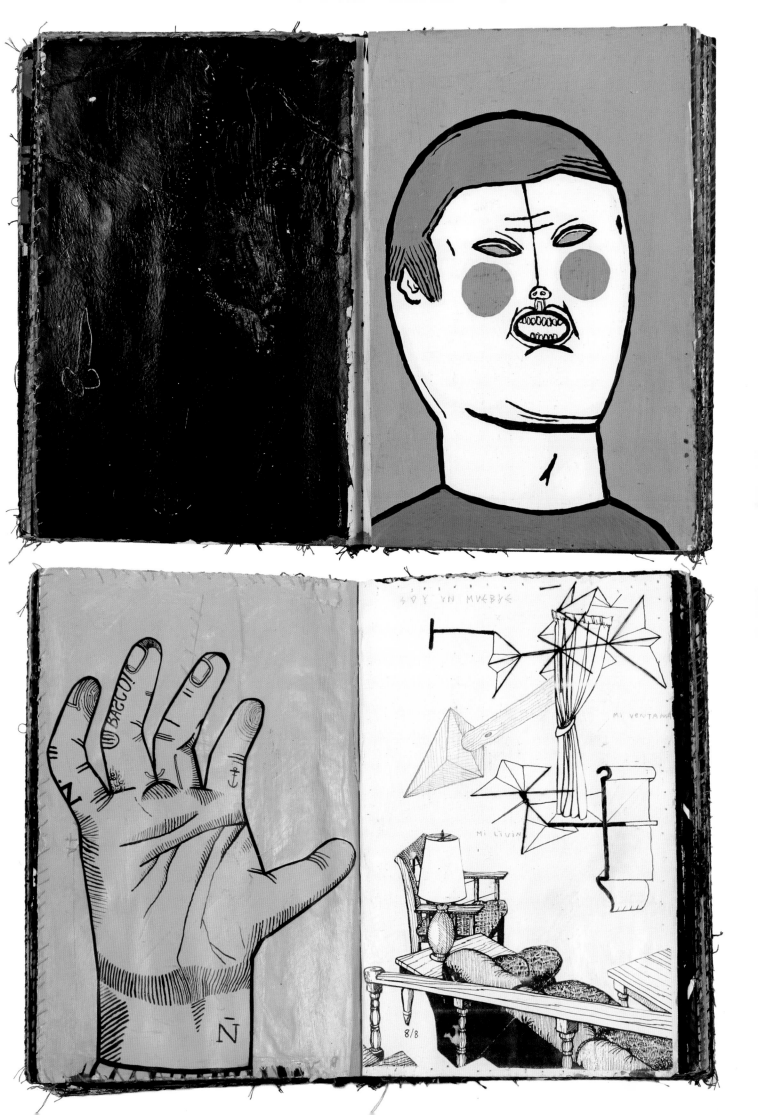

to be painted, and it's useless to pile paintings in a corner'. Whether it's a wall or a canvas, he paints with the same care and honesty.

Basco paints continually in the street and in his studio. He compares his studio work to the process of making an album, and painting in the street to playing live. When he is preparing for a show, he isn't able to work in his studio as freely as usual due to the time constraints: 'I draw a lot and then, when a solo show is three or four months away, I focus on one idea. The development of the subject and the

final result, however, remain unknown to me until it is done. I guess the reason I seem so open is because I believe that any graphic solution may be used if it helps in the creation of an image. I am always searching for new graphic solutions, and I try to avoid cultural trends and obvious elements.'

Although still in his twenties, Basco has done his fair share of travelling. From 2004 he spent three years in the USA. While he had some success with a solo show in San Francisco in 2006, he moved around a lot doing all sorts

of jobs and eventually returned to Chile. With Santiago as his base, over the next couple of years he began to explore different cities in South America. He wanted to document the exciting South American graffiti movement and produce a book about it: 'My intention was to examine the subject of painting walls, its culture and my relation to it.' During this time he visited ground-breaking artists such as Herbert Baglione, Os Gemeos and Nunca. *Donde Esta Mi Corazon?*, which he designed himself, features photographs of murals and

BASCO / VAZKO 08.

atmospheric images juxtaposed with collages and drawings in response to this journey.

One of Basco's growing passions is collecting ephemera such as old books, stamps and magazines, some of which become an element or starting point in his work. In 2009 he created an entire show of paintings on found covers of *Eva*, a Chilean women's publication from the 1940s. These vintage magazines had a particular charm and tended to feature a model's portrait on each issue. For the show he painted over these portraits and adapted them in an endless number of ways. Integrating anatomical parts, icons and patterns, and leaving some of the original models still visible, his arresting images appear partly historical, partly scientific and futuristic.

The Decameron sketchbook, which Basco has taken with him on all his adventures, also illustrates the artist's tendency to reuse and add to found objects. As the years go by he illustrates more and more pages, although no page is ever finished and he tends to go back and forth adding more detail.

As he explains, 'It's a never-ending story, and I don't intend to ever finish the book. That's why, up till now, I haven't actually been willing to show it to anybody... Not a single page is done, no picture in it feels complete.' Although Basco has revealed a few pages of this private work in this volume, his sketchbook still holds some secrets. Many of its pages are sewn together around the edges, hiding some of the book's content. The idea, he says, 'is to keep most of my thoughts and ideas hidden away, within the pages that can't be seen'.

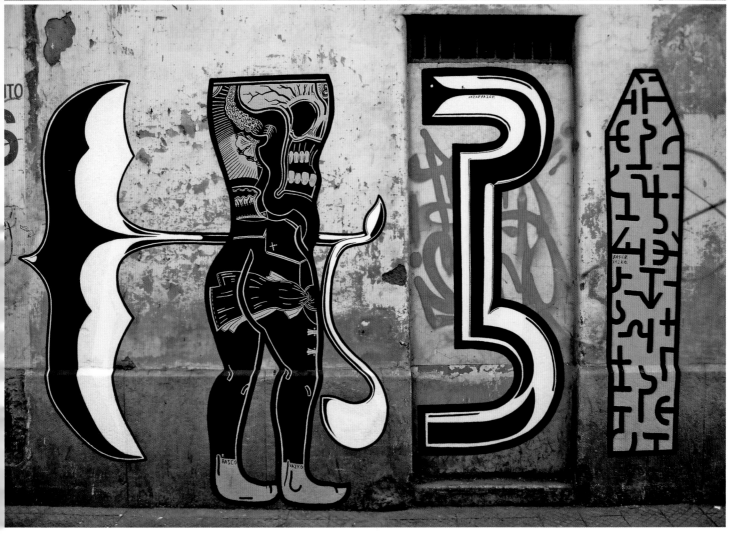

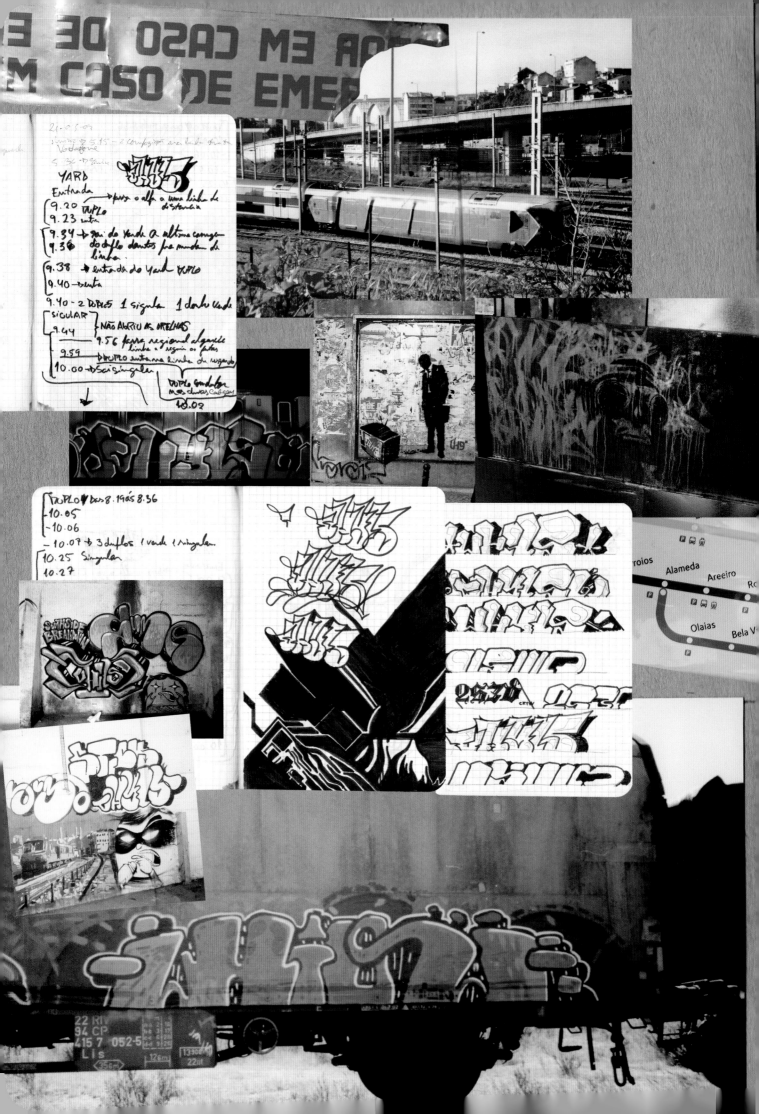

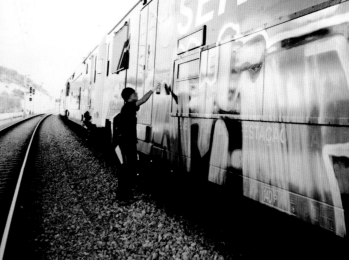

Ephemeral Decay
Vhils

Abundantly creative is perhaps the best way to describe Vhils, a young Portuguese artist who is constantly coming up with innovative approaches to his art. Much of his work is created in situ and focused on the transitory nature of the city, its history and the lives of its inhabitants.

Born in Lisbon, Portugal, in 1987, he grew up in Seixal on the south bank of the river Tagus. The area was an industrial suburb, still quite rural and undergoing an intense process of urbanization. Growing up in a place

that was changing before his eyes had a profound effect on the way he looked at the city. As he saw its character gradually being replaced by billboards and office blocks, he began to think more about the way that the urban environment impacts on us and reflected on this process in his work.

Vhils's passion for art began with graffiti. Until then he hadn't given the subject much thought, but soon it was the only thing he wanted to do. His first forays into the world of graffiti were at

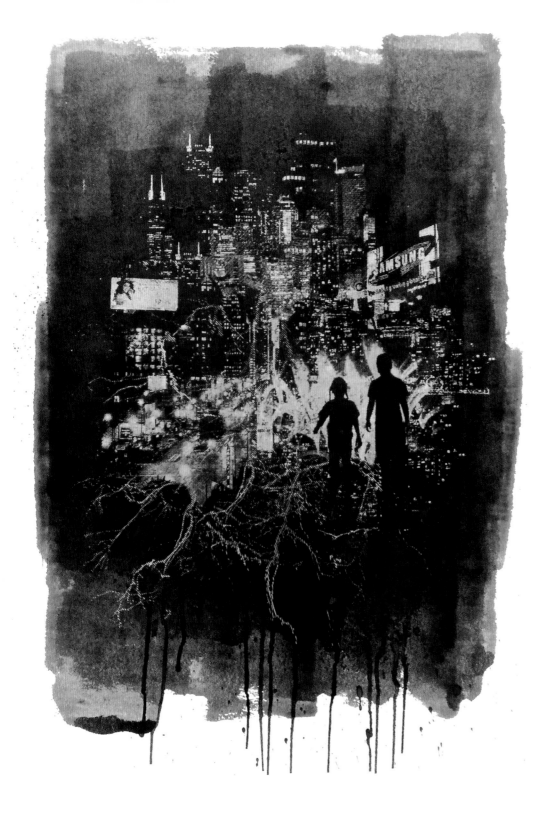

the age of thirteen when he started to paint the trains that ran by his home, heading into the city. Graffiti culture remained a fascination, but another local tradition was also influential on his artistic development. Before graffiti began to spread in Portugal, the only images seen on walls were political murals, many of which dated from after the 1974 Revolution and tended to be socialist in sentiment. Some of these murals can still be seen today, but they were much more abundant when Vhils was growing up. He recalls their effect on him: 'I didn't look at the murals as art, but they did have an effect on me, especially given my father's leftwing political past. I remember the contrast of those murals alongside the growing number of advertisements. My interest in art started out in the streets, with this confrontation between different eras, during that period of intense urban expansion. Everything was either brand new or decades old – there was nothing in between.'

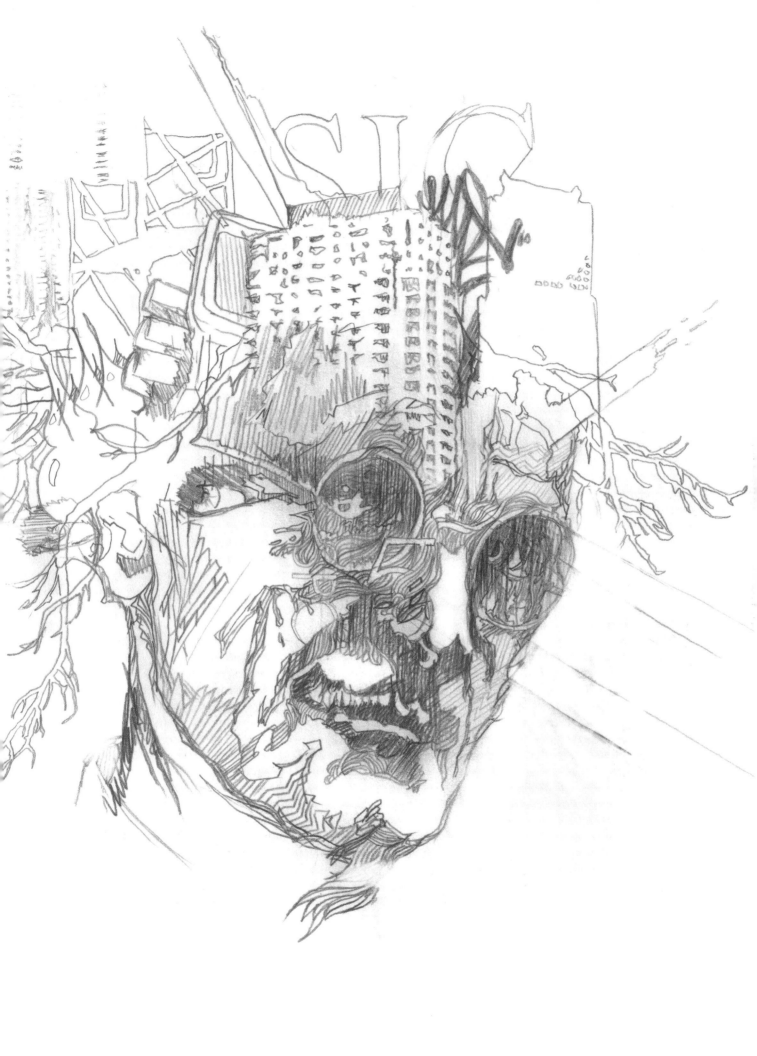

Having written graffiti for many years, he became interested in exploring other techniques. When he came across stencilling he took to it straight away, enjoying the technical process, the way it allowed him to prepare the image ahead of painting it, while thinking more about his concepts. When he first started experimenting with stencils he was still bombing trains, and so used stencils on trains too. By mixing media, he came up with new ideas that might not have happened if he had stayed with one technique. Sometimes he finds the development of a work the most interesting part. 'I do get a bit restless – as soon as I understand how one process works, I am already looking at what I can do next. As soon as I start working on a piece, I am taken over by impulses that drive me towards new ideas and other images.'

Between 2003 and 2005, Vhils became an active member of Lisbon's growing graffiti scene, taking part in painting jams, community projects and group shows until in 2006 he was offered his first solo exhibition called 'Building: 3 Steps'. The opportunity came through Miguel Mauricio, an architect with whom he had already worked on video and motion graphics for the Lux club in Lisbon. Taking place in a traditional gallery, Vhils's show used the concept of graffiti being brought indoors, taking over the space, and then returning to the street. Mauricio helped him to design and build three-dimensional structures inside and outside the gallery, while Vhils painted these surfaces and produced work that flowed from the street across the exhibition space. This led him to find new ways to apply his work onto different materials such as metal, wood and stone. One method was to paint using bleach on a surface that had first been prepared with a wash of ink, burning the image on. He would later use the same technique for screenprints.

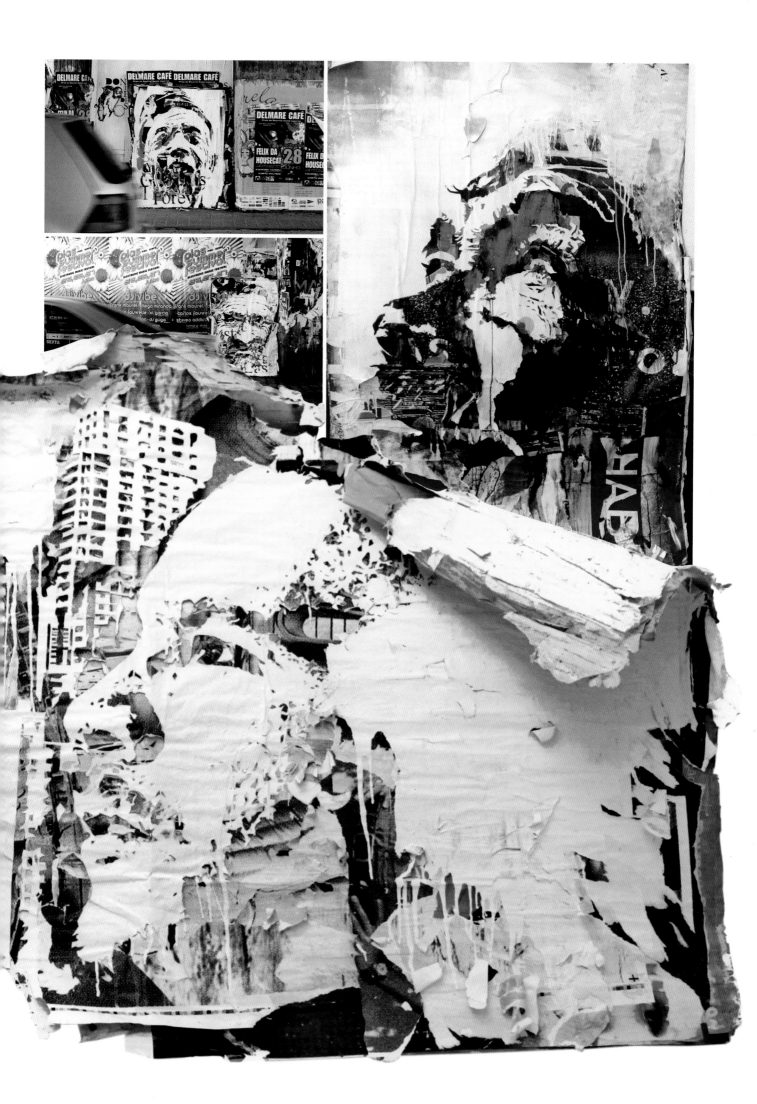

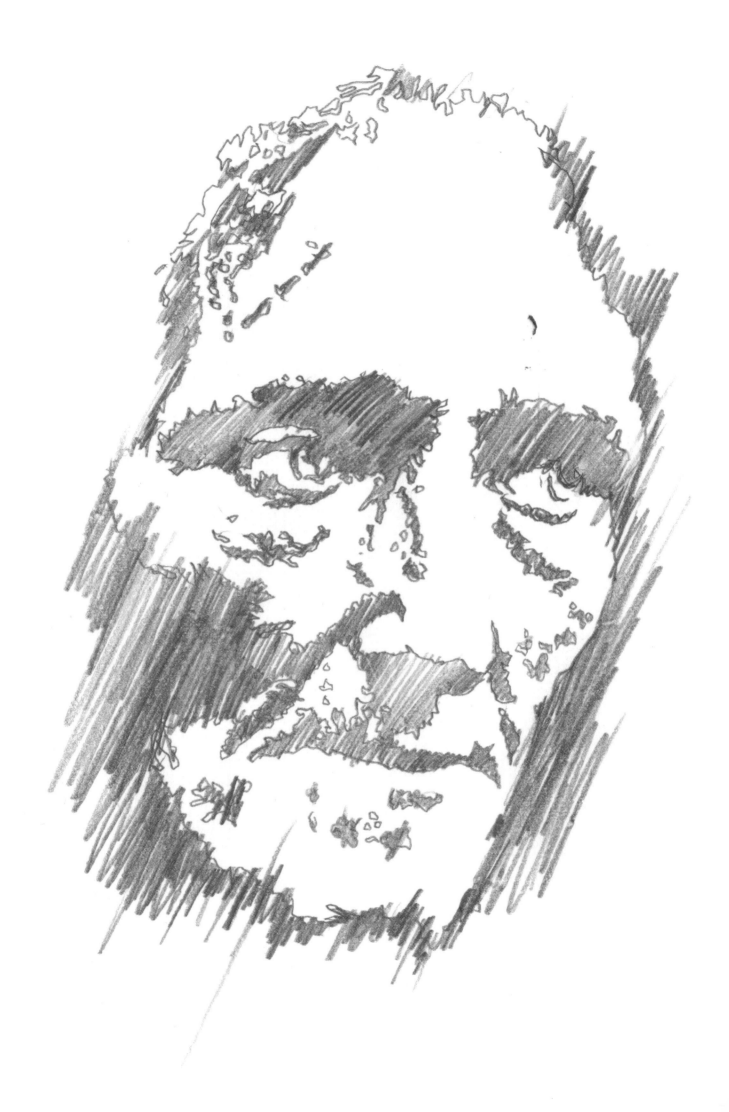

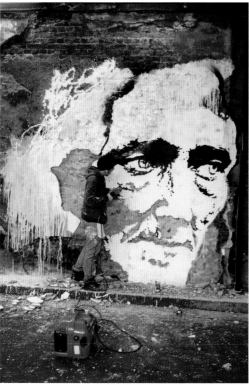

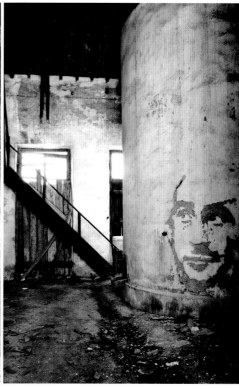

The following year he continued to work on the streets of Lisbon using stencils, spraypaint and other methods that he developed, such as cutting images into billboards. Billposting was prolific in the city, and it was common for posters to be pasted on top of each other to build up into thick wads of paper. By cutting into these posters using a stencilled shape, Vhils was able to create an image or text using the light and shade of the paper layers, as well as revealing text and colours from each layer. He later took this idea a step further on derelict walls – instead of spraypainting a stencil, he decided to engrave an image directly into the wall itself. Both of these methods of stripping away billboards and scratching into a

surface reinforced the themes in his work; the fragmented billboards showed people living in a commercialized and complex society, while the figures in his carved walls feel like the ghosts of the city's people, past and present.

Street art itself is ephemeral, and what Vhils enjoys about some of his methods is the random nature of the results. 'This randomness', he says, 'can be found beneath the layers that form any material. You can cut away at these layers to create an image, but you don't have full control over your creation, as you don't know what images and patterns lie beneath the surface. This is a key concept in my work. Materials change with time, and my pieces change along with them; the tools I use

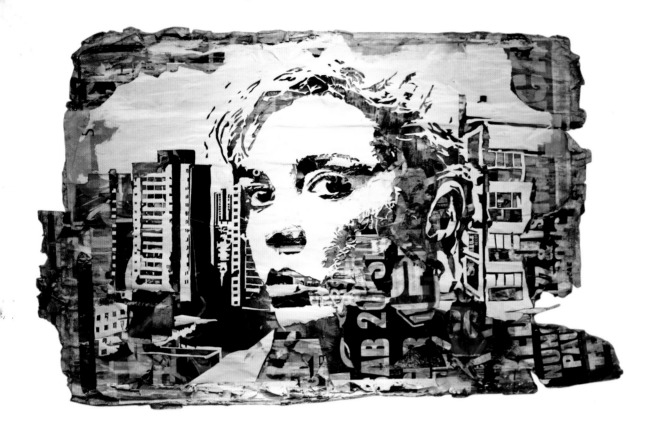

often catalyse this change, and I'm interested in making this a part of the piece. So there is nothing static about them, it's an ongoing process, like a partnership with nature itself.'

In 2008 he applied and was accepted to study fine arts at Central Saint Martin's in London, which gave him further opportunities to create work on the street and in galleries. In May of that year he caught the attention of thousands of visitors with his huge portrait pieces created for the Cans Festival, chiselled directly into a tunnel underneath Waterloo Station. On the crumbling wall of the Victorian tunnel he conjured up the faces of a young girl and an old woman, perhaps suggesting the passage of time. Engraved into the history of the walls, these works and others by the artist evoke the concepts of memory and nostalgia. As he himself says, 'This obliteration of memory, of the past, which I've observed in Lisbon over time, often replaces one thing for another without regard for meaning. I do a sort of symbolic archaeological work in order to recall these lost memories, which are an integral part of who we are today. The galloping pace and intensity of technological advancement hasn't allowed us to digest and absorb the changes to which we have been exposed in recent decades. My work tries, in a poetic way, to highlight and call attention to this phenomenon.'

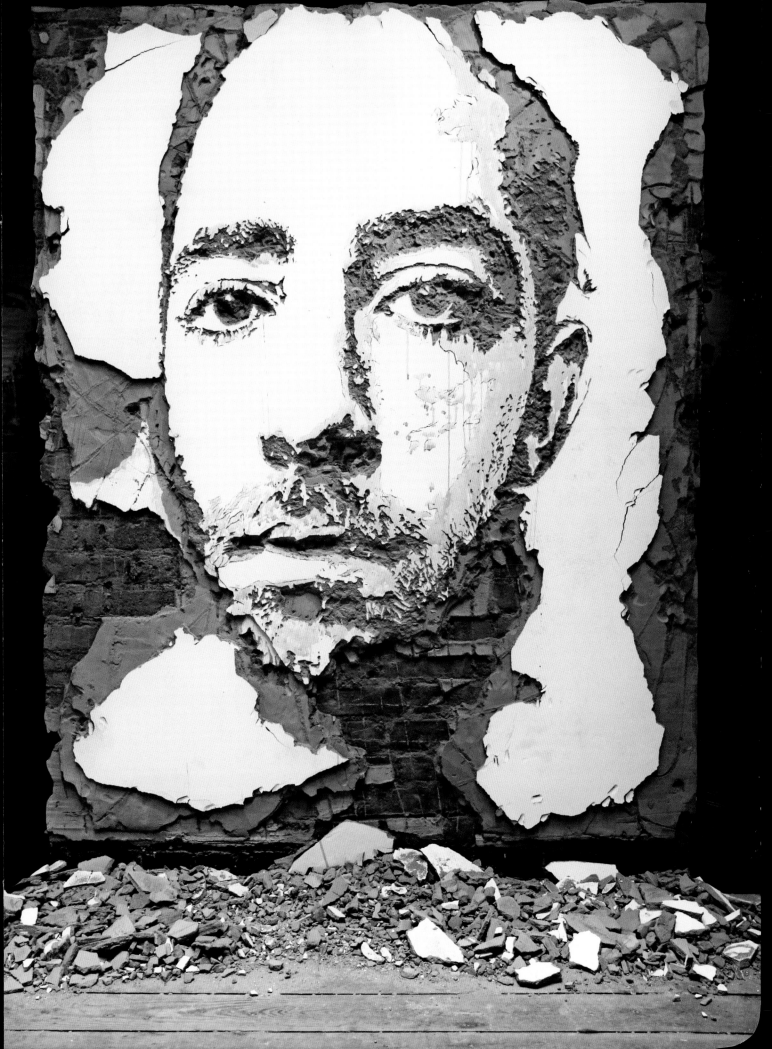

Websites

Arte Cocodrilo
www.artecocodrilo.com

Bastardilla & Stinkfish
www.flickr.com/photos/
stinkfishate
www.stink.tk
www.bastardilla.org

Thais Beltrame
www.flickr.com/photos/thais_
beltrame

Blast, Lastrescalaveras & Losdelaefe
www.flickr.com/photos/blastone/
www.flickr.com/photos/
lastrescalaveras
www.flickr.com/photos/losdelaefe

CharquiPunk
www.flickr.com/photos/charquipunk

Dhear & News
www.flickr.com/photos/dhear
www.flickr.com/photos/la_news

Dran
retroactif.free.fr/dran

Interesni Kazki
www.flickr.com/photos/waone_ik
www.flickr.com/photos/aec_
interesni_kazki

Ramon Martins
www.flickr.com/photos/
ramonmartins

Neuzz
www.neuzz.com.mx

Otecki
www.otecki.com

Ripo
www.ripovisuals.com

Roa
www.flickr.com/photos/roagraffiti

Run
http://www.runabc.org

Sam3
www.sam3.es

Saner
saner-dsr.blogspot.com
www.flickr.com/photos/saner_dsr
saner.com.mx

Sego
www.flickr.com/photos/
segoyovbal

Smithe
smitheone.blogspot.com

Tinho
www.flickr.com/photos/tinho_
nomura

T*Freak
www.tfreak.com

Basco Vasko
basco-vazko.blogspot.com
www.flickr.com/photos/basco

Vhils
alexandrefarto.com

Picture Credits

Page numbers are in **bold**.
(A) indicates the artist or artwork.
(P) indicates the photographer.

1 Bastardilla (A & P)
2 Basco Vazko (A & P)
4–5 Ramon Martins (A & P)
6 TOP LEFT Ramon Martins (A & P); TOP RIGHT Saner (A), Tristan Manco (P); BOTTOM LEFT AEC (A & P); BOTTOM RIGHT Ramon Martins (A & P)
7 Run (A & P)
8 CLOCKWISE FROM TOP LEFT Lastrescalaveras (A & P); T*Freak (A & P); Waone (A & P); Arte Cocodrilo (A) workshop in Oaxaca, Tristan Manco (P); Lastrescalaveras (A & P)
9 TOP LEFT, FROM TOP TO BOTTOM Dhear (A & P); Arte Cocodrilo (A) workshop in Oaxaca, Tristan Manco (P); Neuzz (A & P); Vhils (A & P); TOP RIGHT Sam3 (A & P); BOTTOM RIGHT AEC (A & P)
10 Roa (A & P)
11 Dran (A & P)
12 Sam3 (A & P)
13 Rene Almanza (A & P)
14 TOP Dran (A & P); BOTTOM Dhear (A & P)
15 Waone (A & P)
16 LEFT Arte Cocodrilo (A) workshop in Oaxaca, Tristan Manco (P); TOP RIGHT Oaxaca street, Tristan Manco (P); BOTTOM RIGHT Arte Cocodrilo (A) workshop in Oaxaca, Tristan Manco (P)
17 TOP LEFT Daniel Berman (A & P); TOP RIGHT Uriel Marin (A & P); BOTTOM LEFT Rene Almanza (A & P); BOTTOM RIGHT Daniel Acosta (A & P)
18–19 Daniel Acosta (A & P)
20–21 ALL IMAGES Daniel Acosta (A & P)
22–25 ALL IMAGES Rene Almanza (A & P)
26–27 ALL IMAGES Daniel Berman (A & P)
28 ALL IMAGES Daniel Berman (A), Tristan Manco (P)
29 ALL IMAGES Daniel Berman (A & P)
30 TOP LEFT Uriel Marin (A & P); BOTTOM LEFT Uriel Marin (A), Tristan Manco (P); RIGHT Uriel Marin (A), Tristan Manco (P)
31 ALL IMAGES Etchings by Uriel Marin (A & P)
32–33 ALL IMAGES Woodcut by Uriel Marin (A & P)
34 TOP LEFT Stinkfish (A & P); BOTTOM LEFT Bastardilla (A & P)
35 Bastardilla (A & P) and Stinkfish (A)
36–39 ALL IMAGES Bastardilla (A & P)
40 ALL IMAGES Stinkfish (A & P)
41 ALL IMAGES Various street works by Stinkfish (A & P), Mexico
42–43 ALL IMAGES Travels around Spain by Stinkfish (A & P)
44 ALL IMAGES Sketchbooks created while travelling in Guatemala by Stinkfish (A & P)
45 TOP LEFT Bastardilla (A & P), Guatemala; TOP RIGHT, CENTRE RIGHT, BOTTOM Stinkfish (A & P), Guatemala; CENTRE LEFT Painting in support of MINGA, a peaceful protest group working for indigenous peoples, by Bastardilla (A & P)

46 ALL IMAGES Bastardilla (A & P), Guatemala
47 Bastardilla (A & P)
48–49 ALL IMAGES Thais Beltrame (A & P)
50–51 Thais Beltrame (A), Bruno Werneck (P)
52–57 ALL IMAGES Thais Beltrame (A & P)
58–59 Blast (A), Lastrescalaveras (A & P), Losdelaefe (A)
60 TOP Blast (A), Lastrescalaveras (A & P), Losdelaefe (A); BOTTOM Blast (A & P)
61 Losdelaefe (A & P)
62 Losdelaefe (A & P)
63 TOP Lastrescalaveras (A & P); BOTTOM Blast (A & P)
64–65 ALL IMAGES Blast (A & P)
66–67 ALL IMAGES Lastrescalaveras (A & P)
68–69 ALL IMAGES Losdelaefe (A & P)
70–71 ALL IMAGES CharquiPunk (A & P) in collaboration with La Robot de Madera, Valparaíso
72 ALL IMAGES CharquiPunk (A & P): TOP AND BOTTOM In collaboration with La Robot de Madera, Valparaíso
73 ALL IMAGES CharquiPunk (A & P)
74 CharquiPunk (A & P)
75 ALL IMAGES CharquiPunk (A & P): TOP CharquiPunk and Inti Willy's house, 2007; CENTRE CharquiPunk and Inti Los Pescadores, Valparaíso, 2006; BOTTOM Painting with Cern and Hecho, Valparaíso
76 ALL IMAGES CharquiPunk (A & P): CENTRE Tiwanaku, Bolivia; BOTTOM Portrait of Héctor Lavoe, Lima, Peru
77 CharquiPunk (A & P)
78 ALL IMAGES CharquiPunk (A & P): TOP LEFT Chinese cat, Santiago, Chile; TOP RIGHT San Pedro de Atacama festival, Chile; CENTRE AND BOTTOM Chilean musicians
79 ALL IMAGES CharquiPunk (A & P): TOP LEFT Bolivian musicians, Oruro, Bolivia; TOP RIGHT Bolivian musicians; CENTRE Chilean musicians; BOTTOM LEFT Barracones, Lima, Peru; BOTTOM RIGHT Chilean musicians
80 CharquiPunk (A & P)
81 ALL IMAGES CharquiPunk (A & P): TOP Skatepark, Arequipa, Peru; BOTTOM LEFT Cochabamba, Bolivia; BOTTOM CENTRE Cat, Lima, Peru; BOTTOM RIGHT Cat, Cochabamba, Bolivia
82 Dhear (A & P)
83 TOP RIGHT News (A & P); BOTTOM LEFT Dhear (A & P); BOTTOM RIGHT, CLOCKWISE FROM TOP LEFT News (A), Tristan Manco (P); News (A & P); Dhear (A & P); Dhear (A), Tristan Manco (P)
84–89 ALL IMAGES Dhear (A & P)
90–93 ALL IMAGES News (A & P)
94–105 ALL IMAGES Dran (A & P)
106–107 Waone (A & P)
108 TOP LEFT Interesni Kazki (A & P) and Kislow (A); TOP RIGHT Interesni Kazki (A & P); CENTRE LEFT AEC (A & P); CENTRE Interesni Kazki (A&P); CENTRE RIGHT Interesni Kazki (A & P); BOTTOM Interesni Kazki (A & P)
109 AEC (A & P)

Acknowledgments

Thanks to Olivia Manco and Carla Haag for proofing assistance, translations and support. Thanks also to the following for their great support of various kinds: Elvia Haag, Jean Manco, and everyone involved at Thames & Hudson. A big hug to all the artists featured in this book. Many thanks for their friendship, time and efforts to create this book. Wishing them all well on their further travels.